Jack B. Yeats

A biography

Hilary Pyle

ANDRE DEUTSCH

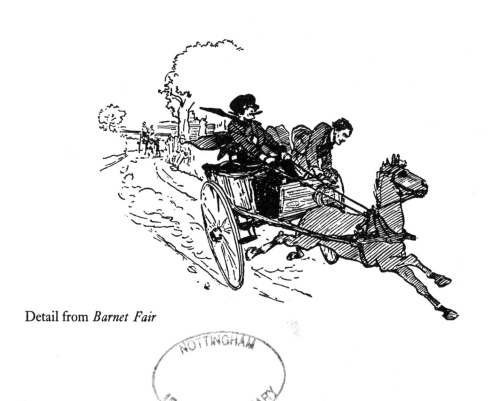

Detail from *Barnet Fair*

This revised edition first published 1989 by
André Deutsch Limited
105-106 Great Russell Street
London WC1B 3LJ

Original edition first published 1970 by
Routledge and Kegan Paul Ltd, London

British Library Cataloguing in Publication Data

Pyle, Hilary
 Jack B. Yeats: a biography – 2nd ed.
 I. Title II. Yeats, Jack, B. (Jack Butler),
 1871-1957
 759.2'915

 ISBN 0-233-98461-5
 ISBN 0-233-98462-3 pbk

Printed in Great Britain by
St Edmundsbury Press Limited, Bury St Edmunds, Suffolk

Dedicated to
F.M.P.

Preface

Since this book was first published in 1970, attitudes towards Jack B. Yeats have altered. He has always had the firm following of those who were sympathetic with his work: but today, as their intrinsic worth is being more widely appreciated, his paintings are suddenly acquiring ten times their former value in the salesrooms.

No doubt prices will continue to soar; but Jack Yeats will remain the same, candid yet elusive, a man who seemed automatically to win the affection of all who knew him. He was reticent about his life. He did not look for any scholarly analyses yet he was eager for his work, particularly his paintings, to be understood. He left a lasting record of his personality in the wealth of his equivocal canvases and quixotic pages.

This reprint of the biography has provided an opportunity to correct some misprints and facts in the original text. There has been room also to add references to critical writings on Yeats, published since the first edition, as well as an up-to-date list of exhibitions devoted to his work.

What better time might there be, than during the present upsurge of enthusiasm for his original genius, to forward plans for the establishment of a permanent Yeats museum, where representative drawings and paintings could be housed, with his written works, personal papers and other memorabilia? 'He is with the great of our time,' wrote Beckett, 'because he brings light, as only the great dare to bring light, to the issueless predicament of existence, reduces the dark where there might have been mathematically at least a door.'

Hilary Pyle
January 1989

Acknowledgements

I should like to thank many people for helping me to write this book.

Most of all I am indebted to Miss Anne Yeats for her hospitality and constant encouragement, and for giving me her personal recollections of her uncle; and to her and to Senator Michael B. Yeats for permission to examine and quote from Yeats's personal papers, letters and writings, and the unpublished letters of John Butler Yeats and William Butler Yeats.

I am also grateful to Mr. William Masefield for permission to quote from John Masefield's letters to Jack B. Yeats. I acknowledge the courtesy of Mrs. L. M. Stephens and the National City Bank, Ltd., Executors of the J. M. Synge Estate, in allowing me to consult the letters of Jack B. Yeats to J. M. Synge; of the New York Public Library Manuscript Collection for the letters to John Quinn, and the Henry W. and Albert A. Berg Collection of the New York Public Library, Astor, Lenox and Tilden Foundations for the letters to Lady Gregory.

As well as this I have received most kind co-operation from the staffs of the National Library of Ireland; the Library of Trinity College, Dublin; the City of Dublin Public Libraries; the Goldsmiths' Librarian of the University of London; the British Museum Newspaper Library; the New York Public Library; the University of Kansas Libraries; and the Archives of American Art.

I wish to record my gratitude to all owners of Yeats paintings, both private owners and curators of public collections, who have assisted my enquiries. My special thanks are due to Victor Waddington and to Leo Smith for their generous and willing assistance in tracing the histories of

individual paintings and for lightening the burden of research so greatly for me.

Among those who have contributed their personal memories of Yeats, or who have helped me in other ways, I should like to mention in particular: J. Adam; Mrs. A. Bodkin; R. B. Beckett; L. Bigelow; Miss M. B. Caldwell; Miss E. Coxhead; P. Colum; Dr. C. P. Curran, S.C.; A. Denson; Miss H. P. Eason; Professor O. Edwards; Dr. E. L. Fitzpatrick; Dr. Monk Gibbon; Mrs. M. Gillespie; O. D. Gogarty, S.C.; the late Rev. J. P. Hanlon; the late Rt. Rev. T. A. Harvey; W. P. Hone; Mrs. S. Le Brocquy; Dr. F. McGrath; the Hon. C. A. Maguire; L. Miller; N. Montgomery; Miss R. Mooney; Miss N. Niland; Miss T. O'Sullivan; C. O'Malley; Mrs. T. Nuttall; B. L. Reid; Mrs. H. H. Roeloffs; P. Stevenson; Mrs. A. M. Stewart; G. Waddington.

Through the generous assistance of the Cultural Relations Committee of the Department of External Affairs and of the Irish-American Cultural Institute, I have been able to pursue my researches in the United States.

I should like to thank the Director of the National Gallery of Ireland and my colleagues there for all of their interest and co-operation; Miss Anne Crookshank and my father for advice and continual encouragement; Mr. Terence de Vere White, again for advice, and for allowing me to avail so fully of his reminiscences in my text; my mother, for her invaluable help, especially in preparing an index; and many others who have helped me in so many ways.

Contents

Illustrations

Part one

'I believe that all fine pictures . . .
to be fine must have some of the
living ginger of Life in them.'

Chapter 1

'What are you for, honourable rust, dust, and green earth'[1]

Jack Butler Yeats was born in London on 29 August 1871. He was, in his own words, 'the son of a painter'. His father, John Butler Yeats,[2] had recently finished his art school training and embarked on a career that was to culminate in his distinction as a portrait painter. One of his sons was to be a national poet, the other Ireland's greatest artist.

Jack, the youngest of a family of five, was the child who inherited John Butler Yeats's particular genius. Looking back at his ancestry it is easy to see how he developed into an artist of such decided personality, and of all painters Jack Yeats's basic influences were his personality and his family background. His father appears to have been the first of that profession in the family; but those who went before were unconventional, characterful men, accomplished in action, in curiosity and imagination, sometimes mystical in thought, and loving life and creating adventure.

The Yeats spirit and provocative mind were dominant in Jack B. Yeats. In temperament, however, he[3] tended to take after his mother, Susan Pollexfen. Jack himself could trace the Pollexfen origins back to the Greeks. He wrote to his brother in 1938:

As in a dream – I remembered that Uncle Fred Pollexfen said that the original Pollexfens were flying tin men from Phoenicia.

[1] Yeats, Jack B., *Sligo*, 1930, p. 156.

[2] To distinguish him from his son, Jack, he will hereafter be referred to by his abbreviated signature, 'JBY'.

[3] Information for this chapter and the next comes from the artist's papers; Hone, J. M., *W. B. Yeats 1865–1939*, 1943; Jeffares, N., *W. B. Yeats: man and poet*, 1949; Yeats, W. B. *Autobiographies*, 1955, among other sources.

He was satisfied. I don't know how. But I, at once, began a search up in the bight of the Mediterranean for any name that would suggest Pollexfen, and in a moment I had it – Helen must be our grand, grand, grand, grand aunt for we must be descended from her brother Pollux so that giving us Leda and the Swan for grand, grand, grand, grand parents that ought to be good enough for any man.[1]

This was written just after he had painted the major work entitled 'Helen'. Pollux was the mythological being particularly skilled in boxing and a suitable connection for a man who enjoyed and continually sketched such a sport. Other attributes of the Dioscuri, Castor and Pollux, were their power over the winds and waves – making them the protectors of sailors – and their place as presidents of the public games: whenever they appeared to mortals, they came riding on white steeds. Pollux automatically had a place in the artist's genealogy.

Grandpapa Pollexfen [of] Sligo, with Helen for a grand aunt would, by being in the shipping trade, only be following in the old tradition.

So Jack Yeats concluded, seeing plainly the logical succession of removal from the Mediterranean to Cornwall, and thence to Wexford, the home of his grandfather's mother, and to Sligo; and he was pleased, as his brother must have been, if the latter vaguely uneasy.

Historically the Sligo branch of the Pollexfen family issued from 'Grandpapa' William Pollexfen. Lily Yeats saw, perhaps erroneously, a connection with Francis Drake.[2] The derivation of the name suggested in Henry Harrison's *Surnames of the United Kingdom* is 'dweller at Pollack's Fen'. R. Burnet Morris[3] quotes the vulgar form of the name given by Risdon[4] and other examples, such as Pollexton, Palston and Polkysfen, the last having occurred at Dartmouth in about the year 1390; and believes that the name may have originated in the place name Poulston, in Halwell parish near Totnes. Pollexfens had been known as traders in Galway in the seventeenth century, but William Pollexfen came straight from Devonshire, the only son of a Cornish barrack-master, who had settled in Brixham, where William was born in 1811. His mother, Mary Stephens,

[1] Unpublished letter. [2] Jeffares, p. 300. [3] *Notes and Queries*, vol. 160, p. 429.
[4] *Chronological description . . . of . . . Devon*, p. 194.

came from Wexford. His father, Antony Pollexfen, had retired from the army to become the owner of sailing ships. They produced a son of iron character. William Pollexfen ran away to sea as a boy and was successful through his fearlessness and forthright determination, becoming a prosperous ship owner in Sligo in his prime. W. B. Yeats wrote:

He has great physical strength and had the reputation of never ordering a man to do anything he would not do himself. He owned many sailing-ships and once, when a captain just come to anchor at Rosses Point reported something wrong with the rudder, had sent a messenger to say 'Send a man down to find out what's wrong'. 'The crew all refuse' was the answer, and to that my grandfather answered, 'Go down yourself', and not being obeyed, he dived from the main deck, all the neighbourhood lined along the pebbles of the shore. He came up with his skin torn but well informed about the rudder.[1]

William Pollexfen was a passionate man, who commanded respect and admiration. No one, even his wife, became intimate with him; the first reaction was to tremble. He kept a hatchet beside his bed in readiness for burglars, and would take to fists in emergencies rather than call on the police; and he had been known to use a horsewhip on adversaries.[1] His temper was violent. He made no friends in Sligo, according to W. B. Yeats, but he kept himself to himself, always silent and reserved. His background was a mystery, except for a few details which revealed glimpses of a life of adventure: an ugly scar on his hand; pieces of coral in a cabinet, beside a jar of water from the Jordan; Chinese paintings; an ivory walking-stick that had come from India; the late learnt knowledge from a chance visitor that he had won the freedom of a Spanish city, perhaps for saving a life.

Despite his fierce demeanour, William Pollexfen was simple, trusting and scrupulously honest. W. B. Yeats saw this as a tragic element in his personality, for acquaintances often found a slight deviation from the truth was preferable to a blow. His servants would secure the house in the evening in a charade performance, making a ceremony of handing him the key when the doors were still unlocked; and he retired to bed believing that all members of the household were safe within the walls for

[1] *Autobiographies*, p. 7.

the night. Admittedly he required the key at eight o'clock in the evening. WB saw his grandfather as King Lear. For Jack Yeats his example conjured up that elusive nineteenth-century pirate Jean Lafitte, and other pirates so superbly ferocious as to be unbelievable. Jack Yeats spent the greater part of his childhood in the house of William Pollexfen.

Pollexfen married to Middleton could not but produce an adventurous temperament of a gentler variety. The Middletons were kindly, practical people, plain, perhaps, beside the Pollexfens, and without the majestic reserve. They mixed quite easily with the country people about them. Not that the family had not known their period of glory. William Middleton, father of William Pollexfen's wife, was an Irish speaker from Dromahair who started his life as a trader and smuggler in the late eighteenth century, sailing between London, South America and the Channel Islands. He was arrested on one occasion in South America, and managed to escape by night. In 1810, in Jersey, he won a child bride as his second wife, under romantic conditions. Embarking one Sunday morning at Jersey he attended the service at Charles Pollexfen's church and there caught sight of the clergyman's daughter, Elizabeth, and bore her home without delay to Sligo.[1] Middleton himself died as the result of an act of charity during the cholera epidemic in Sligo in 1832, when he picked up a dying beggar in the street and brought him into his house. He was smitten down in his sixties, and leaving a young widow.

The following year her cousin, the redoubtable William Pollexfen, sailed into Sligo to her aid. He joined her son, who was also called William, as partner in the milling and shipowning business. William Middleton appears to have been the more businesslike of the pair, but the colourful and very definite presence must have lent necessary moral support. On the death of Robert Culbertson the two men acquired flour and corn mills at Ballisodare, newly built on both sides of the river after the cholera epidemic. Milling is alleged to have been in operation there since the time of S. Fechin in the seventh century. The firm which survives still, in the Pollexfen name, became reputable before long for 'Avena' flour, so named after William Middleton's house at Ballisodare; coal, too, formed part of their import into Sligo.

[1] The Rev. Charles Pollexfen was probably a brother of William Pollexfen's father, Antony.

William Pollexfen married his cousin's daughter, another Elizabeth, and the close relationship may account for the low-spirited and some-times unbalanced disposition of his children. One uncle of WB and Jack Yeats had a tongue of leather fitted over the keyhole of his door in order to keep the draught out; and another, who designed the Sligo quays, gradually went mad, seeking to invent a warship that could not be sunk because of its hull of solid wood. There was a mystical trait, too, coming out in Uncle George's interest in the occult. The business instinct was strongly in evidence. Aunt Agnes, who was regularly sending warm socks to Jack, when he was in Devon, married Robert Gorman, another profit-able connection in Sligo. Gorman was a good judge of cattle and he ran a bacon trade in Union Street.

Susan Pollexfen, mother of the poet and the painter, was practical, imaginative and melancholy. She took no interest in her husband's paint-ing, but in letters delighted in the 'tumbling' clouds.[1] She impressed her intense love of Sligo very strongly on her children and it was always assumed by her and by them that Sligo was more beautiful than other places.[2] Reserve too was her counsel: she disliked the effervescence and the clannishness of the English: and her independence passed on to her children who from early adulthood always signed themselves with their full name and surname when writing to each other.

The Yeats family, a very different strain, full of ideas and talk, and very conscious of family history, had also been settled in Sligo for two generations. The Yeatses were 'respectable' gentlefolk who had come down in the world, and they tended to remain aloof from the prosperous landowning Pollexfens and Middletons. Their own ancestors had never-theless made their way as merchants before John Yeats, Rector of Drumcliffe, had entered a profession. Aunt Micky (Mary) Yeats, his daughter, who lived on the hill above the Rosses, liked to remember the part the Yeatses played in Irish history. In some eyes they represented the less commendable faction, opposing Sarsfield and Lord Edward Fitz-gerald; though her father had rectified matters somewhat by becoming friendly at Trinity College with Robert Emmet. Micky Yeats owned the family silver, including a silver cup with the Butler crest, brought into the family by her grandmother Mary Butler, when she married the linen

[1] *Autobiographies*, p. 61. [2] *Op. cit.*, p. 31.

merchant Benjamin Yeats, in 1773. Butler, the family name of the Dukes of Ormonde, was a welcome acquisition, and has since been used in nearly every generation.

Some gossips told me, wrote Jack in 1938:

that some one, I filled in Lord Dunsany, said that the governor was the first Yeats who arrived in Ireland, and this made me get out the little family tree I had made out, and of course the Yeats I have, and Lilly very likely by now has pushed further back, was Irish in the 17th century.

The seventeenth-century Yeats, whom Jack's sister did not in the event supplant, was Benjamin Yeats's grandfather, Jervis, who had perhaps emigrated from Yorkshire, where relatives of his were living at the time of his death. The name, meaning 'at the gate', would surely have received some laudable explanation from Jack Yeats; perhaps it was the 'vigorous mind'[1] waiting on the alert for whatever might occur. Benjamin's father was another Benjamin; his son, the Reverend John Yeats (1774–1846), was a scholar and a gentleman, who lived an outdoor life, and entertained on a splendid scale. He married a Jane Taylor, the daughter of a Dublin Castle official, in 1803, and in 1811 he was appointed to a living at Drumcliffe in Co. Sligo, where he remained for the rest of his life. He was as friendly and courteous to Roman Catholic neighbours as he was to his own parishioners, which was unusual in those days of strict divisions of society, though between the times of the Union and the Treaty the rector and the parish priest in country parishes in Ireland were often close friends, being with the doctor the only educated men in the district.

A brass plate now commemorates John Yeats's name in St. Columba's Church, Drumcliffe, a bleak building set beneath Ben Bulben, surrounded by green fields and a graveyard live with cawing rooks. The church stands above the river where the famous Battle of the Books was fought. The river winds round below the tall barracks of a rectory, with its wide balcony window, on the first floor, looking back at the church, a Celtic cross, and the stump of a round tower. William Butler Yeats, Jack's grandfather, grew up in this area of legend and history with his religious and intensely home-loving brothers and sisters. Tom, a brilliant mathematician, turned tail to Sligo immediately after taking his degree, and

[1] Yeats, W. B. *Collected Poems*, 1955, p. 228.

never left it again. Mary (Micky) Yeats farmed on her own in her shadowy house above the Rosses, a few miles away from her brother Matthew, the land agent.

William Butler Yeats, however, took up his father's profession, and became Curate of Moira, in Co. Down, in 1831, after a distinguished career in sport at Trinity College, Dublin, where he also edited the *Dublin University Magazine* with Isaac Butt. Shortly after his marriage to Jane Corbet of Sandymount, sister of the Governor of Penang (the name passed afterwards to their granddaughters), he was appointed Rector of Tullylish, which is also in Co. Down. John Butler Yeats (JBY) was born here in 1839, the eldest of a large family. He was very close to his father, a relationship which he valued, and was in turn to encourage with his eldest son:

It was my father who made me the artist I am, and kindled the sort of ambition I have transmitted to my sons. . . . To be with him was to be caught up into a web of visionary hopefulness. Every night, when the whole house was quiet, and the servants gone to bed, he would sit for a while beside the kitchen fire and I would be with him. He never smoked during the day, and not for worlds would he have smoked in any part of the house except the kitchen and yet he considered himself a great smoker. He used a new clay pipe, and as he waved the smoke aside with his hand, he would talk of the men he had known – his fellow students – of Archer Butler, the Platonist, and of a man called Gray who was, I think, an astronomer, and of his friend Isaac Butt, that man of genius engulfed in law and politics. And he would talk of his youth and boyhood in the West of Ireland where he had fished and shot and hunted and had not a care, of how he would on the first day of the shooting climb to the top of a high mountain seven miles away and be there in the dark with his dogs and attendants, waiting for the dawn to break.[1]

The red-headed rector, described on one occasion as 'a jockey', still hunted and fished and shot. He read too. When Macaulay's *History* was published he retired to bed until he had finished all the volumes. His 'flighty' preaching was eloquent, and with his evangelical tendencies he found it difficult to reconcile himself to the rigid Presbyterianism of the North: and he transmitted this attitude to his son, who finally turned from religion altogether.

[1] *Early Memories: some chapters in autobiography*, 1923, p. 35.

JBY went to school at the Atholl Academy in the Isle of Man, to a régime typical of the educational system in the last century, where boys lived in terror of their masters, and longing for their homes. He made a life-long acquaintance there, however, William Pollexfen's son, George – the calm melancholy nature attracted the nervous bouyancy of the creative mind, and when JBY paid a visit to George Pollexfen and his family at Rosses Point, a few years later, when he was at Trinity, George's sister Susan made a strong impression on him.

JBY had been intended for the Church; but confirming through Butler's *Analogy* that he was without religious belief, theology was exchanged for a degree in classics, metaphysics and logic. He then embarked on a career in law, devilling for a time for his father's old friend Isaac Butt. He had great proficiency in philosophizing and debate. His father, retired and living at Sandymount Castle with his uncle, Robert Corbet, died suddenly, leaving to JBY an estate in Co. Kildare with a small income. The following year, on 10 September 1863, he married the greatly sought-after Susan Pollexfen.

JBY and his wife settled for the time near his uncle in Sandymount, just outside the city of Dublin, while JBY completed his terms of law. William Butler Yeats (WB) was born two years later. When Robert Corbet, deeply in debt through his failure as a stockbroker, committed suicide, JBY finally made up his mind to leave his career at the Bar and to seek his fortune as other artists had done in the past, in London. The family settled at 23 Fitzroy Road, Regent's Park. From 1867–8 JBY studied at Heatherley's Art School in Newman Street. Lily (Susan Mary) was born while her mother was on holiday with her parents near Sligo; Lolly (Elizabeth Corbet), Robert and Jack followed subsequently in London. Jane Grace, born in 1875, died nine months later.

JBY made an interesting acquaintance at Heatherley's in Samuel Butler, who was endeavouring to prove himself as an artist, at the same time as he was writing *Erewhon*; but his real friendships were made at the Academy School, where he worked under Poynter. With Wilson the watercolourist, Page, Nettleship and Potter he formed a group aiming to establish the Pre-Raphaelite ideals once more. His conception of Browning's 'Pippa'[1] dates from these days, and he received the approval

[1] Coll: The National Gallery of Ireland, Dublin.

of Rossetti. Gradually his idealism faded for a more concrete style, in the vein of Frith and the realists: but it was not until the 1890s that his style became his own, his version of impressionism. He was in a sense a retrogressive artist, always looking back to something that has gone before.[1]

JBY was a philosopher as well as an artist and a writer. His views were definitely formed, though for all his adulation of rationalism generally inconsistent. He did not know when to finish a painting. He worried away at his work with ruinous effects. The famous story of the pond painting related by WB need not be quoted again. Yet he believed that an artist should aim at retaining the quality of the initial sketch.

He was too much of an intellectual eclectic. He loved certain branches of literature, such as the Metaphysical poets; but he could condemn the Romantics, and, after his first enthusiasm, Browning because he was convinced that human personality was of the utmost importance, and he felt that both Browning and the Romantics had in such a respect failed. Humanity was his consuming interest, and his attitude was charitable, as well as dogmatic. His portraits always brought out the gentler side of the subject. 'The portrait painter', he said, 'with the full mind will find interest in his sitter his chief, his sole inspiration – to make his technique equal to his thought will be his humble painter's hope. The other sort will think only of his technique.'[2] His portrait of Jack as a boy[3] shows a complete understanding of the shy, fair-haired boy, his head bent at a typical angle; he is carried away in a dream on his own, and yet alert at the same time to what is going on before him, inquiring, without giving anything away.

Jack Yeats never commented on his father's painting, though the latter had much to say about his; but when he was interviewed towards the end of his life on the BBC[4] and asked about his original reasons for painting, he said emphatically, and several times, that he painted because he was the son of a painter.

[1] John Quinn, the American art collector, calling himself a 'post-Victorian', dubbed JBY a 'Super-Victorian' in a dedication in Strachey's *Eminent Victorians* given to JBY in New York in 1918; and the same image might be applied to his younger son, who in later years displayed all the traits of an early Victorian.

[2] Yeats, J. B., *Letters to his son W. B. Yeats and others 1869–1922*, 1944, p. 100.

[3] Coll: National Gallery of Ireland, Dublin.

[4] B.B.C. Broadcast interview by T. MacGreevy, 7 May 1948.

Chapter 2
Sligo

Jack Butler Yeats experienced a childhood divided between the endless philosophizing of JBY and the reminiscent romance and active life of the Pollexfen family. The sailors in the employment of the latter tended to regard JBY as unlucky.[1] Certainly Jack was fortunate to some extent in escaping the inexhaustible supervision and the demanding presence which his brother knew, for he spent most of his childhood in Sligo with his grandparents.

The atmosphere was not unconducive to art. Artists had found the county and town of interest before, a J. Brennan, perhaps the Brenan (*c.* 1796–1865) generally painting in the South of Ireland who gave Daniel Maclise his first lessons, depicting Sligo Abbey in 1857.[2] In 1891 the special artist of the *Illustrated Sporting and Dramatic News* in London visited Sligo and Loch Gill and described fishermen at the quays of Sligo, and sportsmen, and holidaymakers boating, in over-conventional drawings, judged to tempt readers to make the journey: he may have inadvertently influenced Jack Yeats thus to see a greater subject-matter in the locality at a time when the latter was engaged in similar black-and-white work. More interesting, however, is the fact that Percy Francis Gethin was born a few years after Yeats, in Sligo, at Holywell in 1874, and he was to work in his etchings the circus life that takes up such a major portion of the other's work.

Mrs. Pollexfen indulged in watercolour painting when she could find time for it; and when Robert, the robust and lively child who could go

[1] *Autobiographies*, p. 51. [2] Kilgannon, T., *Sligo and its surroundings*, 1926, p. 117.

through more experiences in a month than another in ten years, died at Merville, the Pollexfen's house, early in 1873, allegedly after a banshee cry, and all the ships in port lowered their flags to half-mast, WB and Lily were shortly afterwards occupied drawing ships with the flags at half-mast. How good they were is another question, According to JBY one of the sisters drew a horse for Jack when he was a small boy, and made such a sad failure of it that he laid down his head and wept.[1] Jack Yeats's pencil from the start was never idle. About his baby drawings two things were to be noticed, wrote JBY:

. . . he never showed them to anyone. Also, his drawings were never of one object, one person or one animal, but of groups engaged in some kind of drama. For instance, one day I picked up one of his drawings and made out that there was a cab and two men and a telescope; one man looking through the small end and the other man looking through the large end. The telescope itself, which was of monstrous size, lying on the ground – and I asked what it meant and was told that the man at the larger end was the cab man and that he was trying to find out what the other was looking at. At this time Jack's education had not got beyond learning his letters.[1]

This taste for dramatic groupings was evinced in his early love of dolls. He made a house for his dolls, known as 'The Farm', and wherever he went his farm had to accompany him. This model later developed into a miniature theatre for which he wrote plays and designed scenery.

Mrs. JBY stayed at Merville when Jack was an infant, and when her husband's resources were slender, and she returned to London with the elder children, he remained behind. The family came back to Sligo for long spells, according to WB's *Autobiographies*. WB's account of the silent grandfather, inspiring fear and deference, of the quiet religious grandmother interested in nature cures, of the visits of the strange melancholic uncles, and of nearly wild dogs roaming the spacious lands about Merville, makes an eerie background, enhanced by his sister's story of the housemaid attempting to amuse the children by prancing on the floor on all fours with lighted tapers in her hair, out of the line of vision of the

[1] *Christian Science Monitor*, 2 November 1920: 'The education of Jack B. Yeats' by John Butler Yeats.

grandparents; yet both had a nostalgic longing for Sligo when they were in London, and one can but assume that the element of terror was exaggerated in retrospect, and that they blocked out momentarily the more pleasing aspects of life at Merville. These are glimpsed in *Auto-biographies*: the orchard with flowerbeds behind the house, where there were two figure-heads of ships, one a uniformed man, perhaps the Tsar, standing up from the strawberry beds, the other a white lady in flowing robes among the flowers; and the library where the only books were early Victorian novels and an encyclopaedia of many volumes, published at the end of the eighteenth century.

JBY, in his article about Jack's childhood, spoke of nothing but the kindliness of the grandparents who were particularly fond of his young-est son and appreciated his shy interest in all about him.[1]

I think that Mrs. Pollexfen because of her affection for Jack came to the con-clusion that there must be some good in me,

he wrote wryly. Jack himself, drawing a pencil portrait of his grandfather from memory in 1911, shows a bearded old man in coat and hat with a flower in his buttonhole, a symbol not of unholy fear but of dignity and respectability. Local memory recalls the pony trap driving down the main street of Sligo with the young boy sitting upright on the seat be-side the old man, wielding a dinner bell to clear the road before them: and the bond, never openly expressed, was, one suspects, always close. 'That lesson of self concerning silence he learnt doubtless from being left so much to himself in his Sligo home, alone with his grandparents, who ... never thought of meddling with their grandson's freedom.' 'Grand-parents, gentle, affectionate, were the best education for him,' observed his father.

Jack B. Yeats, in so far as he received a formal education, attended a private school in Sligo run by three sisters, the Misses Blythe, and one of his schoolfellows there was the youngest sister of the Dublin poet and wit Susan Mitchell, whose work he was to illustrate in after years.[2]

[1] *Christian Science Monitor*, 2 November 1920.

[2] Information from M. H. Franklin. Victoria Diana Mitchell was also brought up away from her family in Sligo. She afterwards married Harry Franklin, musician and accompanist of Percy French, and settled in Sligo.

His only reference to it comes in a rather bitter outburst to Lady Gregory twenty years later, where he referred to the 'silly old wives tales' they were taught, about Alfred the Great, and so on. 'Whenever I passed the school,' he said, 'I wish I had the heart to do as a bookmaker's clerk I know of in London, who, when ever he passes his boyhood's "College for the sons of gentlemen" stoops clothed as he is in gorgeous raiment and gathers up the mud of the street in his hands and spatters all the windows and he doesn't care that the place has long ceased to be a school.'[1]

Jack Yeats monopolized the lowest position in the class – his grandmother said that he was too kindhearted to compete with the other pupils; but he also preferred to live the life of Sligo and to 'learn' the characters and the skies and the hills, rather than the lessons. He had begun to amuse every one with his drawings.[2] He walked about the country roads, studying the country people, attending fairs, sports, circuses and races. According to his brother he spent his free hours organizing donkey races for the sons of the pilots and sailors and acting as their well-loved leader, a delightful story but deviating from the other pictures of a boy wandering about the place on his own quietly observing. There were weekly markets in Sligo, instituted three centuries before: and four yearly fairs to which Yeats returned for many years afterwards. The race meetings were known as 'four pound nineteens', for the prizes not reaching the value of five pounds the meetings came under no official rules. Jockeys in brilliant striped costumes lined up on their mounts by the flags and sped off around the poles marking the edges of the strand, at times ending in the sea, if one of the great mists arose. On the shore itself were groups of long low tents, made of bent saplings covered with sacking, where poitín, the twenty-four hour whiskey, was consumed in quantity. Vendors of various kinds travelled the track, with toffee-apples and trinkets; and ballad singers would give their performances, and sell their printed ware. Stone[3] has described the informality of these 'unsophisticated' races on the fine strand at Mallaranny, where the race course looked more to him

[1] Unpublished letter to Lady Gregory, 5 December 1909. New York Public Library Berg Collection.
[2] *Autobiographies*, p. 68.
[3] Stone, J. H., *Connemara and the neighbouring spots of beauty and interest*, 1906, pp. 108–12.

like a fair, with roulette tables, and gingerbread stalls, and where un-
expected incidents occurred, such as the horse being drawn out of the
shafts of a cart and entered into a race following a challenge to its owner,
or a rider pulling up sarcastically to allow a competitor to come up level
with him and then spurting tauntingly away to the winning post; and he
described amusedly the fights that arose during and after the races. But
he did not know the people whose recreation he was witnessing, or see
these races as more than little local competitions. The drama and the
heroic spirit, the folk life and tradition in races run for centuries by a
peasantry, descended from Celtic and Norman aristocracy usurped of
their lands, were foreign to him. It was left to the Sligo artist to recreate
the spirit and the customs and culture of life in the West of Ireland in his
drawings.

Among the children Yeats associated with was George Middleton, who
rode on a piebald circus pony, schooled to trot in a circle and finding it
hard to break the habit. With him the Yeatses yachted at Rosses from a
very early age. The Middletons spent the summer at Rosses Point at
'Elsinore', originally a smuggler's house, and in the winter they moved to
the sheltered handsome 'Avena' at Ballisodare. They designed and mod-
elled boats – Jack did a good deal of this in paper at a later stage – and
their converse with the country people widened the acquaintance of the
Yeats children, and aroused an interest in local legend and fairy beliefs.
The Yeatses sailed boats with Great-Uncle Matt Yeats's children. There
were visits to a Middleton married to a 'brawling squireen' at the ruined
Castle Dargan, near Castle Fury, south-east of Ballisodare; and to
Mullaghmore, where Captain Cuellar was washed up after the wreck of
the Spanish Judge Advocate's ship at the time of the Armada. He was
wrecked on Streedagh Strand, which Yeats was to depict in two of his
oils, and the story as a boy must have excited him. Other relatives were
Uncle Alfred Pollexfen, a bachelor, living in Stephen Street, not far
from the Congregational Chapel. George Pollexfen at that time came
seldom from Ballina, but once caused a sensation by coming to a race
meeting with two postilions dressed in green.

The quays at Sligo, busy with the cargo boats arriving and going out,
were constantly fruitful territory for sketching. The Pollexfen boats
arrived here from Liverpool. Jack Yeats sketched the S.S *Liverpool* as it

left Sligo in one of his small sketch note books.[1] When he was living in England he knew the thirty-hour journey, amid a clutter of Irish peasants and their fowls and gear, with cattle merchants who had done all their sleeping in steamers and trains, office workers making a sickly voyage home on holiday, and an odd tired governess. The boat sailed round the tip of Donegal and Rathlin, past the mist covered cliffs appearing and disappearing every moment; and at Tory the island men came alongside with lobsters, burning a sod at night to announce their presence, and setting about their business in the Irish tongue. At the port he would have heard the captain talk boastfully of his successful fights at Liverpool.

Michael Gillen negotiated the larger boats up to Sligo Creek and this pilot and his accompanying fiddler, whom Jack grew to know on frequent journeys in the rowing boat, were portrayed afterwards in drawings of the Pilot and the Music. Michael is probably the approaching figure in the foreground of 'Memory Harbour' (1900).

Rosses Point, five miles away, was frequented in the summer time, and much of what was to be seen there appears again in Yeats's later drawings and his paintings. 'In half the pictures he paints today I recognize faces that I have met at Rosses or the Sligo Quays,' said WB.[2] A former seaman, acting as a pilot, spoke of his visits to Venice, of Antwerp and Le Havre and America, of bullfights he saw at Huelva. A parrot seen on a child's hand there gave a subject for a drawing; strange sights were related or introduced by the incoming sailors. Yeats's watercolour of 'Memory Harbour' shows foreshortened the peninsula with the long single line of thatched and whitewashed cottages, leading the eye to the rocks of Deadman's Point, and to the Metal Man, the twelve-foot high sailor on his pedestal, clad in white trousers and royal blue sailor coat and black tie, with hair of upstanding wire.

Deadman's Point looks over to Lissadell, the big severe Georgian house with two bays, entered by french windows, up white wooden stairs, where the Gore-Booths lived. From Lissadell Ben Bulben is to be seen to the north-east, and Knocknarea across the bay, while all about grow silver birches, quivering over a carpet of bluebells in the spring. There are changing views of an unimpeded sea.

[1] Coll: R. R. Figgis. [2] *Autobiographies*, p. 68.

All through the year, a bianconi car, or long car, provided regular transport. Summer came when the *Morevane*, a small steamer that plied between Sligo and the Point, became active again.[1]

Rosses Point was a village of leisurely life and few barefooted inhabitants, a grey gentle place, with the ancient traditions kept alive and resuscitated by the continual revelation of foreign marvel. People from neighbouring villages came in for the regatta, a lively time of gaiety and quarrel. At night the crews of the losing boats drank at the expense of the captains of the winning boats and on the ground outside the public house a great dance took place, the cake dance. Here cake and a bottle of whiskey, hung outside a window by green ribbons, were offered for the best woman and man dancer. Yeats depicted the occasion in his watercolour, 'Dancing for a Cake'.

In a sketch book of twenty years later Jack Yeats gives a taste of the Sligo life he observed as a boy and a man. Nic Nac, a mournful tramp, occupies a page beside drawings of starlings perched in a cluster on the chimney of McEwan's hotel, beside 'The Young Chief's First Ride' – a hasty scribble of the painting decorating the lounge of the hotel. At Rosses Point he saw the pilot in the peaked cap who was to become such a regular theme in his paintings; and William Gillen with Captain Keeples, the harbour-master, the latter stern, in bowler hat, with fashionable beard and umbrella, advancing on a bent old sailor, scruffily bearded and becapped, hands drooping in his pockets.

Another sailor sitting on a chair claps his hands on his knees and declares: 'I remember I was the first that ever seen the Jacknel up by Ruthlen: sea smooth, light wind from the southard. I seen a little topsail schooner. What's that feller doing there, I said to the mate. He said waiting for morning I suppose' (one must imagine the slow flemmy voice and grunts and pauses as he tells his story). With the characters come lightly-sketched views of large areas of the sea, outlined clouds, seagulls, the lighthouse, the full upright reeds in the foreground and low nubbly outlines of the hills behind.

There was a poetry in the landscape of Sligo that affected the artist as much as the people around him did. The tall guardian hills, Ben Bulben and Knocknarea, one from a certain angle like a sheet of metal cut out

[1] *New Alliance* I no. 2, April 1940: 'Two early bathers' by Jack B. Yeats.

against the sky, cardboard thin, or as Tadhg Kilgannon[1] saw it, the upturned keel of a boat, the curved face being the prow and the sloping side like the hull with the deck underneath; and the other preserving the history of the warrior queen in the heap of stones on the summit. In between the sheltered landscape changes colour and tone beneath a moving sky, the serrated edge piercing a sea of fierce or gentle mood. Sligo itself has a beauty in its stern grey houses. The limitless, island-filled Lough Gill is soaked in legend. To a smaller lake, inland from Drumcliffe, flows the broad short waterfall of Glencar, through beds of garlic, in a strong current. Rhododendrons bend over the deep stream with tall trees surrounding them. Above is the mountain crag, the lake spreads below. JBY describes something of the artist's awareness of what was about him in the following anecdote:

There is a river meandering through the town of Sligo, spanned by two bridges. Beneath one of these bridges is a deep pool always full of trout. Jack told me that he has spent many hours leaning over that bridge looking into that pool and he regrets that he did not spend many more hours in that apparently unprofitable pastime. My son's affection for Sligo comes out in one small detail. He is ever careful to preserve a certain roll and lurch in his gait, that being the mark of the Sligo man.[2]

His manner of walking, and his intimate knowledge of the sea gave rise to a legend, current still, that he spent seven years of his life as a sailor.

Jack Yeats later described winter and summer weather in Ireland as 'generally a tale of temperance, blowing hard only sometimes'.[3] There was one very severe winter in his youth, he was ten at the time, when people skated for the first and last times in their lives and a schoolfellow fell twice through the ice. A coasting steamer, the *Ric Formosa*, was frozen in salt water, below fresh-water falls. The ice rose and fell with the tides: he remembered the sailors' footpaths across to their ship.

There were six miles of lake close at hand that winter for any pair of legs to scuttle over

[1] *Sligo and its surroundings*, p. 223.
[2] *Christian Science Monitor*, 2 November 1920.
[3] *Stork* 4 no. 4, March 1933: 'A cold winter and a hot summer in Ireland' by Jack B. Yeats.

– this was Lough Gill. 'Somewhere in the same loop of years was the
Hot Summer which is easiest remembered.' The schoolfellow who had
fallen through the ice now tumbled with all his clothes on into the water.

Elsewhere he remembers the early bathe taken 'before the cold stone
was out of the water' (a slightly different expression from that used in
County Down, where the spring presents itself 'when the warm side of
the stone turns up').

Almost every year of my boyhood some friend, or myself, stepped too soon into
the creaming edge of the Atlantic. But now I recall that moment of perishing, it
was seldom a creeping up of numbness which would come from the lacey edges
of waves on a flat shore. It was a moving into deep water, the dash was made in
general from the spring board, or the steps beside it, down at the Dead Man's
Point.

William Pollexfen retired when Jack was about twelve years old.
William Middleton was dead, and George Pollexfen took over the
business. In 1886, when it became impossible to keep up Merville, the
handsome residence on Church Hill, any longer, the Pollexfens moved
to the tall bare Rathedmond, overlooking the harbour, opposite Thorn-
hill, Uncle George's house. William Pollexfen walked to St. John's
Church almost daily to supervise the making of his tomb, composing in
his mind the words which now commemorate him and his wife on the
church wall. Jack remained at Rathedmond until 1887 when he went to
live with the family in London. He returned to stay with his grandparents
every summer after this. Five years later the Pollexfen grandparents died
within a few weeks of each other.

Many traits of the Pollexfens were in their grandson, the silence, the
independence, the reserve, the calm elusiveness and puckish humour,
the absence of irritability, the love of ceremony, the upright nature, and
a definite business acumen, which was inherited from the Middletons
too. From the Middletons came the fascination for the turf, and life
extrovert – this later playing a great part in his painting; and from the
Yeats family his literary and artistic gifts, fed by an essential buoyancy.
JBY wrote.

I think . . . he has received the education of a man of genius. His personality
was given its full chance. It has at once the sense of expansion and the instinct

1 At a small race meeting 1897

2 The man from Aranmore 1905

3 Simon the Cyrenian 1902 *4* Ballycastle Bay 1909

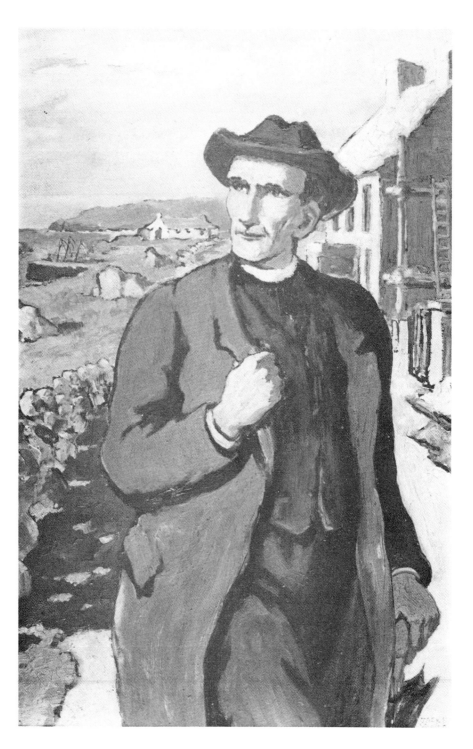

5 The priest 1913

of self-control . . . His personality is as fresh as the dew of the morning, yet in that very freshness is a certain vigour which is like the cold morning breeze that clears away sleep and dull dreams.

He has the habits of a man who knows his own mind.[1]

[1] *Christian Science Monitor*, 2 November 1920.

Pirate: from an advertisement for *A Broadside*

Chapter 3

London

JBY had returned to Dublin in 1880 in dire straits owing to the land troubles and the cessation of his estate rents, but he decided to seek his fortune in London once again, as an illustrator. The family settled in London in 1887. Jack Yeats attended art school there.

For an artist who is said to have been drawing since he left the cradle very few examples of his early works remain; but those that survive are interesting. There are the illustrations to *Beauty and the Beast*, composed during his thirteenth year, and presented to his sister, Lolly, in 1885.[1] There may have been an old edition of d'Aulnoy in grandfather Pollexfen's library,[2] but it is more than likely that a pantomime performance – the tale was becoming popular as a subject for pantomime – inspired the illustrations, for there is a dramatic absurdity in them that suggests a visual rather than a written origin.

Four sheets of drawing-paper are fastened together down the middle, and bent over to form a small book. On the cover, the Beast, a slim elegant creature in grey tail-coat, with a handsome and not over-large boar's head (unlike the traditional repulsive animal), treats with Beauty. A large rose, which is important in the story, and in later life had a definite symbolical significance for Yeats, appears near the lady's head. There are six scenes: the Pasha's departure on his business trip; his encounter with the Beast, as he steals the Rose; Beauty's journey with the Beast back to his castle; the latter's transformation into a Prince; then 'the

[1] Coll: National Library of Ireland.
[2] There was no contemporary edition of it until after the drawings were made.

Pasha in the Days of Prosperity' – a very different looking man in capacious trousers and sash; and 'the Pasha gives his two daughters the sack' – the Pasha sketched in gyrating gesture, freeing himself of two invisible villainesses. The back cover concludes the tale with an impish picture of the Pasha's back in dressing-gown and Turkish slippers, surmounted by a nightcap – 'The Pasha is going to bed'.

Nothing more dates from Sligo days other than a brief childhood sketch on an envelope, but a few drawings of three years afterwards, not long after the family had made the move to London, turn to Sligo for inspiration. They show a more personal humour. In 'The Window erected to St. Valentine in Tullynagracken Cathedral' the line is still dominant over slight and descriptive colour work. St. Valentine, in monk's habit, with a wicked smile on his face, steams open a love letter with a kettle. There are clever details in a somewhat untidy drawing, such as the head of the wind blowing down two lines of lead tracery on to the cap and nose of the post-boy in the background.

The 'Letters from Dennis O'Grady', however, presage the years to come. One is contained in *Ye Pleiades*, the issue of Elizabeth Yeats's manuscript monthly magazine for February 1888.[1] The other, dated the 24th of December, appears to precede the first in its descriptions, and it may come from an earlier version of the magazine, for 1887.[2] The locality as before is Tullynagracken, in Co. Sligo. The name is genuine and not an invention; Joyce[3] gives the meaning as 'the hill of the skins', since tanners lived there: but Yeats must have enjoyed the cacophonous splintered name purely for its sound.

Dennis O'Grady, *Ye Pleiades*'s West of Ireland correspondent, writes from Tullynagracken to report on the hunting season. 'I rode without ambition', stated WB,[4] and despite WB's reminiscences to the contrary Jack tended to doubt his own prowess: 'I was never perhaps born to witch the world with my horsemanship, I was generally on the ground looking on',[5] he wrote in *Sligo*; but his joy in horses, his 'horse heart' was never denied. According to WB 'The ballad of the foxhunter' was Jack's favourite of his short poems. Both of the letters show a fascination with the hunt. In and out of the large attractive handwriting are woven

[1] Coll: National Library of Ireland. [2] Coll: the artist's estate.
[3] *Irish names of places*, vol. III, pp. 591–2. [4] *Autobiographies*, p. 53. [5] *Sligo*, p. 64.

deftly in pen and indian ink likenesses of the characters taking part. There is great individuality and clever narrative in these letters, in the Anglo-Irish tradition, to which the deliberately half-comical figures and caricature horses relate with understanding and sensitive observation. Words and images would always have this inextricable link for Yeats. He was from first to last a literary artist.

Life in London was a complete change from life in Sligo. But Jack B. Yeats sought out the same kinds of pastime he had known before. The family settled in Earl's Court, for the summer of 1887, at 58 Eardley Crescent. The heat was intense, the noise from the near-by American Exhibition unceasing; but Jack was content, because the season ticket compensating residents in the area for the continual din gave him free access to the Exhibition, and he spent every day there. He speaks of the Salt Mine in *Sligo*:

. . . down in the cage: 'See the walls rushing by,' the cage man said, 'fifty thousand feet a second: we are rushing down into the centre of the earth.' The Salt Miner's Slide, we slid it, we were ferried 'across the briny Lake': we stumbled out into the sunlight opposite the Cigar Stand: sixpence and worth it.

There were many similar marvels, but Jack Yeats was most forcibly struck by Buffalo Bill, a very admirable hero, and excitingly legendary at that time. It was only twelve years since the Deadwood Coach had begun its trips between Cheyenne and Deadwood, on the route that passed through Fort Laramie, Raw Hide Buttes, Hat or War Bonnet Creek, Cheyenne River, Red Canyon and Custer. The coach was frequently attacked by bandits and was the witness of hideous scenes of slaughter, and owed much to Martha Canary (Calamity Jane) and later to Buffalo Bill, who were both responsible for its rescue. The scarred and weather-beaten veteran of the original 'star route' line of stages was purchased by Buffalo Bill and added to the attractions of his 'Great Realistic Exhibition of Western Novelties': and it was depicted as late as 1943, by Jack Yeats, in 'The Attack on the Deadwood Coach', where his fascination with the melodramatic thrill of the event is equalled by his personal humour in the situation. Remembering subsequent shows at Earl's Court, depicted in his drawings of the 1890s, he places the hoofs of the fierce Indian

assailants' mounts on roller skates. The dark dramatic tragedy at first disguises this touch of humour.

Colonel W. F. Cody (Buffalo Bill), spare and handsomely bearded, was the last of the great Western scouts, and had experienced Indian warfare at its height, from 1860 until 1885, when instead of being armed with bows and arrows, Indians were gaining the upper hand with guns. A truce had now been reached and the final victory was in sight; so that Queen Victoria's Jubilee coincided with a celebration of peace in the Wild West: and Colonel Cody, in a triumphant gesture, brought the show with attendant captive Indians to London. He later travelled throughout Europe with the exhibition, bringing it back to London at intervals.

Jack Yeats, as a result of his dedicated presence during the summer of 1887, knew the format of the action so well, that when gun shots sounded in the night, and were heard by the inhabitants of Eardley Crescent, he could recount the events to his own family, matching his narrative exactly with subsequent shots as they sounded.[1] He decided the Wild West Show was as

direct and simple as its cradle the prairies. It smelt of
Tan,
New Leather,
Brass Band instruments,
Buffalo Wool,
Coke fires,
Pop corn,
and New Wood.[2]

In the autumn of the same year Jack entered upon the education that his father felt was essential to any young man, at the school that George Moore insisted any young man should be careful to avoid:

Be sure that after five years of the Beaux Arts you cannot become a great painter. Be sure that after five years of the Kensington you can never become a painter at all.[3]

The school of Art at South Kensington had been founded primarily as

[1] Dr. Oliver Edwards was told this by Miss Lily Yeats.
[2] *Sligo*, p. 122. [3] *Modern Painting*, 1893, p. 5.

a school of design, giving elementary instruction in art history, and a basic grounding in technical matters. By Jack Yeats's day the final object was described as the training of people of taste. The students spent the first six months or a year practising drawing from the flat, copying engraved outlines of elaborate ornamentation with pencil and compass. They then graduated to drawing from the antique, and they finally attained to drawing from the life. Rigid detailed training and minute examination were conducive to rendering a natural talent sterile. Yeats learnt little. He did on the other hand develop a technical quality instinctive to him already. His drawing until this time had been purely linear, without shading or soft outline; and the school led him in the same direction, stressing the value of a clear line, and discouraging any traces of a feathery stroke. The necessity of decision before putting pencil to paper was also a part of the training, as a reaction against the previous approach, where objects were measured intermittently by the student, as he worked, holding a pencil at arm's length; and here Yeats's spontaneity was channelled along its natural path.

The director of the South Kensington was Thomas Armstrong, the genre painter, who had worked in Paris with Whistler, du Maurier and JBY's master, Poynter. Around the corner was the South Kensington Museum with the Sheepshank and the Turner collections. While the tuition was obviously academic, it was a sound background. Yeats had sufficient individuality to withstand the stamp, and the only effects were benevolent.

He also studied at the Chiswick Art School, in Bedford Park, and at the Westminster School worked under Professor Fred Brown, recently instrumental in founding the New English Art Club; and here the influence was more longstanding, and was to affect his first oils, some fifteen years later. Yeats was trained in the English tradition and accepted it wholeheartedly during his youth, together – obliquely – with the Empire, and Paddy the Irishman. His first revolt was to come towards the end of the 1890s, when the fight was too much for illustrators and the camera had won. His was a revolt in subject-matter. The stylistic breakaway waited until later still.

For his gifts adapted themselves to contemporary trends and he could accept the Victorian background without fighting against it. He himself

traced his initial influence back to Cruikshank and the early illustrators; not to the satire but to the levity and the raciness. In ways Yeats is closer to Isaac than to the famous George Cruikshank, preferring firmly outlined expansive figures. Yeats is not a caricaturist. He had something of Leech's vigorous vertical line, without his romantic sentiment, but when he turned to Irish life he found a dignity in Irish character, and a life, if removed from the general path of civilized ways, which had its own culture and tradition. Reading Lever he knew 'Phiz', again a promoter of parody. In sporting art a humorous realism had recently died in a fellow Irishman, Richard Doyle, who, a minor artist, was close to Yeats avoiding comic spite by striking off at a tangent into fantasy. Now black-and-white art was bursting forth in a second and final brilliance before it died a natural death; and he stepped straight into the movement. It brought out his humour his humanity and his feeling for character.

Life in Eardley Crescent tended to be depressing for members of the Yeats family other than Jack. JBY was attempting to establish himself as a black-and-white artist, while WB sought the interest of editors and publishers at first in vain. Mrs. Yeats had a stroke during the summer. She and Lily spent the winter of 1887 with a Pollexfen aunt in Yorkshire in the hope of a recovery, but she suffered a second and more damaging stroke on her return to London, and henceforward existed quite happily in a world of her own until her death in 1900.

The removal to Bedford Park at the end of the year improved matters for JBY, WB and the sisters. Bedford Park was a colony for artists, and soon 3 Blenheim Road, the red brick house with the tall chestnut tree overshadowing the garden, was a centre for gaiety and intellectual conversation, provided by the generally persecuted. Evenings saw gathered there Dr. Todhunter, who had left medicine in Dublin to devote himself to writing poetry and plays; John O'Leary, the bearded revolutionary, at last admitted to England; and two old friends of JBY's from former London days, Jack Nettleship, and Edwin Ellis, still Pre-Raphaelite in his painting, and soaking WB in Blake. R. A. M. Stevenson, who had written a book on Velasquez, and was later to write enthusiastically about Jack's first exhibition, visited Bedford Park with a conversation of fantasy and charm. There were also Oliver Elton, a young G. K.

Chesterton, Florence Farr, and Stepniak; Harry Paget, rather pedestrian
in his illustrations, a portrait painter and a boxer – 'thought to be the
strongest one in the park'[1]– and Joseph Nash, whose drawings of ships
were widely known. York Powell, 'the unprofessor-like professor' of
history at Oxford, broad and bearded, and according to WB 'looking,
but for his glasses and the dim sight of a student, like some captain in
the Merchant Service'[2] was to be a lifelong friend of Jack's, a dis-
tinguished scholar, freethinking, boisterous, informed on every subject,
but putting his enjoyment of the human race before his ambition. As
JBY put it, he 'worshipped any one he was fond of . . . this trinity
possessed him, affection, happiness and worship.'[3] He told JBY that he
thought Jack Yeats to be the best educated man he had ever met.
Paradoxically his reputation was built on his expertise in Roman Law,
and in boxing. A letter of his describing a boxing tournament at Wonder-
land, Whitechapel, makes one realize how the bond with Jack Yeats was
formed:

The round-arm swings and hooks are not so pretty as the old straight left, but
the upper cuts are beautiful and the counters as quick and good as ever. Fine
lads with good faces, nearly all; some very well made, some spidery, some too
short in the arm, but useful in short punches. Most of them well made; good
back and shoulders nearly all. You must . . . sit with the bookes, and hear their
improving conversation before the show begins.[3]

His one clash with the Yeats family came as a result of his political
idealogy. He was ardently English in feeling and JBY denounced the
English for aggression in South Africa.

The Yeats sisters were already, as young girls, skilfully guiding the
conversation of the mixed gathering through difficult issues. Lily, the
elder, was conscious of her psychic gifts. With WB she discussed
spiritualism, and Madame Blavatsky, whom WB had visited in Dublin.
Lolly was more practical. Jack was mainly a listener, absorbing all: but
he remembered. In later life talking about Dublin theosophical circles
and Madame Blavatsky he told Lily that he thought AE had been jilted
on account of his conservative doctrine:

[1] Yeats, J. B., *Letters to his son W. B. Yeats and others 1869–1922*, 1944, p. 7.
[2] *Autobiographies*, p. 117. [3] *Letters*, p. 85.
[4] Powell, F. Y., *Letters*, vol. 1, p. 324. to F. P. Barnard. 13 July 1901.

'You see, AE gave it to them in small pints; then some one came from over the sea and gave them whole quarts.'[1]

'The intensity and individualism of genius itself,' wrote G. K. Chesterton, 'could never wash out of the world's memories the general impression of Willie and Lily and Lolly and Jack; names cast backwards and forwards in a unique sort of comedy of Irish wit, gossip, satire, family quarrels, and family pride.'

Jack never seems to have had any difficulty in settling down in London after a childhood elsewhere. He was accepted: he had been ever present, only physically absent; just as when JBY emigrated to New York and lived there for the final fifteen years of his life he was as important a part of the family circle as before. Opinions could be exchanged as freshly on paper as in person. The Yeatses were a curiously ambivalent family, without roots, always and eagerly seeking new ideas and new vision, yet permanently linked to each other by blood. Jack B., if any, had firm foundations at three points, in Sligo, the core of his inspiration, then in Devon (London was an interval for marking time), and after that in Dublin, centres marking three definite sections of his life. In personality and temperament he was calm, and he lacked the restlessness of his father and brother.

A story quoted by Jeffares in his life of W. B. Yeats[2] underlines JBY's impression of his youngest son quoted before. WB and his father were constantly at loggerheads while the former attempted to break from his father's influence:

. . . when we had been in argument over Ruskin or mysticism, I cannot remember which of them, he followed me upstairs to the room I shared with my brother. He squared up to me and wanted to box and when I said I could not fight my father replied 'I don't see why you should not'. My brother who had been in bed for some time started up in a violent passion because we had awakened him. My father fled without speaking, and my brother held me with: 'Mind, not a word till he apologises'.

Jack kept his views to himself, mulled over them and reproduced definite and mildly quizzical statements which no one could parry. He saw

[1] Dr. Monk Gibbon. [2] p. 51.

ideas in their final stages, and not as matter for theoretical discussion; and this provided for a spontaneity and composure in his manner of expression, if, and this concerns his painting too, a carelessness about whether he communicated satisfactorily.

It was an affectionate household at 3 Blenheim Road, with the faithful family retainer, Rose, who still called Jack 'the Baby' and a revered cat, Daniel O'Connell. Sligo was visited without fail every summer, Jack remaining there late into the autumn, sketching; bringing back landscapes, and returning

shouting, mostly Sligo nonsense rhymes (he always comes home full of them) such as

'You take the needle and I'll take the thread
And we'll sew the dog's tail to the Orangeman's head'.[1]

Lolly in her diary for 1888 observed: 'Oct. 5 . . . Saturday cold and dreary. No letter from Jack; but at about 8 o'clock in the evening we heard a loud rat-tatting at the letter box which if you please was Master Jack. We *were* glad to see him. He looks well. We got him tea and cold beef, and he said he had some shrimps himself in his portmanteau which he forthwith began rummaging for. In the search, he came upon and brought out a large bag of damsons and a box of kippered herrings and finally the shrimps, which turned out not to be loose as we supposed but in a broken cup, made their appearance out of the pocket of his best coat. Later on in the evening Lily, while rummaging in his pocket, came on an old piece of rope at which he called out, "Put that back. That's his hair." He is a comical boy and I can't convey the serious way in which he delivers these remarks. We finished up the evening by having kippered herrings "from Stornaway" for supper.'[2]

With Willie he painted a map on the study ceiling. Lily the other self-contained member of the family, and with an imagination reaching into a world of live vision, was particularly close to him.

'In London when Jack arrived late at night', wrote JBY:

[1] Yeats, W. B., *Letters*, 1954, p. 138.
[2] Yeats, J. B., *Letters to his son W. B. Yeats and others 1869–1922*, ed. by J. Hone. New York, Dutton, 1946. Appendix: Elizabeth Yeats's diary, 1888–9, pp. 292–3.

. . . in his polite way he would stop a while with me and talk and then ask if I thought Lily was awake – and long after when I climbed up to bed – as I passed her room I could hear laughing and talking it was Jack and Lily.[1]

Lily was introduced into the William Morris circle rather unwillingly by WB who went to Kelmscott House on Sunday evenings to hear the debates of the Socialist League, and at the time resented the presence of the family where he wanted to establish a literary image they might not take too seriously. Lily made a great impression, and learnt embroidery with May Morris, later becoming her assistant.

Elizabeth at the time was a Froebel student and a student mistress at Chiswick High School, and she was endeavouring to publish some short stories. She kept up her teaching, some ten years afterwards brought out a primer on the instruction of brush painting; and when she moved to Dublin she held classes in art for children.

[1] Letter to Isaac Yeats, from New York, 1 August 1921.

THE GOREY FINAL.

'wot give em another round,' and they wouldn't know each other "

Detail from
The Gorey final

Chapter 4
A black-and-white artist

When he left Art School Jack Yeats did not seek out the studios or society of established artists, other than the friends of his father whom he already knew. He worked alone. His model was mankind: his studio the world of his experience, concentrated eventually in Sligo, whence he returned regularly. He told the late Tom McGreevy that when he first came to London from Sligo he found a totally different environment, but that as in Sligo the objects of his attention were the horses. He spoke about the horse buses, or knife-board buses, where he would climb up the stairs at the back, balance precariously on top and have to sit down suddenly as the bus started again with a jerk. If he was lucky he sat beside the driver, who would lean over and tuck the leather apron around him to keep him warm. Then the driver fell asleep. Similarly on the hansom cabs, with their 'handsome horses', the cabbies dozed permanently, as the drivers on the market carts, naturally enough, coming up to London early in the morning. He once came up on a market cart from Berkshire 'for the experience', and all he learned, he said, was how to grow cold and stiff. He made use of the unwelcome knowledge, nevertheless, in a drawing in *Life in the West of Ireland*. In 'The Sleepers', the driver on a long car nods as the horses plod their way in the dusk.

Boxing was a new and exciting experience. As he put it:

The picture was different under gas than under electric light, the Tawny gas was more blood-thirsty, more of action; I have, if not the vulgar tongue, at least the vulgar heart. I like the fight.[1]

[1] *Sligo*, p. 22.

In contrast to the small country circuses he had known in Sligo, he saw Lord George Sanger's gargantuan wild beast shows in the amphitheatre beside St. Thomas's Hospital. Sanger staged zoological tableaux in scenes from Buffalo Bill; but they were shows first and foremost rejoicing in horse genius, and involving sometimes up to two hundred horses in an act; and they were famous for a few years until impractability weighed and Sanger's had to become a travelling circus. Constant attractions were the theatre, music hall and the London docks. In February 1888 Yeats went to the meeting organized in Hyde Park to welcome T. D. Sullivan and the Irish members of Parliament released from prison after their sentences under the Crimes Act. He wandered further afield, enjoying and observing. The following year he spent Easter at Brighton, watching the military manoeuvres on the downs above the beach, a sham fight between the Royal Naval Artillery Volunteers and the Brighton Artillery Brigade, a grand review and a marching parade, with brass bands and full ceremony. At Christmas he and a friend walked down to Portsmouth, taking three days over the journey, and staying with various friends on the way.[1]

Jack B. Yeats may have had introductions to editors from his father and his father's artist friends, but he was independent enough to approach them on his own. His first printed drawings appeared in the *Vegetarian*. He was still at art school. His illustrations, on 7 April 1888, headed the 'Elves' Polo Match', and a story by the editor in *The Children's Corner* where the Elvine 'Veg's' win hand over glove against the 'butchers' and the 'pubs', because of their healthy and humane diet. There are the elements of an individual style, the angular movement, the economy, the absence of crosshatching, apparent in the straightforward drawing of a man and a boy feeding birds the following week (signed 'Jack', which was a common signature at first); but he comes across most distinctively in these early drawings two months later, with emphasis on line. This paper gave him a wide range for his imagination. He liked incident and character, and showed no sentimentality in the juvenile drawings; and before long he had moved beyond *The Children's Corner*, and was illustrating articles and stories. These included an animal tale, 'Scamp or Three Friends', by Lolly (9, 16, 23 February 1889). A poem

[1] Yeats, W. B., *Letters*, pp. 60, 124, 146.

by his brother 'A Legend' (22 December 1888) has an Irish setting, expressive characters in eighteenth-century dress pass by: the grey professor, withdrawn, bent over his stick, imparting a suspicious glance; the bombastic red-faced mayor marching pompously; the bishop drifting past with nose in prayer book, seemingly ten thousand miles away, then in a second alert, banishing an over-interested crowd. The legend is savoured over. In a stroke or two a horse appears, head and torso, ancestor to 'My Beautiful, My Beautiful', and a cock strides lightly alongside the fence.

There were still amusing incidents at home. In his letters to Katharine Tynan WB described his attempts as a gardener, after he had collapsed through reading over much. He planted seeds of sweetpeas, convolvulus and nasturtium in pots all around the balcony of the house, and seeds of sunflower in the garden 'to the indignation of Lily and Jack, who have no love for that modest and retiring plant.'

'Jack' he said, 'draws as usual'.[1] The latter had, in practical fashion, put up a hammock between a beech tree and a chestnut at the bottom of the garden; he found a lively companion during the summer in Geraldine, a young cousin staying with the family. He and Geraldine kept up a constant bantering together and at dinner they had to be kept quiet almost by force.[2] Business prospered for him. He had a contact in Dublin in the middle-aged and salt-tongued Sarah Purser, who could amicably dispose of the witty menu and racing cards he was designing. His letters to her came from a colleague and equal, and were sprinkled throughout the text with amusing sketches.[3]

He supplied the *Vegetarian* with illustrations in plenty, more than could be published, and accompanied the Vegetarian Society on their annual picnics, making sketches for the paper; and he continued to work in this fashion until 1892, illustrating, and providing blocks for headings to the different sections of the journal.

The nearest that Jack Yeats came to Art Nouveau was in his first work as a book illustrator. Ernest Rhys, the Welsh poet and translator, had become friendly with WB and commissioned a book of Irish fairy tales from him for the Camelot series, of which Rhys was editor. He had him-

[1] *Letters*, p. 58, February 1888. [2] Yeats, W. B., *Letters*, p. 75.
[3] Coll: the late Mr. John Purser.

self begun his career as a mining engineer, and now combined publishing and writing as a living. Their friendship grew, later both were contributing to the *Savoy*, and in 1891 with T. W. Rolleston the two men formed the Rhymer's Club: poets met regularly at the Cheshire Cheese to 'know' each other. Rhys had visited Bedford Park, and had been strongly impressed by the Yeats family, and he asked Jack to illustrate his book of poems, *The Great Cockney Tragedy*. Jack Yeats produced stylistically massed crowds, adopting an exaggerated line that brushed off in his one connection with his brother's literary associates. WB was pleased with their 'tragic intensity'[1]. Book illustration was always a secondary pursuit with Jack Yeats; but it gives an interesting view of his graphic development. His illustrations to WB's *Irish Fairy Tales* a year later show him reverting to a more genuine manner, though still the line is sparse and angular. In a simple scene from 'The Fairy Greyhound' the terrified Paddy M'Dermid, 'every hair in his head standing up as straight as a sally twig' stops in his work digging for the vital fairy gold for a moment to lift his hat civilly to the 'comely looking greyhound': Paddy and the bog are lined cleanly, with neat dark vertical and diagonal strokes, giving movement, while the sky and the hound are contrasted as moonlight with the earth, elevated and removed from the solid and muscular. The frontispiece, an illustration to Crofton Croker's story, 'The Young Piper', uses what was to become a very typical form of composition, a scene with horse and trap on a bridge. Comparing the illustrations with JBY's drawings for *Finn and his Companions*, also published in 1892, the difference between conventionality and the distinctive, if not totally individual style, of the younger man emerges strikingly. JBY would never make a black-and-white illustrator.

Max and Beardsley were all the rage; and soon Jack Yeats could have formed an important link with Ricketts and Shannon through his brother; but he followed his own inclinations, preferring always to strike a lone path.

He started working for *Paddock Life* in 1891, and this was more immediately to his taste than any work he had done heretofore. The horse was always the object of his admiration. London had introduced him to boxing in the flesh, a romantic legend before that, described by

[1] *Letters*, pp. 178–9, 4 September 1891.

seamen visiting Sligo. Now he studied sport of every kind. He attended small events, cricket, football, racing, with the editor of the paper, or on his own, reporting what occurred in his sketches. At Lambeth he watched sparring and fighting, and running and fighting; and he reviewed the results pictorially. They were personal comments, always with a turn of humour, and showing odd incidents of character or situation, seemingly ridiculously trivial, but all important at the time that they occur: and his humour, fed on *Hood's Own*, on Leech, Tenniel and the *Cruickshankian Momus*, has always a timeless rather than a topical allusion, and depends frequently on a pun. 'Outsiders'[1] are the passengers on the open roof of a horse tram on the way to the races, feeling their isolation very keenly as they are belaboured with rain. In 'Something like a "starring" tour' (24 January 1893), the stardom which the champion experiences incorporates stars bursting about the head of the opponent he thumps at the rope of the ring. 'Football Weather' (19 January 1892) transforms a football field into a skating rink on one occasion, and a pond on another, where players wade up to their knees; and 'the latest fashion in football costume' (26 January 1892) is a suit of armour. 'Very Trying!' (2 February 1892) might be termed a little more so. The rugger player aiming for goal misses the ball his team mate holds for him, stretched on the ground, and he sees in front of him in the air the fellow's head. The incident is expressed with suitable horror, the head outlined against the sky; and irony strikes before any feelings of compassion, which are precluded by the lightness of touch and approach. Yeats attended boat races on the Thames, running championships and racing in and outside London: and he also provided his observations of the sporting news in Ireland, at the Dublin Horse Show, or at the Enniskillen Races, describing amusingly, though not disloyally, as other Irish emigrants had done with a more patronizing flavour, the characters he saw, such as 'Billy in the Bowl' and the seller of crubeens.

He continued to contribute to *Paddock Life* until 1894, when the paper dropped most of its illustrators and depended on verbal reports. His contributions to the *Lock to Lock Times* are more general in comedy: the journal confined articles and sporting events to the text, and provided cartoons as a garnish. He drew 'The Man Who Never Forgot Anything'

[1] *Paddock Life*, 26 May 1891.

(8 August 1891), staggering down to a punt carrying picnic baskets on his head, a large parasol over his shoulder with a kettle depending from its hook, a billycan between his teeth, plus everything in the world over-flowing from his arms, and pockets. 'Houseboat Hospitality' (15 August 1891) in the caption – 'Yes Uncle. We are just a little crowded' – is delightful in understatement. Legs and arms protrude from every window. The nephew has rigged up a hammock for himself. The uncle is obliged to sleep on the roof. 'The young man who talked to the Bargee' (22 August 1891) quickly becomes 'The young man whom the Bargee talked to' as an apparently somnolent lump of Bargee galvanizes into action. Sometimes the puns can be too obvious, or rather esoteric; but in general the effect is racy and attractive. The *Ariel or London Puck* accepted sometimes four contributions for an issue, jokes on society in general, or jokes on sport. Yeats spoke affectionately afterwards about the editor of *Ariel*, Israel Zangwill, and found him encouraging to a young man. The one time he saw Beardsley was when he was calling on Zangwill.

In the latter half of 1892, and beginning of 1893, Jack Yeats worked in Manchester as a poster artist.[1] He referred very rarely to his Man-chester days and looked on them as the least satisfactory days of his working life – 'The bread I threw on the water never came back to me, nor led me anywhere', he wrote[2] and he overworked tremendously; but the city had productive memories for him, and in retrospect provided a certain stimulus.

He was receiving so many orders for black-and-white illustrations now that he used to bring work with him to Ireland in the summer. About this time he began to form a more personal style. He had drawn clearly and generously, with a light definite line, and well-shaped figures, and always with a lively touch; but still he was not sufficiently individual in manner; and he depended over much on the verbal element. His drawings were not always spontaneous. However, he was absorbing much

[1] *Bohemian* Monograph the 44th, 1895; Yeats, J. B., *Letters*, p. 54. The date is deduced from JBY's reference, 2 September 1892, and from the subject matter of the black-and-white drawings, which at this stage include Manchester subjects regularly.

[2] *Manchester Guardian*, 2 January 1932, p. 18: 'When I was in Manchester' by Jack B. Yeats.

of what other black-and-white artists were doing. Phil May was the major influence at the time, with his very direct and compassionate approach, his love of humanity, and his economical style that discarded detail and darkness altogether; and Yeats had a great admiration for him, as well as sharing his fascination for the pastimes of the working classes. There was a directness and simplicity about J. F. Sullivan too, and a spontaneity, if he was rather old-fashioned. Good composition and an easy manner marked L. Raven-Hill. Two other leading black-and-white artists, Linley Sambourne and J. Bernard Partridge, tended to be conventional though clever: and Harry Furniss was famous for political caricature. All of these artists had distinctive ways.

Yeats at this stage became more concerned about the pictorial effect of his drawings. He gave weight now to lines which had previously strayed in an untidy fashion, and introduced a contrast of tones, strong black, which he had never used before, and cross-hatched lines where he needed emphasis.

Even his signature, heretofore a round, running scribble, was now appended with some thought. A square forming a bar to the J, from 1892, was shaded in about a year later and the whole name 'Jack B. Yeats' signed with a flourish. This form of signature was used regularly until 1897 and seems to have been the initial step towards the monogram that included all three initials, and was used first in about 1900.

'Rumbo, the Circus Horse', published in *Judy* in 1893 (28 June), a development from one of his earlier characters, 'The Demon Horse', was a personality that placed him on a level with the leading black-and-white artists of the time. His fantasy, original humour, potent satire and distinctive style filled a gap among illustrators who tended to make politics their butt. The following year he was accepted by the more significant papers. In 1894 he contributed with May, Townsend and Proctor to *The Sketch*; and he was invited by Furniss to become a permanent artist on *Lika Joko*.

Jack B. Yeats took the opportunity to marry. An amusing story from his sister tells how 'Jack, while still working at art school, found himself sitting next a fellow-student, pleasing to the eye and of sympathetic outlook. He used to return home to receive his father's periodic enquiry, "And how is Dottie?" "*Cottie*, not Dottie, please, Father." It was a long

time before his parent could get it right.'[1] His father described the courtship in an article towards the end of his life:

No one knew what [Jack] did at art school in London, but one day he surprised his father by telling him he was engaged to be married to a young lady, a very talented art student; and then he showed his moral fibre. . . . It was winter time and every morning from six o'clock till late at night he worked in a fireless room producing black and white drawings for comic journals, etc. At the end of three years he had made enough money to marry the young lady and have a comfortable house very beautifully situated on the banks of the Thames some miles from London.[2]

Mary Cottenham White was always known as 'Cottie'. She was a few years older than her husband and had a small private income which was useful when times were lean. She came, appropriately, from Devon, with which Yeats's family was connected, and where they were to live for thirteen years. Their long devoted relationship, though childless, was a rewarding one. They were married at the Emmanuel Church, Gunnersbury, in Middlesex, on the 23rd of August 1894, according to the rites and ceremonies of the Reformed Episcopal Church, and settled down at the Chestnuts, Eastwort, Chertsey, in Surrey.

Harry Furniss with whom Yeats now worked was not an Irishman, but he had been born in Wexford, and he lived in Dublin until he was nineteen, and had his art school training there. He had done some Irish drawings for the *Illustrated London News*. He travelled in America and Australia, and on his return worked as a Parliamentary caricaturist for *Punch*. *Lika Joko* was his answer to the sedate *Punch*, which he left after a disagreement; and he employed *Punch* artists in the main for his new publication, including George du Maurier, Bernard Partridge, Fred Barnard and J. F. Sullivan, keeping up a high literary and artistic standard. The paper sold widely and the following year Furniss took over the *Pall Mall Budget*, and amalgamated *Lika Joko* with it. The *New Budget* felt the pressures of a less leisurely society, unfortunately, and came to an end in July 1895.

Furniss was a full-blooded exuberant man, with a wide-spanning

[1] Gibbon, Monk, *The Masterpiece and the Man*, 1959, pp. 32–3.
[2] *Christian Science Monitor*, 20 November 1920.

humour, and his full-page caricatures, with incidents overflowing one into the other, and with a strong touch of the fantastic, influenced Jack Yeats to effects of wider proportions. The latter's contribution to *Lika Joko* consisted mainly of the series entitled 'Submarine Society', which occupied complete pages, and ridiculed the absurdities of human society in neutral territory. 'Submarine Society' continues into the *New Budget*. Another series 'Squire Brummles' Experiences' owe much to his wide reading. Pierce Egan's books, published in the early nineteenth century, may be where he first came across the work of the Cruikshank brothers. In one incident[1] 'Squire Brummles, after a round or two with Pierce Egan (in the library), organizes an Exhibition of the Noble Art of Self-Defence at Coverley Court: Squire Brummles v The Mudfield Terror (the host of the Nag's Head).' The show is enacted in the presence of a large house-party and two professional guests. The first and last round, however, become one and the same, because of the awful pose struck by the embryo boxer, and because of the family crest, that of a ferocious boar, tattooed on his naked chest. The Terror, overcome, retires without striking a single blow. It is a splendid series. Yeats had acquired a facility with his pen and a definite style of his own, with an ability to parody, or adapt an old-fashioned manner to his purpose.

The artist was contributing to less elevated publications too, *Chums*, where he appeared regularly after 1892, *Illustrated Chips*, and *Comic Cuts* and other Harmsworth Journals. He also had notions about writing. He gave two stories, conventional, though spirited, to boys' magazines in 1895; one a tale of a Great Irish Elk apparition in a small seaport town on the West Coast of Ireland. All the clichéd requisites are incorporated: an old bachelor uncle; a retired naval officer; two visiting nephews; a faithful family retainer; an injection of Irish brogue; a thrilling chase; and a suitable conclusion with a schoolboy prank.[2] The second is more involved and original, describing a melodramatic play written about a cycle track, and it employs a twist of fantasy which became typical of Yeats's later prose ('A Cycle Drama', *The Success*, 7 September 1895).

In 1896 his first drawing was accepted by *Punch*,[3] a parody on the

[1] No. 3. *New Budget*, 16 March 1895.
[2] *Boys' Own Paper*, Christmas Number 1895, pp. 36–7.
[3] Vol. cx, 9 May.

progress of civilization which has an element of pathos: for the safety of bicyclists a man with a red flag must precede all horses on the road. It was one of the last contributions to illustrated papers bearing his autograph. He appeared regularly in *Punch* from 1910 until 1941, under the pseudonym 'W. Bird', displaying a delightful illogical spontaneity and a fantasy which were frowned upon by one half of *Punch*'s readers;[1] and he had a general dig at human weaknesses. If this comic work had little to do with the overall pattern of his painting of that period, other than illustrating a more mature style of draughtsmanship, the feeling for subject-matter, where a brief caption added meat to a scribble, at least was kept alive, and reminded him of the importance of the titles to his paintings. The strong realism, the enjoyment of the ridiculous and of fantasy, and the dry humour, not always obvious, in these *Punch* drawings, all originated in a deep sympathy with humanity, and produced in his last paintings great works of art.

Jack Yeats now faced the predatory mechanical processes which were driving more artists away from what had been a steady profession. The development of photographic reproduction had given artists of the nineties a freedom denied to their predecessors, but now it ousted the artists themselves as journalism advocated the impersonal.

He had been working a little in watercolour at the same time as he was publishing his graphic illustrations. A painting of a Sligo subject, 'Strand Races, West of Ireland', was accepted and hung by the Royal Hibernian Academy, in 1895. He now entered upon a stage of watercolour painting which essayed a general interpretation of Irish life and character, and was to culminate in his series of illustrative oils for George Birmingham's book on Irish life. But first he retreated from London for good, other than for regular visits there, left the comfortable dwelling by the winding river in Surrey and the bustling life of the metropolis, and chose an existence which he could make poetic and strange. He settled with Cottie in Devonshire in the spring of 1897, lived with the red earth, the cliffs and the sea. In November 1897, he opened his first one-man show of watercolour paintings at the Clifford Gallery in the Haymarket.

[1] Price, R. G. G., *A history of Punch*, 1957, pp. 209–10.

Chapter 5
The living ginger

'I am glad you like my brother's drawings,' wrote W. B. Yeats to Lady Gregory, on 20 November 1897. 'If his exhibition does well or fairly well he intends to go to the West of Ireland next year.' There were forty-three watercolours, and judging by the title he adopted for all of his subsequent watercolour exhibitions,[1] these had been conceived as a group and could be described as 'Sketches of Life in the West Country'. Almost all were subjects done in Devon: 'A Tussle with a Moor Pony', 'The Pugilist in the Boxing Booth meets a Hard Nut that takes some Cracking', and 'Totnes Races', for example.

Stylistically these first genre watercolours develop straight out of the black-and-white cartoons. There is the same angularity, the emphasis on graphic treatment. Inset circles as a narrative device dwell on as spatial idioms as does the tendency to emphasize empty space through the grouping of figures. Their titles often taken from colloquial chat heard at race meetings and fairs were antedated in *Judy* of 1895 and 1896. The 'Johnnie B.' series[2] illustrating a young man's introduction to social life in the East End of London obviously originated the approach to life in the West Country: 'Johnnie B is seeing life in the East End at a boxing-booth,'[3] in particular, may be compared with 'A Cigar for a Kick'.

For the next ten years or so, Yeats painted almost exclusively in the medium, a descriptive artist, adapting what he observed to his artistic idiom, but preserving detail faithfully and relishing in the idiosyncrasies of man and the poetry to which man reaches.

[1] *Sketches of Life in the West of Ireland.* [2] *Judy*, 1896–7. [3] 10 February 1897.

His work is curiously out of context with its time. Yeats was born into a changing art world, but he took little notice of what the upheaval brought about. He told John Quinn in 1906 that he did not meet young artists.[1] His acquaintance seems to have been limited to the older generation of traditionalists whom he knew through his father. When he travelled abroad, to Italy, Paris, the United States and Germany, he regarded these trips primarily as the means of extending his knowledge of man and did not go out of his way to see the work of fellow painters – though naturally what he did see had a certain effect. But he disliked the term 'art', and said that he was concerned with reality.

The word 'art' I don't care much for because it doesn't mean anything much to me. . . . I believe that all fine pictures, and fine literature too, to be fine must have some of the living ginger of Life in them.[2]

The problem had been to choose between painting and words as a means of communication, but he opted for painting which he said was greater than writing. Painting was direct vision and direct communication.[3]

The constant comparisons Yeats was making between words and visual images show how much he was concerned with literature. Having worked as a black-and-white illustrator accepting the London tradition he entered the Gaelic Revival movement his brother was engaged in and became the artist of a cause which had never had an artist before. The Irish tradition rejoiced in a spoken literature. Yeats now translated the essence of that tradition, and the life from which it emanated, the love of poetry and the spoken word, of landscape, of humour, of legend, of idiosyncratic character into his paintings.

His fascination with the reaction of one man to another that he had known in his childhood gave birth to dramatic subjects, viewed from the life. The youth struggling to start a fight, but withheld by his father, was seen in Devon[4] and later depicted in the West of Ireland[5]. In 'Catching

1 Unpublished letter, 13 January 1906. New York Public Library Manuscript Collection.
2 Unpublished letter to John Quinn, 7 September 1906. New York Public Library Manuscript Collection.
3 Unpublished letter to John Quinn, 17 November 1920. New York Public Library Manuscript Collection.
4 ' "Hold Me Hat till I tear 'un" ', 1897.
5 ' "Let me see Wan Fight" ', 1899.

the Young One' boys hover by the side of a shed as a farmer calms a colt in the dark interior. Boxing, the circus, race meetings – he describes every form of recreation. He saw men working at poor but picturesque pursuits, ballad singers, drivers of long cars, fishermen: or in slightly more prosperous professions, pig buyers, shop proprietors. It is life in the country and the country town.

His delight in colloquial idiom gives rein to his irony. 'A Soft Day' (1908), the Irish way of describing rainy weather, shows a drenched jockey standing beside a dismal steed; 'Not Pretty but Useful '(1898) is a study of an over-muscular pugilist. Landscapes were inevitable, views of Strete and the neighbourhood, of County Dublin, Coole and the West; but these are surprisingly few. Yeats regarded them as a relaxation. 'This painting landscapes is very useful to me,' he said, 'and exciting work and a rest from picture making.'[1]

What was more important, however, was the character which grew out of the landscape. There is the portrait of the tall, reserved 'Man from Aranmore' (1905), standing above his pookawn, on a quay, his island rising up behind him. The idea of the man from a separate civilization, cut off from the mainland, is carried out perfectly. The series of portraits of Old John, a small farmer, and his sons, Michael the prodigal, and Young John the witless stay-at-home, date from the same period. 'The Rake', (1901, 1908), a country boy, cavorts in Sligo town with his glad rags upon him. 'The Old Ring Master' (1909) is a late rather tragic portrait of a feeble but dignified figure.

A few 'sacred pictures', as Yeats called them,[2] exist from 1901 and 1902. As a rule, though, in these early watercolours Yeats is restrained and the true observer. Once or twice emotion carried him away, as in 'The Stargazer' (1900), showing a figure of a mounted jockey by the sea, gazing up silently at the sky, and in 'Robert Emmet' (1898), the painting which showed his latent nationalist feelings blossoming forth.

Briefly the development of style in the watercolour period may be de-

[1] Unpublished letter to John Quinn, 16 September 1907. New York Public Library Manuscript Collection.

[2] Unpublished letter to Lady Gregory, [1901]. New York Public Library Quinn Collection.

scribed in three phases. The Devon paintings of 1897–8 are sketches of West Country life in busy linework, where pencil can still play an important part, but is softened by washes in fresh shades, generally pale in tone. There is a definite interest in light and the contrasts of shadow, though it became more specialized in compositions such as 'The Shadow on the Road' of 1901. After the visit to Venice in 1898 colours deepen, there are experiments with merging tones or the effects of running paint in 'The Music' (1898), and 'Catching the Young One' (1899), where mauve and red-browns and blues run into each other, sometimes lightened with touches of yellow or pink, and forms are emphasized with an outline of a contrasting colour. Petrolly blues and greens, often combined together, have a rich strong quality. Where colours do not blend, as for instance in 'Simon the Cyrenian' of 1901, the contrasting tones emphasize the main figure in the composition. Yeats was now employing a drier brush and working several colours together, building up solid figures, outlined firmly. Colours could be imaginary, anticipating the freely conceived combinations in the oils of the twenties, with yellow sky or unusual tones in a background enhancing the central hue, and brushwork too was becoming looser, though the forms remained strong. The technique Yeats employed from the early 1900s onwards was something of a throwback to the 'poorman's oil' of the mid-Victorian era. The colours of the final watercolours are realistic and plain, concurrent with the early representational oils.

Compositionally, shapes become simpler after the early Devon scenes, and paintings tend to develop out of the central figure rather than depending on a general artistic arrangement of details. Yeats was always interested in space: he frequently engineered an empty foreground where the still expanse expedited movement and action in further portions of the composition. There are examples as far apart as 'The Runaway Horse' of 1897, 'The Small Ring' of 1930, and 'The Shadowed Hour' (1946). The apportioning of space played a great part in his pictures, for instance in 'The Auction' (1897), 'We are leaving you now' (1928), 'The Arrival' (1948), and 'Simon the Cyrenian' (1901). In this last the road to Calvary is empty but for the central figure of Simon the Cyrenian stumbling along and Christ in the side foreground surrounded by hostility and spears. The mocking crowd is gathered in a mass on the rim of the

road. 'The Crucifixion' consisted of the tops of three crosses outlined against the sky.

Movement is an essential part of the watercolours, in subject or in composition. 'Memory Harbour' has been carefully planned. The village of Rosses Point is seen from the mainland. In the middle of the harbour the Metal Man points to where the water is deep enough for ships to pass. The Metal Man is slightly off centre to the left. In the right foreground a man is walking off the picture, towards us, passing downwards beyond our vision, on a level with cottages and a laden long car and the road and the shore. The line sets off that in the other direction, the long stretch of water, with moving boats on it, that leads the eye up to the central pivot of the Metal Man, and beyond again to the distant sea and a sailing boat and the sky. Movement occurs too in the shadows of moving clouds on the headland and in the water reflection, and in the fact that the boats are not moving towards the Metal Man – the point to which the eye automatically wanders – but towards us leftwards. Two kinds of opposition are set up compositionwise, giving interest and motion: the channel banks forming diagonal lines that almost meet out to sea beyond the Metal Man and then sweep away from each other horizontally to the sides of the picture; and the boat and the man, repeating their diagonal paths, coming back towards us and slanting away then from each other. One pair of diagonals is static, the other moving, and they set up an antagonism towards each other. The moving light and the feeling of open air and breezes contribute to a lively composition.

Not all of the watercolours were composed as carefully as this, which Yeats regarded as an important work. This was more the style of treatment reserved for the early oils, but where the early compositions are successful there is always this element of linear movement. The artist was conscious of the difficulties of translating real events into something artificial – 'you have all the composition of your figures and the "idea" of your picture to keep a grip on.'[1] Sometimes he realized he had failed; for instance he was dissatisfied with 'There was an old Prophecy found in a Bog', and thought it was 'too much of a little group with a title and

[1] Unpublished letter to John Quinn, 16 September 1907. New York Public Library Manuscript Collection.

not enough of a picture',[1] but he rarely destroyed works or painted them out.

The first exhibition was received well. Several pictures sold, one to the publisher Elkin Mathews who encouraged the unity of the arts, and who would bring out Yeats's children's plays a few years later.

Henceforward the artist's shows were based on the theme 'Life in the West of Ireland', and included his English sketches in a minor role. He exhibited at eighteen-monthly intervals, mainly in London and Dublin, showing the same exhibition, with alterations and additions, in both cities. By 1910 he had seventeen exhibitions to his credit. A small but devoted group of admirers, who saw in him the first really Irish painter, supported him, friends, members of the family, and a few people who had no acquaintance with the artist: Lady Gregory and her artist son Robert, Edward Martyn, George Pollexfen, the Pursers, Horace Plunkett. Patrick Pearse, without knowing him, bought a picture.

Lady Gregory was invaluable in practical matters, looking for the best exhibition space possible on the far side of the water: and she used her influence in another way. The exhibitions became events in the fashionable world where she presided waited upon by the social and literary intelligentsia of Ireland, assisted by Mrs. Jack Yeats dressed handsomely, and the Misses Yeats sporting home-produced tweeds. In 1900 the private view coincided happily with the institution of the Irish Literary Theatre. The following year she organized a symposium on 'the present state and prospects of art'. About eighty guests were present, listening to WB making a 'vague, lofty and mystical address'. A few years later the exhibition walls were being decked in the nationalist colour, green. Sandwich men carrying boards with placards coloured by the artist regularly paraded the Dublin streets.

But his 'human sandwich' did not always 'attract the human herd'.[2] Yeats was not a popular painter, until late in life, and even as an established artist has a limited appeal. A charming note on a catalogue in 1902 shows an exceptional occasion when John Quinn, the American collec-

[1] Unpublished letter to John Quinn, 5 April 1909. New York Public Library Manuscript Collection.
[2] Unpublished letter to Lady Gregory, 17 June 1901. New York Public Library Berg Collection.

tor, became a patron, and Yeats acquired one-hundred-and-six pounds, nine shillings: 'I believe that I have added it wrong, I am tired, but isn't it good: gate money paid, rent and printer.'

Yeats had begun now to keep a pictorial diary of his activities, which gives a very full record of his movements while he lived in Devon. His earliest serious sketch notes, of the singer Albert Chevalier, and of Bertram the Conjuror, at Richmond, date from May 1894; and from 1895–6 survive further drawings of sporting and music hall at Chertsey and Dublin. He discovered in these the difference between drawing from sight and drawing from memory; though he did not develop the concept of memory to any important extent until after he returned to Ireland, in 1910. Another sketchbook describes a circus at Chertsey in March 1897. After the move to Devon in the spring, however, notebooks began to accompany him in earnest wherever he went, generally little ring-back sketch pads, easily manipulable with their loose backs, small and easy to conceal in his pocket. They measured about three and a half inches by five inches. To those who knew Yeats he was a familiar, unostentatious figure in a crowd, screening the sketch book within the flap of his great-coat, and noting down pictorially and verbally the idiosyncrasies of the human race.

The Yeatses had found a house about a mile and a half away from Strete in South Devon, situated in a coomb, off the Totnes Road, beyond Fuge. It was a two-storey cottage with paned windows, tall chimneys and a thatched roof; and a high wall enclosed the garden and the orchard behind it. Not far away at the foot of a steep hill was another sheltered farm-house, beside a mill, fed by a trout stream, the Gara.[1] Coombery was infested with snails – Yeats refers in his diary to 'the murder of snails' – and Coombery became Snails Castle, this in its turn being re-placed by the Irish translation of the name 'Cashlauna Shelmiddy' (Caisleán Seilmide). The motif of a round tower rising out of a snail's shell was often employed to embellish books and envelopes: Jack B. Yeats had a tower many years before WB had one.

Snails Castle was off the main road, but places of interest were easily accessible. The Castle lay on the road to Slapton, a mile from Slapton

[1] An appropriate name, Sligo is on the Garavogue, and Lough Gara lies on the border of Sligo and Roscommon.

Sands. To the north were Blackawton and Totnes, to the west Plymouth. On the far side of the next headland was Brixham, whence came William Pollexfen to Sligo. An undulating road from Dartmouth to Torcross wound for seven miles above lofty cliffs and carpets of sand, and a sea trailed with ships by night and by day. Maritime legends abounded. The road turns inland at Torcross; and from Torcross to Kingsbridge is cider country. Local cider was still prepared in the traditional manner. One of Yeats's sketches shows the loading of a press from a wheelbarrow, the men straining, pulling the long lever with all their might, and the juice slowly dripping into the kegs.

JBY wrote to Willie in 1900:

It is beautiful here. I wish it were possible for you to come and occupy Jack's spare room. He was speaking about it yesterday. His house is extraordinarily nice and comfortable – Chippendale furniture, etc., with pictures and art in a small thatched house among thick woods seems as if it were something quite new. I think you would like the place greatly. Cottie is as hospitable as possible, and both have the gift of making life peaceable.[1]

The tall-backed settles and the Staffordshire pottery dogs and figure of Dick Turpin on Black Bess, later familiar to visitors at Yeats's Dublin dwelling, came from Cashlauna Shelmiddy. The walls of the simply furnished small bedrooms were lined with pictures. A steep wooden staircase led down to the dining-room with grandfather clock and a french window leading onto a verandah; and the sitting-room with its elegant furniture had always some charming bowl of flowers. A cottage fireplace was provided with a three-legged pot, and pottery jugs on a high mantelshelf. A large room at the back of the house became a studio, and a drawing of 1899 shows a ladder going up to a bunk or shelf, a large model yacht on the settle, a wooden armchair, and a full bookcase. There is much of the atmosphere of a ship's cabin.

The grounds sloped steeply to the south to the Gara. Cottie grew beans and petunias and foxgloves, and kept hens. A glasshouse was full of potted plants. 'Our garden spirit', sketched by Yeats with a frozen cobweb between its fingers, must be one of the figures, in the garden of Cashlauna Shelmiddy, described by Masefield as 'grim scarecrows' of

[1] Yeats, J. B., *Letters*, p. 63.

Devonshire sailormen and smugglers;[1] but in appearance the figure was very similar to the Metal Man in Sligo.

Their dog Hooligan (Hoolie), of a lively irrepressible nature, had accompanied the Yeatses from Chertsey. Sketches of 1897 and later, in delicate watercolour and pencil, or pen, show the interior of their house, and the yellow dog in various proprietory attitudes. He can be the Chocolate Box dog, or the Dancer all in Yellow. He plays flirtatiously with his sticky nose, as the Honey Bear, or depicted 'after Landseer, of the full eye', he instantly becomes long necked and beauteous and meaningful. The Marble Hound on the Doorstep is stretched out like a carved beast. Yeats's affection for his animals results in most amusing sketches of Hooligan, and Skew, the cat, in warfare with each other, Skew, in characteristic poses, constantly taunting the 'cherub', sometimes merely by a provocatively placed reflection; or Hooligan on his own, the Mighty Hunter, on the trail of the fleas in his neck.

The Yeatses were soon established in the neighbourhood, keeping open house for the local children. Jack Yeats put his toy theatre in action every Christmas for the Valley School children, showing his toy plays or a circus. He judged horse competitions. In the winter there were hare hunts and beagling, and in the summer dog racing, sports, the Great Fair at Kingsbridge, and the Dartmouth Regatta. Life followed a certain pattern, beginning with a visit to London in the spring, then home, to the busy fairs and pastimes in the locality of Strete. Sometime in the summer Dublin and Sligo and the West of Ireland must be reached, and then in the autumn a taste of London again.

Yeats walked about around the district, sketching gate latches, a mole trap, an enormous grasshopper, a wren's nest, a hare, a heron rising from a cattle pool, a young bull in the marshes with flies about his head, and – when the harvest was being taken – 'the motions of the mowers'. He was frequently drawing the local characters, who provided the subject-matter for his Devonshire watercolours, and the incidents which he observed: Manning's cow being surveyed professionally by a passer by; or the Strete schoolmaster, with long hooked nose, generous moustache and a dab of a chin, marching along with the enormous keys of the school.

Yeats went to Italy either in the spring or in the autumn of 1898, and

[1] *Jim Davis*, 1911.

probably with his wife.[1] Some time was spent in Venice, where the soft luminous colours of the water, the mauves and madders, affected the painter, as did the reflections he saw. The technique of his watercolours alters after this, and the ochres of the Devon sketches give way on his return to a more mellow colouring. Interested in foliage, and in sketching woodland, he was intrigued by the vine groves. Further north he admired the mountain altitudes and villages set on cliffs, the carts drawn by huge oxen. He returned home by Como, where not unnaturally the bicycle track had to be paid a call. He stayed at Luino on Lac Majeur, and travelled back through Lucerne, and then up through Luxembourg and Belgium. But continental things made little impression on Yeats.

Even in Paris the Fair must be seen. The Yeatses spent a short holiday there in June 1899, and were amused by the wild-eyed man with the red beard who drove the engine on the toy railway at the Fair, and by the lights of a merry-go-round flickering on Napoleon's Tomb. A steam-boat on the river, the gardens with classical statuary, and dapper humanity, the gendarmes, a *sans-culottes* in blue overalls with a typical French moustache in white, a small girl in branching hat, walking with a clipped poodle, all breathed the atmosphere of the French capital: but the artist was happier back in Strete sketching cattle and fishing boats, or visiting the Barnum Bailey circus at Torquay. Perhaps the cow beneath a criss-cross of mauve pink and cobalt sky with a globular poached egg sun was a reminiscence of some painting seen in Paris; but Yeats was more himself rocking at the antics of the clown, the giant spelling and the tattooed lady, and he admired the Japanese rope tricks and the act comprising seventy horses in one ring.

All local events were attended: Totnes Fair, where he noted the different types – the stolid farmer, the musician, the tramp – and jotted down details of the farmer's dress, the silver chain, his bowler hat, kerchief and frock-coat, his red hair; and he sketched the auctioneer's mark on heifers' flanks, their tails whisking flies away. It was partly the ingrained artistic

[1] Unfortunately the Italy sketchbooks are undated, so that I am grateful here for biographical data provided by Mr. Victor Waddington. The style of sketch would certainly place the visit at about this time and since the artist was in England and in Ireland from May until September 1898, the trip must have been undertaken early or late in the year.

journalism, partly training in observation, and partly a preparation for future compositions. St. Ives produced a schooner on the occasion that he was there – sailing vessels, three-masters and five-masters, appear reasonably frequently, and with triumph, at various points in these diaries, and their grace and their historical associations obviously meant much to him; and Penzance yielded almost Cruikshankian characters. He saw 'Fourpawr's Great Olympia' in an avalanche of startling circus acts at Dartmouth, and three weeks later Lord John Sanger's circus, now on the move. He saw steeplechasing at Brent, and Bampton Fête, at the ancient town of Tiverton, the latter staging a procession of Juvenile Druids and Archdruids in all their regalia. Blackawton Show showed horses and pigs. The artist enjoyed scenery at Torcross and Finch and Frogmore. Another circus took place at Slapton, John Scott's circus, famous for its equestrian acts, and duly described in detail. Clowns were important (they still were fifty years later) – 'Four Great Talking, Whimsical, Quizzical Clowns'. Yeats was as interested in the words of the people as in their appearance. He was taken by dialect, and unusual expression; and he constantly recorded patter at the circus and music hall. He watched a girl helping a clown to straighten himself before he went in to the ring, 'stroking down his tails'. With a small sketch of another performer followed:

w'y don yer carry a naker
An ankerche'f a useful thing ter old ot tea can and bind up yer ed and wipe gents not come a smeller off of ther bike and ter clean yer boots and ter dry yerself after bathg [*sic*] I sed.
I dont bathe he said shortly![1]

At the end of June 1898 the artist paid a visit to London to see the Earl's Court exhibition and a naval spectacle. He set sail from Plymouth

[1] Yeats worked quickly with pencil and afterwards coloured the sketches lightly with watercolour. The style changes from a slighter version of his watercolours, in the late 1890s, to experiments in crayon or in plain wash, at the turn of the century. There are landscapes sketched in a dark runny wash. Always the style slightly anticipates that of his more serious work. The sketchbooks are important in dating early works, providing initial studies for many watercolour compositions, or noting subjects worthy of treatment. They were the repositories of subject matter for later paintings. The artist continued to return to them throughout his life.

7 Bachelor's Walk, in memory 1915

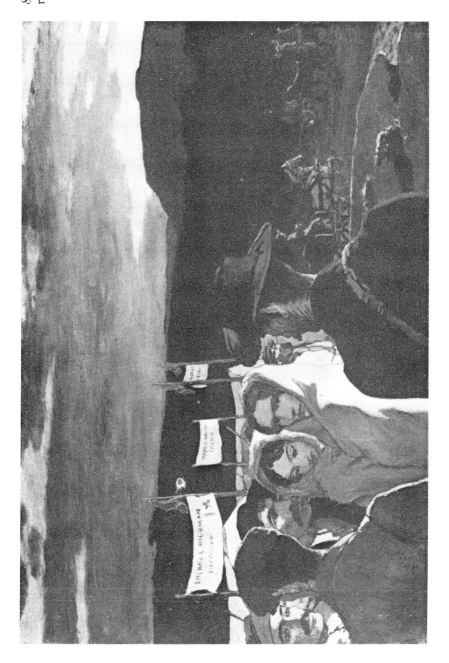

9 Self portrait c. 1920

on 30 July, stopping at Cork to watch the inter-county championships for hurling and football, and then travelling by steam tram to Blarney. He continued on to Limerick and Galway, where he attended the Galway Races on 3 August, collecting further material. Next Tuam, a brief stop at Sligo, and then a circuit of South Donegal, of Killybegs, Glenties, Ballybofey, Strabane and south again to Enniskillen, and back to Sligo. He enjoyed the local characters, and amusing incidents; but now in Ireland again he revelled in the blue mauve mountains, and water, in the sprawling stone walls, in the gorse-grey landscape culminating in the points he knew so well, in smudges of boats moored by the pink rocks and hillsides lightened with buttercup silhouette or with blackberry blossom; and he rejoiced seeing the shadow of Ben Bulben once more.

The final event before he returned to Devon was the 1898 celebration at Carricknagat, on 4 September. Not everyone remembered offhand who Bartholomew Teeling was – Yeats himself described him alternatively as Keeling, Teelin and Teeling. The young chief aide-de-camp to General Humbert had shown himself to be very courageous a century before, and was responsible for the victory at the Battle of Carricknagat; but when the tide turned and the French surrendered, instead of being bartered for an English officer, Captain Teeling, who was only twenty-four, was tried by court martial as a British subject, and executed at Arbour Hill. On the summit of the hill by the road leading from Ballisodare to Collooney the foundation stone for the monument commemorating his bravery was laid on 4 September. It was a historical ceremony. Four special trains arrived at Collooney, from Sligo, Manorhamilton and Tuam. Detachments came from twenty-five parishes, most of them with their own banners and band: the Sligo Temperance Association of the Sacred Heart, the O'Connell and the Trades Banners, the Ballintogher banner sporting the head of Tone – brown with age and stiff, the Sligo Banner with the round tower, all flew above the army of five hundred horsemen wearing green sashes and moving six abreast, to the sound of Irish airs. The procession measured over a mile in length, and marched after last Mass along the road to Ballisodare, filing past the scene of battle, and returning to the site of the monument for the stone-laying ceremony. It was led by an important local figure dressed in the character of Emmet, driving with a four-in-hand, and wearing a green coat, black

gaiters, and flourishing a plumed hat. The Tubbercurry Band followed.
Next came the nationalist members of Sligo Corporation, drawn by four
gallant greys. Yeats's watercolours 'Robert Emmet in 98', and 'The
Banner', give a fine impression of the ceremonious occasion, suggesting
conjointly the commemorative procession of 1898, and the historical
event of the previous century.

Marquees and tents were gathered about the ceremonial place. Gay
streamers, with 'Who fears to speak *for* '98' in yellow letters on green, and
flags of the United States and of France, and a banner in green and gold,
with crowned harp and hounds, flew aloft. Characters in fancy dress and
a man with a 'yankee' tie loitered near the wooden platform. Children
munched bread spread with bacon as they waited. Then Father Brady,
wearing a sash over his shoulder stood up on the stage, and raised his
hand to indicate that he was about to make an oration. (Yeats noted the
presence of a tin of water instead of a drinking glass on the table beside
him). Father Brady rode away to the music of a fife and drum band, and
then celebrations began in earnest, minerals, deelish, cakes, rock and
apples, being served at the tents. The *Sligo Champion* commented com-
fortably on the orderly proceedings, nearly fifteen hundred people were
neatly dispersed by seven o'clock in the evening. But it was a Sunday, and
the public houses could not co-operate in perpetuating the festivities.

The 1898 celebrations made a profound impression on Jack Yeats as
they did on many others. His romantic emotion and affection for Ireland
had been an inspiration, and since he had lived in England he had be-
come more and more aware of the peculiar beauty of the Irish landscape:
but now the first stirrings of nationalism occurred within him. His brother
was president of the English committee of the Wolfe Tone Memorial
Association, and Jack B. must have heard much talk about Tone before
attending the celebrations: but visually he had stumbled upon something
new, and the excited uplifted crowd, and the colourful ceremony appear
to have had a more immediate effect on him, and activated a bias which
grew stronger and deeper with the years. Home Rule would never be
enough for him.

But life still remained gay. Lady Gregory was pressing for him to go
over to Coole in the summer which followed the first exhibition, sug-
gesting that July might be more conducive to sketching since the house was

full of children in August.[1] If he went in 1898 it would only have been a brief visit, and it is very likely that the first time he went there was in the spring of the following year.

He held his second exhibition, *Sketches of Life in the West of Ireland*, in London in February 1899 and went to Ireland in April, where he and Cottie stayed with Lady Gregory at Coole. He sketched the grey building, framed by branching trees, from across the lawn in front of the house. There was much material to be gained in the country about him. At Ennis he watched families bidding farewell to emigrants with a constant flapping of shawls 'like bats'; and here also he did a sketch of 'The Fiddlers', very similar to 'The Music', a watercolour of the previous year; and he noted an ash-plant seller, who would become the subject of a later oil. 'Inside the halls of justice' he sketched the gnarled attentive faces briefly, but with a Daumier-like precision. At Kinvara he saw the castle, and the harbour, with turf boats and seaweed, and he visited Gort on a Saturday to observe Market Day. He found the Castle very much ruined. There was a circus at Gort a couple of weeks later, where umbrellas were essential in the auditorium, and everyone saw the bandsmen's coats hung out to dry after the opening procession. The following day was Fair Day in Loughrea, the town packed with burly and stringy farmers. An old lady in the crowd smoked a pipe. Yeats explored the Abbey, and sketched the town and the lake from the belfry, and he then looked at the St. Ruth burial place. There was a local funeral in Gort the day after this, where the coffin was laid across some chairs in the kitchen, and a mourner tied his goat to the handle of the street door as he walked in.

Lady Gregory found Jack and Cottie 'such dear pleasant guests – no trouble to any one.'[2] The couple would have 'very nice chats' with Lady Gregory in the morning after breakfast, before the day's work began. Cottie must have enjoyed the old-fashioned walled garden with shrubs, and columbines and box-hedges; and she and Lady Gregory exchanged plants for the garden and seeds thereafter. Soon a neat workmanlike signature was carved on the trunk of the spreading copper beech, beside the other celebrated names.

Coole opened up to Yeats a new society, which had been known

[1] Yeats, W. B., *Letters*, p. 302.
[2] Lady Gregory to Jack, Monday 9 September, n.d. The artist's estate.

previously at second-hand, through his father and his brother – Coole during the summer was the core of the Irish literary world. Through its portals passed – invariably – WB. Other members of the Yeats family might be there, and Sarah Purser, Douglas Hyde, Standish O'Grady, the Fays and the Abbey actors, R. I. Best, Sir Horace Plunkett, and the Sligo artist Percy Gethin; York Powell, Augustus John, Miss Horniman, and Susan Mitchell, all found their way there at one time or another. Near by, at Tulira, lived Edward Martyn. George Moore one day invited the party over to see a seascape by Monet at Moore Hall (Yeats never made any comment on it, or on Impressionism). John Masefield, Synge, and John Quinn, all of whom became close friends of Yeats, visited Coole. AE had a warm affection for the young couple. Jack went sketching with him, and he used to tell a story afterwards about how they both sat down to draw a landscape, and after a time when he went over to see how AE was progressing, AE's paper was empty but for some winged figures. He had not a high opinion of Russell's work, but a pastel was kept at Cashlauna Shelmiddy because Cottie liked it so much.

Arnold Harvey was a young divinity student from Trinity College, who went first to Coole in the summer of 1899 to coach Robert Gregory in classics for Oxford; and after that he used to visit Coole regularly every year. He and Jack Yeats took an instant liking to each other, and T. A. Harvey would stay at Cashlauna Shelmiddy, or invite Jack and Cottie over to stay with him; or holidays after this would be synchronized so that they might meet at the same point.

Bishop Harvey has described the company at Coole as being divided into two very distinct groups, the older, drawn from the literary and artistic world, and the younger, consisting of Lady Gregory's son Robert, and his friends.[1]

Jack Yeats appears to have attached himself to the younger group, except when he went on lone trips, sketching about the vicinity. Geraldine Beauchamp was a niece of Lady Gregory, a very unsophisticated girl whom the young people were inclined to mock. The Persse cousins came too. Daphne was an intrepid boxer as a child. She challenged one of the stable lads who was considerably smaller than she was. Everyone crowded down to the stable to watch her sparring and launching blows;

[1] 'Memories of Coole', *Irish Times*, 23, 24 November 1959.

and Jack Yeats was at the back, rapidly sketching. At night two eagerly awaited events brought the company together: the first when Jack Yeats took out his diary and rapidly sketched the events of the day, and opened the eyes of the guests to how they appeared to the irreverent eye; and the other when AE returned from his day's labours, and showed a pastel sketch of a woodland or a lake scene, peopled with mysterious flamelike beings, inhabitants of the true world, obscured by the visible landscape to all but the pure eye; though he admitted that he caught sight of them whether his eyes were open or shut. Willie Yeats was regarded with amusement. His room was above the gun room where Harvey and Robert Gregory were often together, but he never complained about the noise. At lunchtime he would descend and announce that he had written three lines. A particularly fruitful morning produced five. Jack never seemed to laugh at his brother. Each had a great respect for the other.

Sometimes there were races on the lake, Robert and Harvey and Richard Gregory, a cousin, in a boat with square sails decorated by Robert, and WB and Jack in a vessel surmounted by the emblem of a duck. The retriever, Croft, proved a hindrance in the larger boat, and Robert and Arnold seized his legs and attempted to swing him overboard, succeeding only in capsizing the vessel. All four struck for the shore, Croft in the lead, casting worried glances over his shoulder to see how the young men were faring. When he reached the shore, well ahead of them, he shook himself cheerfully and violently and sat down to await their arrival. The smaller boat, manned by Jack and WB, proved to have the more effective crew.

Chapter 6
Miniature drama and
A Broadsheet

The end of 1899 was a sad time. Mrs. JBY's lingering illness came to an end and she died in January 1900. There is no comment from Jack Yeats anywhere, he was characteristically silent, but his sketchbooks cease for a while and do not commence again until the summer of 1900, and not in number until the year after that. He never made a direct comment on a matter about which he felt deeply.

JBY appears to have been concerned about his son's career at this period and he wrote to Lady Gregory lamenting the fact that Jack would not go back to art school. Jack stayed at Blenheim Road with him for a month in 1901 while his exhibition was being shown, and JBY was anxious for him to attend a course for a few weeks.

I have often urged him on this point but so far without avail. He does his pictures without models and so never gets the practice from the life that falls to the lot of other men. I have taken Cottie aside and talked to her, but she always believes whatever Jack wishes her to believe, and I think she does pretty much the same with everybody else. Cottie's charm is so real that I never wish her other than she is. So I must not complain. I only know that some day Jack will have a rude awakening. I only pray it may come *soon*.[1]

JBY was a theorist, Jack B. said little, preferred to put what he thought into practice. Just two years before he had settled down to giving himself some unconventional disciplinary exercises. He worked in pen and indian ink from photographs of the blackfaced ram, the shorthorn bull,

[1] Skelton, R., and Clark, D. R., *Irish Renaissance*, 1965, p. 59.

the Hereford and carthorse, among other subjects, and he did detailed studies of bone structure, or of agricultural objects, in a straight, if unexciting manner. A study of his wife is conducted in the same fashion. Not that he did a great deal of this kind of work – he found it boring. He preferred greatly to train his memory, in drawings of Start Bay in moonlight or a sketch of two acts seen at the Cork Palace Theatre. The same year he did some straight drawings in Sligo, essays in interior, the McEwan's Dining Room, the Post Office, the Elsinore Hotel, Eades's School in Sligo, the Pilot Master's house, Mrs. Gillen's kitchen, the family office, and so on.

He was experimenting in other ways too. From 1893 until 1909 he made cut-out stencils,[1] of every kind of figure, thus strengthening the foundations of a firmly outlined style with a definite flat pattern. He seems to have started with geometrical designs, squares and rectangles cut from scraps of paper or a luggage label. Naturally enough he could imitate the characteristic silhouette of the Metal Man[2] or of a pugilist; and there are impersonal prancing steeds, melodramatic villains, pirates and a nigger. Sometimes different parts of the stencil shapes were impressed in contrasting colours on the same piece of paper. He caught the character of Dan Leno, the Dublin music-hall artist, admirably, and the strong features in stencil portraits of his friends T. A. Harvey, and J. M. Synge. His profile self portrait was not so good. He sent a stencil of his pirate creation, Theodore, to the Rev. T. A. Harvey – 'you will remember he was a kind curate to Lafitte the pirate'. The largest attempt seems to have been a study for 'The Rogues' Company', which included Sweeney Todd, Pink Charlie, Good Queen Bess, Drake, Three Fingered Jack, Charles II, Captain Kyd, Cromwell and Jack Sheppard. They were done as a personal experiment, and not intended as serious works, the first aim being simple comedy. In his tiny booklet, *Jack B. Yeats: an Appreciation* – on Jack by Jack – (1902), the stencil plays a part in the brief satire on art appreciation.

[1] Coll: the artist's estate.

[2] A letter from York Powell to Oliver Elton dates this in 1901: *Letters* vol. 1, p. 324. 12 July 1901. Another letter, from YP to Jack Yeats speaks of a stencil reminding him 'of the *Captain Cuttle*, little ship sign, with the middy taking a sight of the sun with his sextant'. *Letters* vol. 1, p. 392. 22 January 1904.

Prints as such, though, made an enormous impact on his graphic work of this period. He collected nineteenth-century ballad sheets through-out his life together with prints and pulls of sailing vessels or of coaches dating back to about 1850. During the nineties his interest in Japanese art was stimulated, and among his papers exist several colour prints cut from magazines, and various examples of prints by Toyokuni. In 1901 he was doing very credible imitations himself with the thread line and faded colouring, which at a cursory glance would appear to be genuine oriental prints. The gentle satire disguises a Jack Yeats pirate in Japanese garb.

But the nineteenth-century theatrical prints had the most far reaching influence. Robert Louis Stevenson, with 'penny plain, twopence col-oured', probably introduced Yeats to the miniature theatre, certainly the artist acknowledged a debt to him. Yeats was an avid collector of the second-generation writers of juvenile drama, John Redington for one, and then his own contemporaries, Pollock, son-in-law and successor of Redington, and H. J. Webb, Pollock's rival. The Redington theatrical portraits in Yeats's collection included, not unnaturally, Captain Mac-Heath and Sixteen String Jack as well as the celebrated early nineteenth-century actors in Shakespearean roles, or as Pantaloon, Columbine and Harlequin. The worked and shaded line, and the early Victorian senti-mentality gave way to Pollock's bold and plain manner and fantastical romanticism, and these had the strongest influence. Here he saw the tropical and the marine, in plays such as *The Corsican Brothers* and *The Blue Jackets* and *The Sleeping Beauty*. H. J. Webb's figures are smaller than those of Redington and Pollock, and tend to be smudged; though his approach is attractive, and his melodramatic subjects, *Paul Clifford the Highwayman*, *The Smuggler* and *Three Fingered Jack*, provided a source of inspiration.[1] At 124 Old Street, St. Luke's, Webb with his father's collection showed some of the original designs by West, Skelt and Hodgson; while Pollock, in his historical shop not far away at 73 Hoxton Street, displayed a large model stage with a full setting of early panto-mime, and tinsel framed pictures of old theatrical heroes.

According to a bill among his papers, Yeats was writing to Pollock as

[1] Yeats had examples of *Champion Parlour Drama*, *Boys of England* editions, *March's Monster Plays*, *Mathew's* and *Clarke's Juvenile Drama*, in his possession, though he mainly concentrated on collecting Pollock and Webb.

late as 1933 for drop scenes and wings for his miniature theatre. He exchanged theatrical prints later with Joseph Holloway.

The artist began showing plays on his own toy theatre to the Valley children at Strete in January 1900, with a performance of *Esmeralda Grande*, which he put on again in the summer for his father, Lily and Harry Hall. Slightly more ambitious was the miniature-circus exhibition the following Christmas; and this was again in the summer for close acquaintances, including Pamela Coleman Smith. The event depended on display and patter, opening with the entry of attendants, and then the ringmaster, in whose pompous commentary lay the introduction of the performers to come – jockey acts, clowns, Indians, an Irish ballad singer, the Ride of all Nations.

8th and lastly let me [introduce to your notice] the Jockeys, each of which are [just] one foot and a half high and weigh from 28 to 36 pounds. These little men keep themselves so small entirely by eating nothing but mustard.

That will conclude
The Entertainment
This Evening. I thank
You one and all for
Your kind attention.[1]

The turns employed for the most part horses in brilliant demonstrations, interrupted regularly by the irrepressible Tuffcake and Cream. Another circus was prepared for the following year, though both were then broken up. In 1902 *The Treasure of the Garden* was shown, in 1903 *James Dance, or the Unfortunate Ship's Boy* (a pantomime), in 1904 *The Mysterious Traveller or the Gamesome Princes and Pursuing Policeman*, and the subsequent two Christmases the 'Galanty Show'; after which the theatre appears to have been abandoned for regular performance. Yeats however left a permanent record of it in his drawing of 'Captain Teach, the Pirate', in *A Broadsheet*, November 1903, and in the watercolour, 'The Toy Theatre', which shows a small boy operating his model. He later described the difficulties in producing the plays, in two articles written in 1912.[2]

[1] MS. record. Coll: the artist's estate.
[2] *The Mask* 5 no. 1, July 1912, pp. 49–53. 'How Jack B. Yeats produced his plays for the miniature stage' by the Master himself; *The Music Review*, Autumn 1912, pp. 83–5. 'A theatre for everyman.'

Evidently the pursuit was important to him. He had first worked with a stage measuring eighteen inches wide, but this had limited the size of his audience, and he had a stage more than twice the size made for him by a carpenter. This allowed five or six people to sit abreast and have a good view of the action without seeing the hands of those who manipulated the figures. He spoke of the use of coloured papers for colouring the scenery, a device for saving time, and lightning, suggested by a zigzag in the backcloth covered with blue paper, down which a light was dashed at the appropriate moment. Coloured fires came from red and green matches used in quantity.

All the year I collected all the bits of coloured paper and tinsel and general magpie treasure I could come across. Then about the middle of September I began to write the play and make rough drawings of the scenes and characters. By about Hallow's Eve it was regularly laid down. Then the best of the business began. Every evening the main room began to look like a Chinese ship's husband's store. The papers were heaped ready, some crimson, a lot of blue in several shades, and a good deal of a very bright green paper, quantities of strawboard and white cardboard, bottles of ink, black and coloured, bright bits of tin, silver paper, paints, laths, manuscript fasteners, glue in a glue pot, paste, some little China bowls for mixing inks, and three pairs of scissors.

I cut out, or mostly tore out, pieces of paper about the size I wanted, and pasted on the strawboard and when the paste was dry pulled the scenes together with brush and ink and some body colour. I did much the same with the characters, which were about nine inches high, only for them I used white cardboard and less coloured paper and more paint. When my characters were finished I fastened each to a lath by a folding back foot-piece, with a manuscript fastener. By these laths they could then be slid on and off the stage . . .

I took all the parts myself, moving to either side of the stage as was necessary. For music 'heard off' I had a musician with a kind of zither and tambourine for the drums.

About St. Stephen's Day everything was ready . . . A couple of long stools and some chairs were arranged in rows, and the children of the valley in which I then lived came in and took their seats.

I allowed them a little time to sit and cough, and pinch each other and shuffle their feet, and make little squealing noises – like a grown up audience. Then I rang an old bicycle bell, screwed to the back of the stage, and up went the curtain.

There is a poignant note in a letter to John Quinn, in 1906[1]. One of his reasons for returning to Ireland, the artist said was the fact that he would prefer to give shadow shows to Irish children whom he found more receptive. But the account to T. A. Harvey a year or two earlier strikes a different tone. He described *The Mysterious Traveller* supplementing the account with delightful comical sketches, of a clown sitting cross-kneed on a chair, puffing his pipe, and of a postman creeping laden to the post-box where the clown on another occasion is concealed.

Last Friday Mrs Yeats gave her annual tea to the valley children and I gave them a performance on my theatre. It was an Old Fashioned Harliquinade with Clown and Pantaloon and a comic policeman. I think it amused the children more than any of the other entertainments I have given them. It really wasn't half bad. I had some working figures of which I was very proud. A town crier who rang a bell, and a figure of the clown which smoked a pipe (real smoke which I blew through a tube from behind the scenes.)

There was also a pillar box which opened and showed the clown sitting inside then the door snapped to again. Then there were *practical* windows out of which the clown looked, and there was a figure standing against the wall, and waggled his head. [*sic*]

The play was called

The Wonderful Traveller
or
the disguised Princes and the pursuing Policeman.[2]

Three of the plays were published by Elkin Mathews. All display the love of word linked with visual image, the melodramatic impulse and the feeling for moment typical of the late paintings. These cardboard figures offer stable tableaux of whatever splendour was set in motion by the exaggeratedly agile script accompanying them, a succession of melodramatic incidents narrated in a bloodthirsty macabre manner. The method was deliberate. As he himself put it, 'The plays were written to suit the stiffness of the actors.'[3] His subject was piracy, heroic and villainous.

James Flaunty, or the Terror of the Western Seas was published in 1901.

[1] 13 January 1906. New York Public Library Manuscript Collection.
[2] Coll: the late Rt. Rev. T. A. Harvey, 18 January 1904.
[3] *The Mask*, July 1912.

This and *The Scourge of the Gulph* compromise in illustrating the characters as cardboard cut-outs set in their scenes – a manner adopted slightly later in the illustrations to *The Fancy* – but which do not expect any co-operation on the part of the reader. With James Flaunty, however, Yeats expresses the intention of producing future plays with loose scenes, and characters on sheets for cutting out, and mounting, and this was done with *The Treasure of the Garden.* He assisted with the colouring and other details too. In a letter to Elkin Mathews on 13 January 1903, he wrote, 'I send . . . 2 Flaunties coloured and the proscenium which is to go with the stage Baillie wanted'; and he continued to colour the publications in batches as Elkin Mathews asked for them. The playlet opens on the Coast of West Africa where some beachcombers are attacking the Shuler (or wanderer), William Pine. James Flaunty The Terror enters opportunely, and saves Pine's life at the point of a sword. With that Lieutenant Florry of his Majesty's Ship the *Cormorant*, approaches Flaunty and asks assistance in locating the *Spitting Devil*, vessel of the pirate Blackbear. Flaunty consents, though not to the joy of his betrothed, Nance McGowan, the daughter of the landlord of the 'Happy Return', who fears the rapine dexterity of the *Spitting Devil* Quicktraders. Flaunty reminds her, however, that his fee will act as a marriage portion to her father. An emissary of *Spitting Devil* now comes to him, in the person of Gillen, who persuades him that the pirates' cause is the more worthy one, asking him to trick the British brig into the pirates' hands. Pine overhears the treaty, and offers himself to Flaunty as henchman, asking only for a passage home [to Sligo] when the affair is through. The bid fails, and Flaunty is condemned to death for treachery; but at the last moment, Pine, remembering that his life means little to him now that there is no means of returning to Sligo, with the magnanimity of Carton claims responsibility for the deception and endures for Flaunty the capital sentence.

JBY always talked of Jack as the poet of the family, and he described *James Flaunty* as a 'most *poetical*' play; 'it assures for ever Jack's fame – and people will study that play as presenting the right model for all plays big and little.[1]

The Scourge of the Gulph of two years later concludes in irony. Joseph

[1] Letter to Lady Gregory, 7 May 1902. *Irish Renaissance*, p. 61.

Miles, once known as the Scourge of the Gulph, is discharged from the crew of *The Distant Land* for insulting La Lolita, the pirate captain's wife. The crew land on Savage Island to search for water, bearing La Lolita in a litter, but are captured by hostile natives; and when the bosun at last escapes, losing an arm, he brings a letter from the slain lady to say that she would like her skull to be buried in a box with silver bands on the Island of the Plumes. Captain Carricknagat sacrifices all in the attempt to fulfil his wife's wish. As they reach the Isle of the Plumes his last companion the bosun dies of black thirst. Joe Miles sees an opportunity for revenge, and believing the box to be full of treasure shoots the captain, only to find 'An empty skull, a black box, a dead skipper! Have I done anything or nothing?' The theme is expressed with a poetry and restraint equal to that in the earlier play. An idea of a similar nature was to be explored in a more realistic fashion twenty years afterwards in *Rattle*.

In *The Treasure of the Garden* Yeats comes nearer home, and looks for inspiration in family history, adding the tragic element. A pirate, Willie McGowan, renounces piracy – ''tis a horrid trade'. He returns to the 'Connaught' village where he was born, Poolthoia, a pseudonym for Rosses Point, as the illustrations with Ben Bulben's familiar bulk behind it indicate. McGowan spends three years at home sailing the *Gleaner* up and down the Western coast for a shipowner, Mr. Henderson, and having enjoyed it hitherto is now confronted with an unpleasant task, a voyage to America with a load of emigrants in a boat wholly unfit for the purpose. He will be paid well, and win Henderson's daughter if he goes; but the emigrants are bound to perish. McGowan refuses, Henderson sails away with his daughter. Scene two opens with McGowan digging in the garden, and finding the treasure that Henderson had seen as an omen of good luck in a dream. The scenery, to be pasted on to cardboard before it is used in the miniature theatre, leaves a space for a beam of moonlight coming through the colour, and lighting him as he rises with the crock. The play ends tragically for McGowan. The *Gleaner* capsizes. All escape, with the exception of Henderson, who slips as he steps off the yawl on to the shore, cracking his skull on a rock, and his daughter Jess, who throws herself into the waves as the *Gleaner* goes down. McGowan's fortune means nothing to him. There is the element of inconsequence typical of the artist's writings in the 1930s.

Yeats, in these small works, was carrying Walter Crane's *fin de siècle* fairy tales one stage further. He continued the Pollock tradition, and introduced his individual and stylistic illustration; but his pounding poetic lines have a personal quality which counteracts popularity. His references to Carricknagat, to the name McGowan – his own pseudonym[1] – and to Gillen – where he combined the florid forename 'Eldorado' with the family name of the pilot so closely associated with the Yeatses in Sligo, and his inclusion of Irish ballad sheets in surroundings to which they were utterly foreign, must have afforded him great personal pleasure, just as the oblique references to Sligo were important to him.

The whole sentiment of the plays 'in the old manner' is built about Yeats's home district, but these allusions are too privately introduced. It is as though the miniature plays were a form of personal release while the watercolour was insubstantial as a creative channel for the artist.

Cottie took an interest and made some figures for the miniature theatre. A photograph of about 1906 in Jack Yeats's scrap-book of the Valley performances shows characters in a play of Mrs. Jack's, which it states, was never played. WB, however, when he received Gordon Craig's model stage with which to plan Abbey productions to Craig's theory, enlisted Cottie's not Jack's assistance; and he wrote to thank her for the little figures which, he said, made the whole scene look different. He experimented with 'the effect of shadows of figures on a wall in a stage scene; . . . I wrote the result to Craig, who is delighted, and is going to use that effect in his great performance of Hamlet in Moscow'.[2]

Craig wrote to Jack Yeats about his miniature theatre in 1912, and asked him for an article on it for *The Mask*. 'It is curious,' he said, 'that we have never met and that I have never seen your theatre at work, for I should have been a good audience –'. He hoped to show Yeats his own little theatre, on which he moved his screens; but Yeats never went abroad after this, and the suggestion came to nothing.[3] He also asked Jack Yeats for his opinion on the effect of his screens in the Abbey Theatre pro-

[1] See p. 96.

[2] Unpublished letter 28 April 1910. Coll: the artist's estate.

[3] Unpublished letter 12 March 1912. The artist's estate. The two artists had corresponded briefly in 1900 about Craig's publication *The Bookplate* – this before Craig was acquainted with WB, but Jack Yeats was never as closely associated with Craig as his brother was. See also *Studies*, Summer/Autumn 1977, pp. 198-200.

ductions, but Yeats was non-committal, the screen 'seemed natural' to him.

His one debt to Craig appears in his design for the backcloth of *The King's Threshold*, when it was produced in the Abbey, in 1913. He attempted the austerity demanded by the latter with a landscape sketch using the bare essentials of mountain and moor, in fundamental colours. He had a further connection with *The Mask*, in 1925, when he was invited to submit an opinion to a symposium seeking to interpret a drawing by Antonio San Gallo the younger for a 'revolving triangular scene'; but he was as much at sea in offering an explanation as his fellow deliberators were.

The interest in theatrical prints combined with an enjoyment of nineteenth-century ballad sheets printed both in Ireland and England. Oral tradition had sought a wider audience in roughly printed songs, distributed not by the composer, but by a ballad singer travelling the countryside; and Yeats knew these performers well, from Sligo and the West, moving about with their fluttering sheafs of printed paper. Many of these broadsheets were issued by a Dublin printer, P. Brereton, decorated with interesting old woodcuts, sometimes surviving from the eighteenth century; and they found their way into Yeats's collection, together with some Belfast and Liverpool printings of popular ballads. Out of these grew *A Broadsheet*, produced by Yeats, at first with the help of Pamela Coleman Smith.

The young American illustrator, Pamela Coleman Smith, had been caught up in the tail end of the decorative wave, and was greatly under the influence of Walter Crane. She left Jamaica in 1899, and came to London, when she called on the Yeats family in Bedford Park. The following year, in the summer of 1900, she stayed with Jack and Cottie at Snails Castle, and enjoyed their performances of the miniature theatre, just as they must have approved of her telling of Jamaican folk stories for children. She had illustrated several art printings of nursery tales. Her style is distinctive, though rather conventional. She was impressionable, and gradually adopted several of Jack Yeats's ideas.

The first issue of *A Broadsheet* was published in January 1902. The pictures were hand-coloured by Pamela Coleman Smith and Jack Yeats. Traditional ballads and original poems with a folk or fairy flavour, by

writers such as WB, Lady Gregory, Professor Powell, AE, John Mase-
field, and Wilfred Wilson Gibson, were issued on a large sheet with
illustrations or independent drawings, in romantic linear style, curvilinear
with frills and strong outlines, by Pixie Smith, or rugged and rectilinear,
with strong shade contrasts, by Jack Yeats. Masefield's poems were per-
fect for Yeats, colourful and racy, sea songs and tales of fever and slime;
York Powell provided translations from the Irish, French and Danish,
and AE 'Babylon', and an excerpt from his play *Deirdre*: and Irish bal-
lads included 'The County of Mayo', translated by George Fox, 'The
Grand Conversation under the Rose', later to be the theme of an
important picture by Yeats, and 'The Peeler and the Goat'. It was a
successful achievement. The hand-colouring proved an onerous under-
taking, however, and the publication ran for only twenty-four numbers.
In January 1903 Jack Yeats wrote to Elkin Mathews rather sadly:

I received a letter from Miss Pamela Smith yesterday saying she thought it best
to withdraw from the Broadsheet. So I will have to go on myself. . . .

 I have put with pictures by *Jack B. Yeats & others* because I will try and get
an odd drawing here & there when I can. I think Miss Pamela is tired really of
the Broadsheet, there is too much colouring for her fancy, & she always has so
many 'irons' in the fire that she never can do the colouring with any comfort to
herself. But I will regret her drawings very much.[1]

On 20 March, obviously in response to an appeal by Mathews he prom-
ised to keep down the block expenses, the blocks for April should not be
more than six or seven shillings: but it was a costly venture, and this,
with the pressure of other work, brought *A Broadsheet* to an end at the
end of 1903. The final number represented all sides of folk culture in the
British Isles – a Christmas sea-chanty by Masefield, and Irish translation
by Kuno Meyer, 'Morgan le Fay, and the Wolf Hound', by the Welsh
Ernest Rhys, and an extract from the Christmas Mummers Play, per-
haps the Leicestershire version – all illustrated with sensitivity and gusto
by Jack Yeats.

 The move of the Misses Yeats to Dublin not only gave Jack B. Yeats
further opportunity to unite the visual with the spoken word, in his
illustrations for the Cuala Press, but it extended his field for design.

[1] National Library of Ireland MS. 4558.

When Mrs. Yeats died it was decided to leave the house in Bedford Park, and to return to Dublin, as was done in 1902; Lily and Lolly settled with their father in Dundrum, just outside Dublin, and they joined Evelyn Gleeson at the Dun Emer Guild, which was established to encourage handcrafts: Lily Yeats was in charge of embroidery, and Elizabeth, with a hand-press, an eighteenth-century fount, and linen paper produced at Saggart, began to publish books in limited editions by Irish writers.

Jack and Cottie were asked to design banners for the new cathedral at Loughrea. They are strong anonymous figures, wearing Old Irish dress and Celtic ornaments, with their symbols indicating their identity; the colouring is rich, with thick black outlines stretching into pools of shadows and with vigorous movement in the folds of the garments. All are silhouetted against a pale gold ground. They are embroidered in silk and wool thread, the needlework background being done by the girl embroideresses at Dun Emer, and the figures by Lily Yeats herself. St. Ita was the first to be worked, in the summer of 1903.[1]

About 1902 Jack B. Yeats was designing comic postcards of horse and jockey for a firm of printers in Vienna. His ingenuity found expression too in bookplates, of which he designed several, and in bookmarks, delightful cut-outs, probably never reproduced, illustrated on both sides. Some examples dating from 1906 and 1907 give the Pirate full sway, and bring alive characters from the novels of Dickens.[2]

[1] These banners have been carefully preserved at Loughrea, and are still used on the first and second Sundays of each month. Cottie (MCY) also did designs for Cuala embroidery.
[2] Coll: Terence de Vere White.

Chapter 7
T. A. Harvey and John Masefield

Yeats's friend T. A. Harvey was ordained in 1903, and went to a curacy at St. Stephen's Church, in Dublin. Yeats's letters to him[1] convey the artist's personality perfectly. Graphic sketches illustrate all of his colourful stories and anecdotes, a practice he unfortunately abandoned in later years. He described the books he was reading, 'Old Man Walt Whitman as a pillow book' – he did not take Whitman seriously – and Maryatt; and *Tom Cringle's Log* by Michael Scot, which was a masterpiece.

It's all about Jamaica and the Gulph of Mexico – and is a particularly Bully book – it's full of sudden death and roaring robust humour – its date is about 1810.

Michael Scot was in the West Indies gathering impressions from 1810 on and the result was the *Log*,[2] first published in book form in Paris in 1836. It is full of humorous anecdotes.

What do you think of a man getting stung in the nose by a scorpion in the middle of the night and waking every one else up, to make a poultice for his nose, – and when the poultice was made and fixed, and all had again sunk on their couches, he made such fearful smothered groans in his sleep that some inventive Spaniard shoved a small hollow bamboo right through the poultice onto his mouth so that he could snore through it comfortably – but it made him 'look like a sick snipe'.

[1] Written between 1903 and 1909. Coll: the late Rt. Rev. T. A. Harvey.
[2] The book began as a series of sketches in *Blackwood's Magazine* from 1829 until 1833.

On 4 October 1903, he wrote to Harvey from London describing one of the tales he heard on the Sligo Quays that summer:

One man gave me a really most vivid account of when he was in the American navy taking a Southern fort. – he told among other things how before they went ashore they were told, if they saw a bottle of whisky or a ten dollar gold piece or a pound of tobacco lying on the ground, not to touch it for it would be attached to a mine which would blow them all up. I dare say some thirsty souls wouldn't care so long as they got one good swig at the whisky while in the air.

(A sketch shows a shattered man fifty feet up into the air taking one last long glorious draught.) In another letter he describes how he sat in the pilot's watchhouse at Rosses Point with William Gillen, and McGowan and 'Time Enough' Bruen, who while they talked of shipwreck and fights with 'Billyingpins' and 'cutlass fish on the Merrican Coast' smoked thick manilla cheroots that smelt like burning oakum. '"Time Enough" was called so because "Hurry Out" won the Race'. His amused shock at hearing that Miss Beauchamp, the naïve Gregory cousin, was not to trouble herself about Harvey's matrimonial plans because he had 'a nice black Persian' gave rise to a cosy sketch of Harvey comfortably ensconced at one side of the fire, smoking a hookah pipe, with his beturbaned, beveiled, betrousered spouse on the opposite side of the hearth; but the Persian turned out to be a cat.

Harvey came to Strete, to stay, in September 1904, and in October Yeats wrote to him from Killybegs where he and Cottie had put up at Roger's Hotel.

Killybegs is a delightful little land locked bay. Yesterday was as hot as June and so we got a little boat full of the corpses of the dead and 'gone' fishes and rowed around.

There were 'Saxons' staying there too. Yeats sketched from the window and went for long walks to draw, enjoying the country, all full of 'twistey little corners. Not great expanses like Connemara'.

He and Harvey saw some boxing at Wonderland when they were both in London in February 1903, Harvey penetrating this doubtful area with a slight loathing and more than a slight shuddering and fear for their lives. Yeats, more used to such an atmosphere, was at ease. A great Jew,

in a white shirt, with diamond studs and cuff links, presided, as young men from Camberwell and Earl's Court fought in an easy-going, friendly fashion, shaking hands before and after the battle. Yeats was sketching the grubby audience and the muscular combatants with equal concentration and Harvey observed his delight in the formality and the colourful ritual. Boxing, he said, was the only good thing Yeats got out of England. Almost any aspect of an active or sporting life was turned to subject-matter for Jack B. Yeats. He described in one letter how he walked most of the way there and back to see a point-to-point twenty miles from Strete, on a day of snow. He relaxed with croquet and billiards; and golf was taken up later, he and Cottie playing in Devon:

. . . the ball has a tendency to curve outwards like a boomerang. I suppose a ball never actually came back and hit the man who hit it. The hitter, however, can always lie flat on the ground having delivered his shot – and remain flat until the ball subsides.

Golf was permissible he thought, though it had caused injury indirectly to Rosses Point, to him 'the finest place in all the world'.

Mind you I dont object to golf or any good game only its a pity they have to play it on lovely green lands beside the sea. I am sorry it can't be played in a brickfield.

Rosses Point, where he used to wander, was now 'a smiting-off place for the surplus female population of Sligo'. He had a great aversion to tourists too and longed for some 'untourist trampled place, very close to the sea, where a chap could bathe and sail toy boats and sketch.' He had given some thought to the problem.

An awful drove of tourists go through parts of Connemara . . . but one thing is good they are very frightened all the time. I think every summer there ought to be a scare in the Yellow Papers.

LAST BUFF.

STRANGE DISAPPEARANCE OF TWO TOURISTS IN CONNEMARA –
HOTEL PROPRIETOR ARRESTED TRYING TO DISPOSE OF THEIR
RETURN TICKETS.

GHOULS

SEIZURE OF GHASTLY BAIT IN LOBSTER POTS

Other friends of Yeats were Ralph Hodgson and Harry Hall, the arche-ologist. Harry Hall had artistic forbears: his father was the official artist of the Parnell Commission, and his grandfather was an artist too. He and his German friend, a lawyer named Alf Steubel, described themselves as 'the Globe trotter and the German student with the green knapsack', and kept in touch from the various parts of the world they visited, sending

Greetings to the Painter-Man woning far by West
At Strete by Dertemouthe is he as I guess, & to the Painter-woman,
the Fenian Hooley & the cat.[1]

With the poet John Masefield Yeats built up a juvenile drama of the high seas and piracy that Masefield incorporated into his poetry, Yeats used for illustrative purposes, and later employed as subject-matter for some of his finest oils. John Masefield, a younger man than Yeats, from the beginning had shared the same enthusiasm. He grew up in the coun-try, on the border of Herefordshire and Worcestershire, beside the canal, which brought the sea and its marvels to him. The Ledbury hounds passed by each season. Small circuses announced themselves with the magnificent procession into town, and then left with the laying low of the Big Top. He knew the old mail coach, the October Fair in Ledbury for hiring, and local sports, the boxing booth, Aunt Sally, and little theatrical groups acting plays of an earlier time – it was a tumult of noise and deck-ings 'to make the heart lilt'. Mummers and their Christmas plays were one of his loves. Perhaps not unnaturally he had grown up on *Punch*.[2]

Some stories say that Jack Yeats spent seven years at sea, learning a sailor's life and sailor's jargon; but he gathered his intimate knowledge of marine terms from the sailors at Rosses' Point, and from Masefield. Masefield had been to sea. He joined a ship at thirteen. Afterwards, as a writer, he lived for some time at a Sailors' Home in Greenwich: he was well read in the fiction of mariners, in old books of seamanship, in authentic accounts of famous voyages, in records of seamanship. In August 1911 he listed the ballads in the *Sailor's Garland* for Yeats, what was genuinely traditional and what was from his own hand in so far as he had adjusted certain stanzas and phrases – this for the purpose of

[1] Harry Hall to Jack Yeats, *c.* 1905. The artist's estate.
[2] *Grace before Ploughing*, 1966.

tracking down the pirate publishers who would rearrange the anthology and publish it as their own work.

After his experiences as a sailor, Masefield spent some years tramping in the Americas, and in England. Masefield was a poet of the people, and thoroughly English. He was interested too in painting, and organized two exhibitions of British painting at Wolverhampton in 1902, and at Bradford, for the opening of the Art Gallery in 1903. With Yeats he shared an enjoyment in a vigorous life of every aspect, a delight in story-telling. His complete lack of self-consciousness and of self-criticism ran perhaps to excess. WB later denied Masefield's critical capacity to Jack, saying he distrusted it because Masefield was surrounded by 'such a crew of female economists and emotional journalists', and that living with his inferiors must surely weaken his powers of judgement;[1] but in these early days painter and poet were fresh in their unaffected spontaneity and their matter-of-fact joy in the picturesque whether it was verbal or visual. Masefield regarded himself primarily as a storyteller; and it was his love of stories that first impelled him to write.

Yeats of course collected books and probably knew *Tom Spring's Life in London* and *Sporting Chronicle*, of the early 1840s and *The New Book of Fox Hunting*, of 1807, which found their way into his library, before he met Masefield. These yielded historical accounts of life at sea, racing, hunting and pugilism; but Masefield had first-hand knowledge of a mariner's existence. The writer described by Rothenstein in 1902, as 'a quiet youth, with eyes surprised at the sight of the world, and hair that stood up behind like a cockatoo's feathers'[2] – Jack Yeats caught this impression exactly in his watercolour portrait – was known to the artist in 1902, and they may have met in London, or at Coole Park. Masefield was writing for *A Broadsheet* at this time; and 'The Tarry Buccaneer', describing the ideal romantic pirate a boy wishes to be, in *Salt-Water Ballads*, is dedicated to Jack Yeats.[3] They are pounding lusty songs, from the mouths of salt-soaked sailors, descriptions of shipwreck and burial parties, of yellow fever and green water, all seamen's yarns in dialect, elucidated by a glossary; and with the picture of Hell's pavement and

[1] Undated letter, *c*. 1913. Coll: the artist's estate.
[2] *Men and Memories*, 1931, p. 373.
[3] As is Masefield's book of old-time sea life, *On the Spanish Main* (1906).

the forbidden paradise of the shore there are glimpses of the homesick longing in a sailor's heart as he hears a familiar strain in an inn as he passes by. *Ballads*, of the following year (1903), sing of Spanish waters and buccaneers, the clank of gallow chain, the merry chink of brimming glasses, the pluck of fiddle string and the wash of green tossing sea.

Masefield visited the Yeatses at Snails Castle in April 1903, and saw a schooner and some carved figureheads at Teignmouth, and a barquentine at Frogmore. Later discussions arose over types of craft: 'When I went across in the Dolphin' wrote Masefield to Yeats[1]

I passed under the stem of the old hulk, and I take back all I said of her having been a frigate. She is a slab sided, fir-built, ugly model, with nothing much to recommend her; yet I feel sure that her masts were once in the navy. You should go aboard and look for the broad arrow on them. She must have had a lot of men in her at one time and another. One never sees an old ship without thinking that, and wishing that one had art-magic, to make her talk about them.

Yeats's sketchbooks and Masefield's *Ballads* lament the greed of man which had ruined Haul Sands. Sir John Jackson removed a natural breakwater and so aided the sea in its destruction of the shore and of a cottage near the brink. Masefield while at Cashlauna Shelmiddy also heard many old tales from the Slapton fishermen and the boatmen of the Ley.

Their main pastime, however, was the construction of toy boats and sailing them on the Gara stream behind Cashlauna Shelmiddy. Jack Yeats sent for a model schooner to Galway, which arrived in a large crate looking 'like a canary bird in a cage'.[2] He was very anxious to find out the history of the river on which they sailed their vessels, some map which might mark it, and Masefield in his researches could find only the Lee, on a map of 1765. He found a sixteenth-century map with a 'deep nick' in the coast, and a map of 1680 with a 'crick' curving inland. 'An old book of voyage speaks of "The Dart Mouth and Goutster". Perhaps that is the Gara.'

Some of the toy boats were built from wooden boxes – one in *Jim Davis* called 'The Snail', and consisting of a window box, recalls the days

[1] 2 December 1907.　　[2] Letter to J. M. Synge, 15 July 1905. Synge Estate.

at Strete. Jack Yeats described the vessels of their construction some years later in *A Little Fleet* (1909).[1] 'The Monte', a fore-and-aft schooner, was built from a flat piece of wood about five inches long, with two masts of thin wood and paper sails. She foundered on a nasty rock after a difficult time in currents and shallows. 'The Moby Dick', supposedly a Mississippi steamboat, was built of a flat piece of board and measured about fourteen inches by six. A cardboard box formed a cabin, and a cocoa-tin inside provided a fire with smoke pouring up out of a cardboard funnel. She was the first vessel to sail through the Two Snags Passage, but in her second voyage she came to an end through an accident with her anchor. The most handsome ship in the fleet was 'The New Corinthian', made of a toy lifeboat with a lead keel fastened on; but 'The Theodore' (the fireship), a long cardboard box with lines of ink painted on her, which perished in flames after a heroic and long lasting voyage, and 'The Pasear', a top-sail schooner, built from a bright green cardboard tie box with a lid and a ballast of stones within, excelled in lengthy trials, each travelling for about a mile. Long light sticks were used at various points on the stream to steer the ships around dangerous corners through narrow and difficult channels; the chart in *A Little Fleet* shows the perils with which the voyage confronted them, starting in the north with No Name Straits, Blackwall Hitch and Marbley Shallows, then south through Two Snags and Pirate Leap, veering to starboard at Bad Snags, by Desolate Deadman's Teeth, through Twisty Straits, and then north again towards Huckleberry Cove. It was a highly imaginative pursuit. 'The Theodore', the 'Monte' and the 'Pasear' survive in illustration in *A Broadside* for August 1913, with the poem 'The Gara River', by Wolfe Tone MacGowan.

Jack Yeats wrote to Harvey on 18 February 1906, to say

I have a pond in the corner of the orchard now, and when Masefield was here in the New Year we slaughtered a ship 'The Theo' with revolver shots. When we were done with her I tell you she looked used up.

[1] He considered *A Little Fleet* as a book for boys, suggesting to Elkin Mathews (6 December 1910) that review copies be sent to *Chums*, *The Boys Own Paper*, and perhaps some school magazines in the larger schools. He also mentions the magazines published on the *Worcester* and *Conway* training ships. (National Library of Ireland MS. 4558.)

And he told Synge that they had 'sailed cardboard boats to destruction' on the pond and on some flooded marshes.[1] Much of the thrill came from bombarding the models. Masefield provided little brass cannons with the cheque from 'Hall Sands', and Yeats the powder and the balls to which they subjected the objects constructed with cardboard and string and sticks and created events.

Yeats continued to make toy ships for years afterwards, photographs and drawings exist of objects made from matchboxes, corks, straw, even a banana skin, and so on, up until about 1928. In *Sligo*, he writes enthusiastically about tin-can racing on a sandy shore with a gale of wind. He practised making folding boats, from paper and cardboard, assembled with matchsticks fastening certain points, and with details painted on. In his article of September 1936, 'Beach-made models',[2] he admits that the more perfect the model, the less likely she is to survive the seas in perfection, and he favours disposable craft that can yet sail the sea 'like a bird that's bred among the Helicons'. He said that there were always in his pockets three chalks, black, blue and red, to colour yards and to write the names on ships; and for the sails he had the leaves of his sketchbook. His ships 'rose to the swelling of the voiceful sea'. The drawings are delicate and lovely, and all of the slight constructions made from very mundane matter, in these sketches, have dignity. He used the toy boats as subjects for late paintings, such as 'The Launching' (1945); and the slight-seeming, but sympathetic, subject-matter was the foundation for works of strong imaginative content.

A character who came into being through Yeats's friendship with Masefield was Theodore the buccaneer. He appears in countless places: in *A Broadsheet* and *A Broadside*. He gives his name to one of the toy boats, he forms a frontispiece for Masefield's *A Mainsail Haul*; and a whole myth is built up around the willowy effeminate stripling with his amour, Constanza. 'The Alphabet of Piracy'[3] shows 'Theodore on the Pebbly Beach' in suitable high-heeled boots and sash, looking down his nose with typical naïve arrogance. According to Masefield

[1] 4 February 1906, Synge Estate. [2] *London Mercury* pp. 425–7.
[3] The artist's estate, dated October 1904.

A bloody trade the pirate's trade is.
 But Theodore
 Though dripping gore,
Was always courteous to the ladies.[1]

This poem was illustrated by Cottie; but Theo became very much a protegé of Jack Yeats's and a splendid series of drawings dating from the latter part of 1906, or from 1907, show Theo's adventures from infancy, as he sits on his grandmother's knee and hears the tale of Barley Sugar Island, and then graduates to the knee of Uncle Ben. 'Theo the Terrible' on one occasion 'escapes from the crew so's to do a little mending on his laced nightie.' He steals the key of Constanza's room, tries on her corsets, and admires the effect of her comb and her flower in his hair. In a moment of penury he pops her jewels with 'Fanny Fence'. Whether he rues it is not revealed. Certainly a barber regrets the day that he makes a mistake in cutting Theo's elegant hair. They are delightful inimitable sketches in indian ink, with light touches of wash. At one point Theo finds himself being fired through the barrel of a cannon.[2] Theodore became the henchman of a historical character, who was revived from the romance of Ingraham – Jean Lafitte, the heroic, proud and moody pirate captain, also represented, though as a secondary character, by Yeats. Lafitte's death was a mystery. Masefield did some research on this. In an undated letter, he told how he had come upon an account of Lafitte's death in Honduras. 'They broke up his establishment at New Orleans; he sailed to Honduras; died there in penury and was eaten by the local pigs.' Theodore survived into honorable old age. He is shown in *A Broadside*, for January 1909, talking to his grandson:

Rum, red rum is my delight,
It makes my old hulk water tight.

Jack Yeats had long been an admirer of Reynolds' verse. His drawing of a boxer illustrating 'Molesley Hurst', by Reynolds, in *A Garland* of 1895, captures the atmosphere of pugilism in the early nineteenth century to a nicety. Then he became interested in *The Fancy*. There was some ques-

[1] *A Broadsheet*, 1903.
[2] In a diary for 1906, with entries in the early pages by Lily Yeats; which suggests these were done late 1906 or early 1907. Coll: Dr. Monk Gibbon.

tion as to whether it was by Reynolds or not since it was published under the pseudonym Peter Corcoran. He wrote to Elkin Mathews from Cashlauna Shelmiddy on 20 March 1903, just after he had returned from a visit to London saying,

I did call with 'The Fancy' but you were out. And it was my last day so I couldn't call again. However I will bring the little book next time I come up to town . . . oh yes it was Reynold [*sic*] who wrote the book evidently – I went to the library and looked this up as you suggested.[1]

He was working on *The Fancy* six months later when he illustrated 'The sonnet on the Nonpareil', in *A Broadsheet* of September 1903. He persuaded Masefield to edit it, and they brought out an illustrated volume of *The Fancy* in 1906.

The poems, purporting to be those of 'Peter Corcoran', were John Hamilton Reynolds's swan song to the wild life as he spurned it for a more respectable way of life. The young English poet, friend of Hunt and Keats, whose strength lay in his satire of Wordsworth, had been a keen young blood of his day, but must now devote himself to the law. 'Fancy', as he saw it allegorically, was 'life preserved in spirit'. He put it bluntly:

Fancy's a term for every blackguardism—
A term for favourite men, and favourite cocks—
A term for gentlemen who make a schism
Without the lobby, or within the box—
For the best rogues of polish'd vulgarism,
For those who deal in scientific knocks—
For bull-dog breeders, badger baiters – all
Who live in gin and jail, or not at all.[2]

Masefield's description of the gigs and coaches drawn up in the field, the Jews, the Gypsies and the flash coves, the green turf and the white-roped square, the members of the group, 'The Fancy', chewing straws and consorting in small cliques, and the approach accompanied by music

[1] National Library of Ireland MS. 4558.
[2] *The Fancy*, p. 58, by John Hamilton Reynolds. With a prefatory memoir and notes by John Masefield and 13 illustrations by Jack B. Yeats. London, Elkin Mathews, 1906.

of the two champions, swathed in rugs and sucking oranges, explains the attraction of the old-fashioned verses, which were revived as Pierce Egan's early books of life in London of the same date had recently been. 'Then comes the heart-stirring moment,' wrote Masefield,

when the gipsies beat back the mob from the ring-ropes with their whips. The principals toss their hats into the ring and jump over the ropes, and spin a silver crown for the choice of corners. Then the two men peel, aided by their seconds, amid a gabble of chaff and heavy betting. Ah! it was life to see the two athletes advancing to the scratch, while the ring became hushed, and the ear heard the time-keeper's watch tick. And to see the muscles playing under the white, tense skin, and the sparring for a lead, and the eyes of the fighters bright and eager. 'And then,' as Reynolds says, 'the fight'. It was life indeed, but it was something more. It was, as Hazlitt tells us, 'the high and heroic state of man.'

Yeats's illustrations to the text, thirteen in number, are mostly un-characteristic of his style, except for the portrait of Corcoran, romantic, with curly black hair, long narrow face, lying in bed in his last hours, penning the verses, with the boxing repartee framed in scenes on his wall, boxing gloves lying on the Regency mantelshelf. He deliberately adopted an old-fashioned manner, complementary to the poet.[1] The illustrations to the playlet, *King Tims the First*, represent scenes from juvenile cut-out plays, melodramatic figures posing on a stage in front of outlined cardboard trees and bushes. Darker, romantic scenes in strong black outline and shading illustrate the poems: plump bemuslined Bessy cavorting home with her amour, Kate dealing coldly with her lover after a casual fight he now regrets, the puglist alone in his corner of the ring, basking for a moment in the tension and excitement of the audience about him, the young swell hearing the church bells doubly sweet in his ears as he makes his way home after a sparring match at the Fives-Court: all examples deliberately recall the early Victorian wood block, with a subtle emphasis on individual mannerisms.

[1] His painting of 1935, 'About to write a letter', seems to refer directly to his images of Corcoran. See *Irish Arts Review*, Spring 1985, pp. 46-47.

Chapter 8
John Quinn and America

Yeats's best illustrations were those he did for the Irish writer, J. M. Synge, at the instigation of Masefield. But first he paid a visit to America at the behest of a friend and patron.

John Quinn the Irish-American barrister was prompted to come to Ireland after reading about Jack Yeats's pictures, and about Hugh Lane's exhibition of paintings by Hone and JBY, in 1901. He became an important patron of Irish literature and art. His first trip to Europe was paid in the summer of 1902, when he visited the Yeatses in Bedford Park. Jack who was there took him in hand, and showed him the sights of London. JBY regarded him as 'the nearest approach to an angel'.[1] He commissioned several portraits from him; and at Jack Yeats's exhibition in Dublin in August he bought eight pictures outright, as a beginning.

Then with the latter he went to the Raftery Feis at Killeeneen, in County Galway, travelling from Dublin, through Mullingar to Athenry, and at Athenry taking a side-car. Raftery the Irish poet had been buried at Killeeneen early in the previous century; Lady Gregory now placed a headstone on his grave.

The road was busy with some hundred side-cars and other vehicles, people walking, throwing greetings at the American as he passed – 'a pleasant journey to you!'[2] Five or six hundred people gathered for the ceremony. From the audience WB, Jack Yeats and Quinn watched the performers mount the raised platform where Douglas Hyde, Edward Martyn and Lady Gregory sat beneath the green banner with Raftery's

[1] *Letters*, p. 731. [2] *The Outlook*, 16 December 1911, pp. 916–19.

image on it: local people competed for prizes in Irish singing, reciting of poems, for storytelling in the Irish tongue, for dancing, flute playing and fiddling. One old man had to be persuaded to go up and speak. He had been present at Raftery's death. He spoke in Irish, gesticulating with a blackthorn stick. The feis continued until after nightfall, when Lady Gregory and her friends climbed on to two side-cars, and travelled to Coole in the dark night.

Jack Yeats used Raftery as a subject for the September *Broadsheet*, in an illustration to Lady Gregory's translation of Raftery's 'Repentance'. Yeats sees him raising up his supplication in his native surroundings, sitting on the graveyard wall.

The following year Yeats was busy with *A Broadsheet*, and his plays. He spent February and some of March in London with his exhibition. In August he was in Dublin. Afterwards he went to Coole, where he attended a Feis, and sketched a sports meeting where 'every bush was a dressing tent'. He made various studies of the Barrel man, who, in the country game was assailed with sticks by those about him, his only protection being the barrel into which he could duck. This was the subject of one of his late poetic paintings, 'Humanity's Alibi'.

The most notable event of the winter of 1903 was a visit to the Shipping Exhibition in London, where there were models of schooners, venerable broadsheets, and a Dutch ship of the late seventeenth century.

Then through John Quinn came the opportunity to go to America. WB wrote from New York, where he was on a lecture tour, delighted at seeing Quinn's rooms lined with Jack's and JBY's pictures. Quinn now suggested an exhibition by Jack. It was to take place at the Clausen Gallery, in New York in March and April and Jack and Cottie were to be present.

Bishop Harvey has described Jack Yeats at this time as a tall untidy figure, dressed in loose clothes, and wearing a nonchalantly-fastened tie, a rough frieze coat, a broad-brimmed hat and a Claddagh ring. He walked with a rolling gait, and proceeded along the street always with a picture or a drawing pad in his hand, sometimes passing his friends by without noticing them, because his mind was on other things. An early studio photograph shows him in a loose tall collar smoking a cigar and ruminat-

ing. Another has caught a typically wistful look, which is evident in J. B. Yeats's early portrait, and appears in most good likenesses throughout the years. Yeats was gentle and kind, simple, unaffected, shy and genial, a lovable character, according to anyone who knew him. Cottie was as gentle as he. She always wore big stone earrings and Celtic brooches with large stones. The two had a flair for leading an unordinary life. Yeats loved animals and could not bear to see a woman adorning herself with furs and feathers. Mrs. Harvey took off a fur wrap and hid it behind her back one day when she met him unexpectedly – she felt confused and embarrassed.

The artist's strong sense of humour could be whimsical or macabre, appearing almost cruel, were it not for his deep sense of humanity. It blended with a childlike love of slapstick comedy. Once when he stayed with Bishop Harvey at Lissadell he said, 'I know I haven't the same sense of humour that other people have. Listen to this story. Two men were walking along a road and beside them lay a fence. One looked at the fence and said "Oh there's a hen." "That's not a hen," said the other, "That's an owl." "Oh," rejoined the other, "I don't care how owld it is." ' On another occasion he told a tale of the night watchman on the pier at Rosses' Point. A man fell into the water and called out for help as he was swept away. "Don't worry", called the watchman to the diminishing figure, "You'll be found all right in the morning; we'll collect you on the beach."

Jack and Cottie set out on the Mesaba in mid-March. Yeats found the sea trip well worthwhile, and gathered a good deal of material on the journey. The first officer came from the North of Ireland. Chief Engineer Robertson had been on the Atlantic for forty years, and had much to tell; all were full of information except for the Purser – a fat spectacled man, who gave away nothing. They passed by the Nantucket Light Ship, pitching in high seas. York Powell, hearing about the surprise trip from Pamela Coleman Smith at the last moment, wrote a hasty letter before they set out, and he impressed upon them that there was a fine collection of Japanese things in New York, and that Coney Island and the Bowery and Tiffanys must on no account be missed. He gave them the names of some American friends. Professor Powell was very ill at the time, with a heart disease, but in his warm-hearted fashion he was eager to make the visit memorable for the artist and his wife. 'I think in New York . . .

the river must be the best part,' he wrote again on 23 April, and he extolled the 'Chinkee' restaurant. He died six months later.

Yeats wandered about New York as he did wherever he was, noticing street signs and flags hanging above buildings. An appealing notice in the window of a deserted shop took his fancy: 'Having been fired out I am now located at No. 8 25th St. W.' Several times he saw a New York stenographer in an enormous spoon-bill hat. He rode in Central Park, and watched 'a squirrel with his forepaws on the man's necktie, and his hind paws on his chest, nipping a nut from the proud man's lips'.[1] In the Museum he was taken by a Matisse, and by a gold piano supported by gold mermen. He did several drawings of Brooklyn Bridge. He travelled on ferries to New Jersey, and to Ellis Island, where he took a great interest in the emigrants, Italian and Irish, walking down the gang-way from the ship, their gloved hands and the legs of their children being examined as they came down. 'I noticed no emigrant smiling at any time while going through the long inspection', he observed, in the monumental style of utterance reminiscent of his brother. Back in New York he explored 'the land of the Tooth Picks', walking about Mott, Park, Pell and Doyer Streets. A sketch of Pell Street is similar to the setting in the oil of 1943, 'The Belle of China Town', and 'Little Chinee in China Town', a back view of the little girl in blue trousers, long coat top, and brimmed hat decorated with roses – 'cheap 5¢ chip hat' – walking down a cobbled street, is the subject for that late painting. He thought about the subject a good deal, and in July 1905, when he was in Swinford with Synge, he did another sketch for it. Yeats dined at Chinese restaurants with Mrs. Jack, and visited a Chinese theatre, where he was interested to see that the heroine was acted by a man, that the hero was weeping, and that the villain was so indicated by the white spot on his nose. A Chinese man walked among the audience of oriental faces, and long pipes, bearing a tray on his head, laden with oranges, itself topped by a tray of matches, that again crowned by a tray of toothpicks and cigars: and finally surmounting all was a bowl of sugar cane.

Among other theatres that Jack Yeats visited was Knickerbocker Theatre – where the ice-box carried round by a negro was rather a novelty – and he found Forbes Robertson 'a middling dreary Hamlet'.

[1] *Sligo*, p. 140.

10 The mail car, early morning 1920 *11* A Shannon trader 1923

12 Communicating
with prisoners 1924

13 Portrait of Mrs Jack B. Yeats 1926 *14* The contortionist 1926

15 We are leaving you now 1928 *16* From Portacloy to Rathlin O'Beirne 1932

He attended the Vaudeville, and the Dewey. He saw the Cake Walk performed at Tony Pastor's music hall. He revelled in the Sicilian Marionettes at Brooklyn, and the Italian marionettes at Elizabeth street, which filled his mind with ideas for drawings. There was a cloaked drama with Roman soldiers and saracens and great fight scenes: 'fair-haired ladies and Knights and Saracens tromp and clash and bang and die in fighting heaps'.[1]

Besides Chinatown he visited the Jewish quarters and, as York Powell had insisted, the Bowery, where he enjoyed seeing Alligator Hotel – open day and night – and the Sign of the Green Teapot; and at Miner's he delighted in the patter. There was song about a lady who lost an eye, and who substituted it with a cat's one, with the result that –

One of her eyes would go to sleep
The other was all for rats.

A saloon belonging to Daniel O'Shea advertised the 'Strength & Purity' of its beer. The quays of New York were frequently sought out. There is a feeling of breadth in all of these diary sketches of the American visit, described rapidly, for the artist appears to have been deeply impressed by the space about him, and by the height of the ships and of the buildings.

He and Cottie travelled home on the *Celtic* seven weeks later, Yeats in splendid mood, with the experienced eye of a caricaturist jotting down lightly the idiosyncratic personages with whom he journeyed: 'Parson Morgan, the fancy preacher and his little freckled boy' and 'The Chemical Blonde, mother of the fearful child', the 'Man afraid of Detectives', 'Mish and Mishus Mish, a long lugubrious pair', 'The Australian Sheep Farmer on his first visit to England for forty years'; and the sing-songs in the saloon, where the listeners were deeply moved by 'drink to moi only with thoyne oyes. . . .' Then he became serious. On the horizon loomed the Irish coast.

The visit to New York was a disappointment as far as his exhibition was concerned. Some of his friends said that it came too closely on the heels of his brother's début in the States, and that it was not advertised widely enough. The artist sold only twelve pictures during the show, out

[1] *Sligo*, pp. 152–3.

of sixty-three that were on view, and ten of these were bought by Quinn. Quinn continued to buy his works for several years after this, but there were no other American champions. The trip, however, to a country which had been real to him through talk since boyhood, and which was only a step across the Atlantic from Sligo; setting his eyes in the flesh on the other Coney Island, on the Bowery '. . . a long Village where everybody knows everyone else',[1] and on 'the ringing harbour lights of New York'[2] was an unforgettable experience for him, of permanent value, and provided his imagination with a bottomless store from which to feed until the end of his painting and his writing life.

[1] *Sligo*, p. 13. [2] *Op. cit.*, p. 12.

Detail from *Barrow race*

Chapter 9
J. M. Synge

In December 1904, Masefield, who was working for the *Manchester Guardian*, suggested to Synge that he should write some articles on the Aran Islands for the paper. Synge decided instead to investigate the life of the people of Connemara and North Mayo, and he asked Yeats to come with him to illustrate them. They had often spent a day walking together and now they would have a whole month.

On the third of June 1905, Jack Yeats crossed from Holyhead to Dublin and met Synge, and they set out for Galway. Yeats said that Synge was the best companion for a roadway any one could have:

. . . always ready and always the same; a bold walker, up hill and down dale, in the hot sun and the pelting rain. I remember a deluge on the Erris Peninsula, where we lay among the sand hills and at his suggestion heaped sand upon ourselves to try and keep dry.

When we started on our journey, as the train steamed out of Dublin, Synge said: 'Now the elder of us two should be in command on this trip.' So we compared notes and I found that he was two months older than myself. So he was the boss and whenever it was a question whether we should take the road to the west or the road to the south, it was Synge who finally decided.[1]

They travelled from Galway along the coast to Spiddal, and there entered the Irish-speaking area of Connemara. Synge was in a position to converse with the inhabitants. They drove further west to Cashla Bay and Carraroe. 'It is remarkable that from Spiddal onward – that is, the whole of the most poverty-stricken district in Ireland – no one begs, even

[1] 'A letter about J. M. Synge', *Evening Sun* (NY), 20 July 1909.

in a roundabout way,' commented Synge in one article. They saw Annaghvaan, Lettermore and Gorumna, all islands connected by causeways to the mainland.

'Synge was fond of little children and animals': wrote Yeats.

I remember how glad he was to stop and lean on a wall in Gorumna and watch a woman in a field shearing a sheep. It was an old sheep and must have often been sheared before by the same hand, for the woman hardly held it; she just knelt beside it and snipped away. I remember the sheep raised its lean old head to look at the stranger, and the woman just put her hand on its cheek and gently pressed its head down on the grass again.

Synge was delighted with the narrow paths made of sods of grass along the newly metalled roads because he thought they had been put there to make soft going for the bare feet of little children. Children knew, I think, that he wished them well.[1]

They then took a ferry across to Dinish Island, listening to the ferryman relating a sad tale of poverty and circumstance, and this yielded a character study for illustration to the article.[2] They returned to Trawbaun village on the mainland, and afterwards they sailed north in a hooker. All the time the two men took note of the economic conditions about them: dress, employment, livestock; the 'relief works' on the roads, condemned by all who had to resort to them. Only one member of each family might be employed there, and how, many asked bitterly, can a man support a family on one shilling a day? Tiny cottages, some without windows, the stony soil, the sad lack of fishing boats, work on the bogs and in tiny fields: it would seem impossible for people to exist there.

Soon they were in North Mayo, the other 'congested district' of the West of Ireland, which Synge chose to investigate; they travelled for forty miles by long car from Ballina to Belmullet. Inhabitants of the Belmullet peninsula suffered in a different manner. It was too far from the sea to eke any living from kelp saving; and the men went regularly to Scotland and England for the harvests.

'Yet', Synge summed up,

the impression one gets of the whole life is not a gloomy one. Last night was St. John's Eve, and bonfires – a relic of Druidical rites – were lighted all over the country, the largest of all being placed in the town squares of Belmullet, where a

[1] *Evening Sun*, 1909.
[2] And also the late painting, 'Many ferries'. See *Eire-Ireland*, Summer 1983, pp. 30–34.

crowd of small boys shrieked and cheered and threw up firebrands for hours together.

Yeats remembered a little girl in the crowd, in an ecstasy of pleasure and dread, clutching Synge by the hand, and standing close in his shadow until the fiery games were done.

After Erris the two men travelled inland to West Mayo, where they found emigration to America an even worse problem at Swinford; and then they turned north to Charlestown. Spanish asses were seen regularly in these districts, and were not altogether satisfactory. They had been imported by the Congested Districts Board in the hopes of improving the breed already there.

The trip ended at Charlestown. Synge had definite ideas on the work the Congested Districts Board was achieving, and suggestions as to how the lot of the western people might be improved. They were an attractive and an interesting race, and both men's first feeling was one of dread that reform of their lot might lessen their individuality rather than improve their well being.

'Synge was always delighted to hear and remember any good phrase', wrote Yeats.

I remember his delight at the words of a local politician who told us how he became a Nationalist. 'I was', he said, plucking a book from the mantelpiece (I remember the book – it was *Paul and Virginia*) and clasping it to his breast – 'I was but a little child with my little book going to school, and by the house, then, I saw the agent. He took the unfortunate tenant and thrun him in the road, and I saw the man's wife come out crying and the agent's wife thrun her in the channel, and when I saw that, though I was but a child, I swore I'd be a Nationalist. I swore by heaven, and I swore by hell and all the rivers that run through them.[1]

Yeats was obviously delighted with the phrase too.

Yeats's illustrations to Synge's articles were very suitable. His strong, linear style depicting a noble if poverty-stricken race, a barren land, encompassed by an antagonistic sea, and the strange hard life working on the roads or building boats or saving kelp, concentrated on the wild uncompromising nature of the existence, describing people who had never known the comfort and well-being that most of the *Guardian* readers must have experienced. These are not the artist's best drawings.

[1] *Evening Sun*, 20 July 1909.

Space was not always happily used; and he seemed oblivious of what the effect of the proportions would be in reproduction. Synge wrote to MacKenna about the tour with mixed feelings. 'Jack Yeats . . . being a wiser man than I, made a better bargain, and though I had much the heavier job the dirty skunks paid him more than they paid me, and that's a thorn in my dignity.'[1]

The articles made a great impression on the editor of the *Guardian*, C. P. Scott, who asked Synge to provide more, and suggested 'Irish types', which would have been an admirable subject on which to work with Yeats. The two men discussed it, but it came to nothing. Yeats, however, accepted an invitation to do some drawings of 'Life in Manchester' – he had already provided some of London life besides the Synge illustrations – and in October he visited 'that old brown city again, with all overwork ideas by then thrown down the gully-hole of time' for a crowded colourful week.

Yeats came back from his tour with Synge and surveyed Greenwich with Masefield. Later he returned to Ireland with Cottie, and they stayed at Coole. WB must have been talking about the shades of Elizabeth ladies he had seen, because Masefield was disturbed, warning Jack Yeats, 'While I was there I had a continual feeling of something malignant and uncanny surrounding the house every night.'[2] Yeats's sketches of this year show no feeling of repulsion. He watched members of the house party strolling or reading by the lake, playing cricket or croquet, or sailing; he saw easels set up, a small boat moored at the bank, a fleet of geese in movement, a puppy tumbling on Cottie's heels. He must have remembered Masefield's letter as a trifle exaggerated.

The artist visited the feis at Galway in the company of John Quinn, who was in Ireland at the time. He was also in Castlebar and Leenane; and he paid the annual visit to Sligo, reaching further, to Killybegs and Strabane. In September he traced his steps to Dublin, enjoyed the Henry Street Waxworks: Marcus Antony 'who was assassinated in Rome in the year A.D. 77 by his friends: thousands have been heard to say he must be alive', and Captain Hiptree, the 'noted commander in the Turkish army. You will see blood flow from [his] wound.' He was out with his sisters at

[1] *Irish Renaissance* ed. R. Skelton, and D. R. Clark, 1966, p. 72.
[2] Unpublished letter 1 May 1905. The artist's estate.

Dundrum. In the city he noticed the ruses of the Dublin newsboy, again to be a regular subject for his paintings, and he went to hear John Dillon speak at the Gaelic League meeting at the Rotunda. Yeats was taking a keen interest in the turn of Irish politics at the time, and he was kept informed from home when he was in Devon by Lily, who sent him, among other things, the postcard of the Irish Language Procession at Smithfield in March 1905, and the following year that of Michael Davitt's funeral procession crossing O'Connell Bridge.

He was beginning to feel restless and told Quinn that he missed much of the joys of life through living in an alien country. Quinn was interested in his attitude to Irish politics and sent him a cutting about some hooligans from the South interfering at a Belfast funeral. Yeats did not believe that it was true, but thought it was propaganda, 'a cheerful kind of Unionist press-information-supply-association that sends little notes of news, imaginary outrages and such, to English papers (free).' But he told Quinn not to have such idealistic notions about Irishmen.

There are braggarts and fakirs here as everywhere else. In a word, or in a lot of words, Ireland consists of drunkards, murderers, thieves, humbugs, ex-police-men, Unionists – and honest men –

You ask what I think of the Sinn Féiners. Well, I don't think a great lot of a great many of the Sinn Féiners but I believe in the Sinn Féin 'idea'. I think its a good thing for its full of living ginger, and I do *not* believe in the new form of three water groggers. Stephen Gwan[1] began an article in an English paper which I saw. It was immediately after the Irish Council Bill had been refused at the meeting in Dublin. These were his beautiful words: 'This Bill seemed to *breathe* a *suggestion* of a *hint* of a *spirit* of distrust of the Irish people.' That's the sort of grease that won't fry anything very large.

Ireland consists of all sorts of people. In fact, it is a nation ready to start at any time – though I know that if we had Home Rule tomorrow, for many years there would be many queer things done, as there would be among any people who had had no hand in governing themselves since modern ways of governing became necessary.

. . . If I could live in my own country I would be interested in some kind of politics. But here in England it is so strange to listen to the people getting excited about things that I do not give a thrawneen about.[2]

[1] [*sic*] This would be Stephen Gwynn.
[2] 16 September 1907. New York Public Library. Manuscript Collection.

It may have been his association with Synge that was making Yeats so restless. He was illustrating for him once again. Synge's prose in *The Aran Islands* and in *In Wicklow, West Kerry and Connemara* was splendidly balanced by Yeats's visual description, attempting in pen and watercolour to do what Synge expressed in words and to depict the life of the people. He knew the Western life from living it himself and had not had to acquaint himself with it as Synge had had to do. He wrote to Synge about the illustrations to *The Aran Islands* thanking him for the photographs which he had found useful, and saying 'I have done several particularly Bully ones! I think though I say it that shouldn't. When I finished reading your manuscript – I was bothered to understand how you could leave such people.' He provided twelve illustrations in all.

Synge went to the islands several times in order to learn the language and become friendly with the people, who finally accepted him as one of themselves. He could play the fiddle for dancing at parties, and kept them informed from his newspaper missives about politics and foreign affairs. He found himself studying the form the social life of the people took, and the way they eked out an existence, and he had also a tremendous interest in the old folk tales and the verses the storytellers recited, the apparitions they had seen. Yeats never attempted to illustrate one of the folk tales. He never entered the level of fancy hoping to solidify it in a factual portrayal: he was much more interested in the people themselves, whom he had known on his own visits to the islands and illustrated with Synge's references to them in the narrative: the drunken man whom Synge employed by mistake in the darkness to carry his bags for him in Galway; the man in charge of the hooker importing cattle from Inishmaan, a man of power; the seanachaidhe who had been a pilot in his youth, and could wear as a symbol the typical pilot's cap. In 'An Island Man' the low horizon and the tall form against the sky is used to effect. The other drawings show the various activities of the islanders that Yeats had been in the habit of noting in his sketchbooks, kelp burning, thatching, evictions, the prolonged public-house evening with porter which to women islanders was a mystery and a persecution. There is a heroic dignity and romantic quality in the illustrations, as literal and matter-of-fact in their detail – such as pampooties and dress, the manner in which thatch roofs were tied down with rope – as Synge is in the text.

The life of the people is described objectively, and Yeats could do this as well as preserving the strange spirit of the ancient civilization that Synge underlined constantly through the book.

Jack Yeats would appear to have introduced Synge to melodrama when he took him to a performance at the Queen's Theatre in 1906. Melodrama was life's blood to Yeats, and not only coloured his plays for children, but affected his painting.

Yeats also advised Synge about the jockey costume for Christy Mahon in *The Playboy*,[1] again showing his more intimate knowledge of the West of Ireland scene. He described in a letter on 11 January 1907, three different styles of dress Synge might use, all with tweed or frieze trousers, one with a jacket made out of a land-league banner, and another with a football jersey and a white handkerchief around the neck, which he said was the costume 'the brave Muldoon', the famous jockey of the 1880s, used to wear.[2]

The following month, on 19 February, he wrote to Synge, now re-leased from 'the gore of fire', as he put it, to condole with him about the hostility his play had invited, and suggested that if he did not want to leave out 'the coloured language' he should station a drummer in the wings

to welt the drums every time the language gets too high for the stomachs of the audience. They used to do this in the old Music Hall.[3]

Synge told him an amusing story about the ordinary Dubliner's reaction to his play. The janitress of the theatre was scandalized at the use of the word 'shift'. She said she would not think of using such a word to herself. Then she strolled on to the stage and remarked to the carpenter, 'Isn't

[1] Yeats seems to have had little to do with the Abbey Theatre as such. He told Lady Gregory that he rarely sketched there because it was too dark. (Letter, 15 March 1909. New York Public Library, Berg Collection.) His brother did ask for scenery designs for *The Well of the Saints* [*Letters*, pp. 442, 444] in 1904, and the artist may have collaborated with Pamela Coleman Smith and be the 'another' mentioned in the programme. Again he designed the backcloth for *The King's Threshold* in 1913 and was later asked to retouch the mountain outline of a design by Monck or not as he saw fit. (Unpublished letter from WB *c.* 1917. The artist's estate.) But these seem to be the only connections he had with the Abbey.
[2] Letter, Coll: Mrs. E. Stephens.
[3] 19 February 1907, Synge Estate.

Mister Synge a bloody old snot to write such a play?'[1] Yeats decided that he sympathized with 'injured innocence'. He himself saw *The Playboy* in London. 'If you can't be innocent you can be injured anyway.'

Synge was in bad health, but he recovered sufficiently to visit the Yeatses at Cashlauna Shelmiddy for a week at the end of May. He had been threatened with an operation, and for a man in such a frail condition, it was a long journey. He left Dublin on 30 May on a boat travelling to Plymouth, with a stop at Falmouth on the way. He went from Plymouth to Kingsbridge by train, and there Yeats met him with a trap.

The Yeatses took a trip down the Rhine during the summer of 1907, visiting Rotterdam, where Yeats sketched a merry fat porter with a cheroot in his mouth, pushing their baggage on a cart. The artist was interested by the breadth of the river, and the views; by the various traffic – the sail boats, the rafts, the steamships; and the barges, which were all accompanied as far as he could see by a special species of dog. He liked the Dutch people and noticed small incidents such as a captain 'saucing people in tow, barge boy saucing him back and barge roustabout shooting him (captain) with an iron bar', or a bridge of boats just before Cologne, described with a delicate pencil silhouette line of the cathedral and the town, coloured with pale blue wash. The river, and its enormous expanse, however, made the greatest impression.

His father went to New York early in the New Year, with Lily, who was exhibiting her embroidery there. It was JBY's first visit, and he stayed on for a short time after she returned, and continued to delay his journey home so repeatedly that he passed the remaining fourteen years of his life there, and never returned home. Jack Yeats used to say that circles were limited in Dublin, and that he might have come to an end of his interest in them; but that in America there were endless circles within circles to explore.[2]

Yeats had been providing black-and-white illustrations for *The Shanachie* (1905, 1907) and for the *Queen's College Magazine* (1907). In June, 1908, the Cuala Press revived *A Broadsheet* in a new format, under the title of *A Broadside*, which kept him busy for the next seven years. Now instead of one large sheet, a sheet of paper was folded over, and

[1] Yeats to Quinn, 12 March 1907. New York Public Library. Manuscript Collection.
[2] K. Tynan, *Memories*, 1924, p. 287.

there were usually two small drawings illustrating the printed matter on the first two pages thus formed, and a full-page illustration, sometimes hand-coloured, on the third. Yeats had preferred the former shape of *A Broadsheet* but subscribers found it unwieldy.[1]

He himself edited and collected, or asked friends to provide poems and ballads which he illustrated. The verses are colourful, melodramatic, romantic or of nationalist sentiment and include ballads, lilting tales of heroes and of pirates, of dramatic combat, of villains, and lovers, of those who had died for Ireland, of 'a land that is fairer than this'; and the pictures were in the same vein.

He wrote to Synge on 14 April 1908 – cautiously:

> I am restarting the Broad Sheet which I think you saw, it was a monthly sheet with ballads (ancient and modern like to hymns) and chaste pictures by me. Have you done any ballad lately that I could print in it. I would be very thankful if you could let me have something – the Broad Sheet (or Broad Side which is the new name, as I daresay you might expect) only pays for what it gets with 'my thanks.'
>
> Even, if you'd let me have that ballad you did of the nine men jumping on the one, I think it would be too 'bloodish' for the Broadside – at least it isn't quite that only I personally have a horror of those terrible things. I don't think there are so many now. I know when I was a boy in Sligo I used to often hear of fearful beatings after fair days. I saw a ticket snatcher at Windsor races once running with all the crowd behind him and he fell – and I tell you, if the police hadn't got in to him quick they never would have been able to carry him away on a hurdle – they'd want to use a sack.[2]

It was not lack of daring but physical weakness which kept Synge from contributing. The series opened with a poem of tropical clime about the sailor's life, by Masefield, and 'The travelling circus', a large illustration, typical of Yeats. In August, a poem by Ernest Rhys, 'The Swordsman to his Sword', shows Jack Yeats illustrating Rhys seventeen years after his first attempt, in much more confident manner. He sees a Celt in tunic and criss-cross garters sitting under a canopy on the sea-shore, fingering the blade of his sword lovingly. James Guthrie, the poet, with whom Yeats was acquainted through *Root and Branch*, and who

[1] Letter to Lady Gregory, 15 March 1909. New York Public Library. Berg Collection.
[2] Synge estate.

shared his interest in prints, James Stephens, Lady Gregory, Seamus O'Sullivan, Seamus O'Kelly and Padraic Colum, all contributed: and poems were found by Sir Walter Raleigh, Henry Kingsley, Mangan and John Philpott Curran. Yeats himself – his brother offered nothing – provided an extract from *Esmeralda Grande*; and an issue, in September 1908, was devoted to Wolfe Tone MacGowan's poems. Wolfe Tone MacGowan has been identified as John Masefield,[1] but the evidence among Yeats's papers and the crude quality of the verse tends to indicate Yeats as the author. The last issue was published in May 1915. G. N. Reddin provided an invocation to Ireland in his translation 'My little Rose', prophesying the sacrifice of less than a year later, and the grim struggle following it:

. . . they shall fight and win your freedom back
And all you had, you'll have, and all you lack,
My Little Rose.

Masefield wrote in 1909 to thank Yeats for copies of *A Broadside* and *A Little Fleet*.

By the way, before I forget, let me tell you how much I enjoyed your picture of 'The End of the World'. That was one of the best of all your drawings. I liked to think that the two gentlemen making for the tree were you and I.

Poet and painter visited each other regularly until Yeats went to live in Ireland, and afterwards corresponded. Masefield described in rhyming narrative the people he met on trains or in the street, and in the 'Cashlauna Ballads' the schooners and pirates he encountered in the British Museum; and he described for Yeats the effect of the pageant of Coronation. *Dauber*, the long poem about the sailor lad who dreamed of becoming an artist, must have been inspired originally by his friendship with Yeats.

Yeats's last letters to Synge show a primary concern for the dramatist, and anxiety for his well-being, and they are filled with amusing anecdotes which he hoped would take Synge's mind off his illness. He described a wrestling match he saw in London –

a big affair with Russians, Italians, French, Turks and a Negro. It was very funny

[1] Colm O Lochlain.

to listen to the English audience, having an open mind they were very particular that everything should be according to the rules.

If one large Fat Turk in reaching for a hold smacked an Italian with his open hand there were cries of SHAME! a little man behind me after yelling 'Fair Play for all' explained to his friend 'theyre all a lot of furriners'.[1]

Again there was a story of an acquaintance in Kinvara:

down on the quay a sort of sailor man sitting in a Connemara turf boat hailed me as Bos and invited me aboard. I gave him a cigar, and he told me of the adventures on the deep in Norwegian and Yankee vessels. I asked him to drink, also the crew of the turf boat. When we got to the grocers the sailor man invited other friends of his to roll up to the bar and drink at my expense. Later on he spotted me in the inn yard and touched me for 2/– to pay his fine for being drunk and disorderly the week before – I was what they call an easy mark.

The artist visited Synge in Glendalough House in September 1908. Three months later he wrote to him sympathizing about his mother's death; and when the three months became six Synge joined his mother.

John Quinn persuaded Jack Yeats to write an article about the playwright, because he felt that he would give a more personal view of Synge than WB would do. Yeats wrote:

If he had lived in the days of piracy he would have been the fiddler in a pirate-schooner, him they called 'the music'. – 'The music' looked on at everything with dancing eyes but drew no sword, and when the schooner was taken and the pirates hung at Cape Corso Castle or The Island of Saint Christopher's, 'the music' was spared because he *was* 'the music'.

He remembered a story too, related to him by Synge, illustrating the less romantic side of the life he sought out:

He told me once at the fair of Tralee he saw an old tinker-woman taken by the police, and she was struggling with them in the centre of the fair; when suddenly, as if her garments were held together with one cord, she hurled every shred of clothing from her, ran down the street and screamed, 'let this be the barrack yard,' which was perfectly understood by the crowd as suggesting that the police strip and beat their prisoners when they get them shut in, in the barrack yard. The young men laughed, but the old men hurried after the naked fleeting figure

[1] Synge Estate.

trying to throw her clothes on her as she ran. But all wild sights appealed to Synge, he did not care whether they were typical of anything else or had any symbolical meaning at all.[1]

In 1909 Jack Yeats published *A Little Fleet* and turned from watercolour to paint some panels in oil. He was back in Dublin in May, for an exhibition in the Leinster Hall, and he attended a cinematograph show at the Theatre Royal, and a performance at the Abbey, and visited Hugh Lane's gallery in Harcourt Street. He and Cottie went out to Tallaght, to Blessington and Poulaphouca, perhaps looking for a permanent place of residence. Yeats's dissatisfaction with a foreign life was now very real. As he had put it to Synge, 'I wish I could live in Ireland. Everyone who has any right there should be in it.'[2]

After Dublin, the Yeatses took a train to Connemara, where they visited Ballycastle. Yeats did a sketch for 'A Japanese Toy in Mayo' (*Life in the West of Ireland*) and several drawings for 'Downpatrick Head', from a distance or from a close range; and painted some oil landscapes. There were visits to fairs, and funeral, a court scene for the trial of poteen makers. He recorded an accordion player, playing, on an instrument of 'purple, green and silver', 'Donal Abu', 'The Wearing of the Green', and

I married a tinker's daughter
In the town of Skibbereen
But at last one day she galloped away
With me only shirt in a paper bag
to the shores of America.

'Long Harvey' was paid a visit, then Coole, where Yeats had ideas for 'Going to the Races', and for 'Poor Maggie'. There are pleasing individual sketches of the owner of the Maggie stand and of a country jockey with his coat tails falling out from under his racing jacket, and of the cake cart woman.

In September Yeats was again in London, at music hall and trotting race, and then he and Cottie returned to Strete for the last winter they would spend there. Mrs. Yeats told Mrs. Harvey later that they had lived in Devon for over ten years, and that they did not know their

[1] W. B. Yeats, *Synge & the Ireland of his time*, 1911.
[2] Letter, 14 February 1905. Synge estate.

neighbours in the slightest. It was only when they were leaving that she realized what pleasant people they were. The artist, however, would appear to have enjoyed more there than merely the boxing mentioned by Bishop Harvey. But he had decided to plumb the living depths of life beyond the ginger. He sold Cashlauna Shelmiddy and the orchard on 24 June 1910, and on 18 July, he and his wife left Strete to take up residence at Red Ford House, in Greystones, County Wicklow.

Illustration to *Outriders*

Part two

'No one creates . . . the artist
assembles memories.'

Chapter 10
Greystones

Affection is 'the greatest tribute' of an artist or a writer to his subject, Yeats told Dr. Thomas MacGreevy; and again, after a discussion in later years about Burke's *Essay*, and Stephen MacKenna's reference to it in his translation of Plotinus, Yeats said, 'There's too much old chat about the Beautiful: it's something that I've been turning over in my mind and I have a definition. The Beautiful is the Affection that one person or thing feels for another person or thing, either in life, or in the expression of the arts.'[1] Affection was expressed by the artist, Yeats thought, for a mountain, for water, for light, for an animal (donkeys especially were the object of his sentiment: he felt that a girl might imitate the donkey's manner of stepping to advantage, and thus save the cost of dancing lessons). He went so far as to say that he did not think about whom he was painting for, but worked only to please himself; and that the public, if they so chose, paid him for it.[2]

He denounced art theory in a less formal way when writing to John Quinn.

I know there have been fine painters who said there was nothing in their pictures but *light and shade and colour*, but such men may paint better than they know, I think these things are done by a sort of clairvoyance (for want of a better word). So a man in spite of himself may do great things.

I should not be surprised, if one asked one of the great old painters what he thought of his own Venus, if he would reply that the handling of the paint was the only thing that made the picture worth anything, and that was why he painted it.

[1] Dr. MacGreevy. [2] W. Rothenstein, *Men and Memories*, 1931, p. 254.

Now this would not be true. He would be deceiving himself. If he spoke the truth he would say: 'I painted it because she was such a damn fine gall.'[1]

He was asked by the Fine Gaedheal political party to speak to the Irish Race Congress in Paris in January 1922, on the subject of painting. It was an idealistic lecture. He spoke of painting as 'the fairest and the finest means of communication humanity has yet found because it is the most simple'.[2] He wrote to Dr. Bodkin in the same impassioned vein[3]

About those dear old masters most of them tried to paint only what was: not what they saw, a few followed 'Fancy'. Many of them made 'pictures'. These were the most wretched and very few followed truth. Which is a difficult road for any man, but especially for the painter. As it is necessary for him then to approach that ideal state of a man knowing himself. The painter of the material thing that was, the painters of 'Fancy', and the 'picture' makers, are often curious and interesting but nothing more.

Painting has never yet taken its true place as the freest and greatest means of communication we have.

Pictures, Yeats believed, came from life itself and were a part of life 'and the way to enjoy pictures and life is the same': the true painter must be a part of the land and the life he paints. He drew a distinction between the true artist and the false artist whose work attempted to display the tricks of his trade. 'The roots of true Art are in the affections, no true artist stands aloof.'

Beauty is truth and a just balance,

He told the conference in his lecture.

– but not a compromise, the artist compromises when he refuses to paint what he himself has seen, but paints what he thinks some one else would like him to have seen.

And he concluded:

I began by telling you of the question I asked my friend: What would the finest

[1] 7 September 1906. New York Public Library. Manuscript Collection.
[2] *Ár nÉire* Vol. IX, No. 11. 18 February 1922, p. 171.
[3] Letter, 16 April 1921, Bodkin Estate.

picture in the world give? Well, as I asked it, I should answer it. The finest picture in the world will give the finest moment finest felt by the finest soul with the finest memory. Well, we have bad and we have great souls. And we have had, and we will have, great moments.[1]

His straightforward definition combines with his idiosyncratic humour in his description of his pedigree to John Quinn as 'starting in the upper right-hand corner with "Man" and ending in the lower left-hand corner with "true painter".'[2]

Affection was evident in the artist's watercolour work. His first two years in Devon gave him fruit for amusing and penetrating scenes of local life in England, which he enjoyed to the full; and then with the purpose of the newly elect, exulting in the celebration of 1898, he saw Sligo as a symbol for the whole of Ireland. Here was a permanent subject-matter, a life that he knew intimately, to be interpreted and recreated in his art. His sketches made during his summer sojourns in Ireland acted as a base for his watercolour work. It was the same with the early oils. He felt a commitment to record accurately a life that meant all to him.

Basically, the early oils are descriptive paintings, just as the water-colours are. They are painted by an artist deeply interested in individual personality and character, in local incident and folk customs, and with a deep appreciation of natural surroundings: whose main gift is as a storyteller, a very skilled storyteller. Narrative qualities increased with the years, and Yeats could eventually persuade the viewer to enter into the imaginative process of storytelling. But in these early paintings everything, title, background, presentation are contributed by the artist, illustrating the central theme in what are pictures with a definite literary slant. It is of interest to observe that the artist chose to illustrate Canon Hannay's *Irishmen All* (1913) in oil, showing that he tended to regard himself still as a descriptive interpreter, and he did not yet place oil as a medium apart. The illustrations are fine achievements, paintings of typical characters making up the Ireland of the day, parish priest, busi-nessman, farmer and so on, the results of carefully trained observation

[1] *Ár nÉire*, Vol. IX, No. 12. 189–90.
[2] Reference in letter from John Quinn to Jack B. Yeats, 4 May 1922. New York Public Library. Manuscript Collection.

combined with a natural and intuitive creativity, and they demonstrate individuality, good draughtsmanship, a sense of design and gift for dramatic narrative.

The change-over from watercolour to oil was gradual. The artist was experimenting with different media in the early 1900s. His earliest known oil was painted in 1902, a version of 'Simon the Cyrenian'. About 1906–7 he was doing some more. He wrote to Quinn from Clifden to say that had been spending three weeks at landscapes, 'doing a little more in oils than usual'.

Conversion coincided with the move to Dublin in 1910. In November Yeats was writing to William Macbeth to offer him some oil paintings. Macbeth was the dealer who attempted to arouse public interest in native American art when the impressionists were all the rage; and he had acted as Yeats's agent in New York since the Clausen exhibition in 1904. Yeats wrote:

I am very much obliged to you for bothering about my pictures as I know you do not go in for watercolours very much. I am however getting to work in oils a good deal more now and may after a time have something to send you in that medium.[1]

Only a few oils painted between 1906 and 1910 survive. At his Dublin exhibition in 1910, however, he exhibited nine oil paintings. After this date, with the exception of some work as an illustrator in lighter mediums, he devoted himself to the technique.

With the early landscapes Yeats appears to have worked in the open air. He and his wife would hire a rowboat, when they were in the West, row out to some small island and moor the boat, while he painted. He described something of the discomfort it involved in a letter; 'it is no pleasure to sit on a desolate coast, perched on a damp rock, with the cold showers sweeping over you and your paint and a drop on the end of your nose.'[2] These works are painted in exactly the same manner as the watercolours of the same period. 'Low Water, Spring-Tide, Clifden', exhibited in 1906, gives an impression of being a watercolour carried out with oil instead of water. 'The Race Card Seller', painted about 1908, is more

[1] Archives of American Art.
[2] Letter to Quinn, 21 May 1909. New York Public Library. Manuscript Collection.

confident, colours and tones are developed more strongly. But there is the same strong outline filled in with flat paint.

The compositional approach has not altered, and there is the expected central character, and low horizontal background. The emphasis with Yeats, in the watercolours and first period oils, was on character, and landscape was secondary. He preferred scenery with a human element. Landscape in the character works is an appropriate setting, and provides an additional comment on the subject of the picture. The rims of mountains or fields or buildings at the base of single silhouette figures are reminiscent of those in the nineteenth-century theatrical prints and juvenile drama cut-outs that he collected, providing a suitable low horizontal background to the figure; and Yeats's typical low horizons would appear to have their origin in them. They not only allow a complete concentration on character, but there is the added concept of character growing up out of its environment.

In watercolour this isolation of the character-subject, as in 'The Squireen', 'The Canvas man' and 'The Rake', seems to be unique to Yeats, though there is an obvious parallel with Degas in early oils such as 'Before the Start' and 'A Country Jockey'. Whether it is permissible to imply such a debt it is difficult to determine. 'Four Jockeys' by Degas (*c*. 1889) obviously raises the question. The Irish artist would have seen 'A peasant woman', from Hugh Lane's collection shown at the Municipal Gallery in Harcourt Street in 1908, and thereafter, but he is unlikely to have seen the first. Both are artists of strong traditional feeling, and stylistically there is a good deal to compare, especially in the horse paintings. However, Yeats never referred to the other painter and the similarity could be incidental.[1] The silhouette figures as compositional elements date back to such works as the 'Haulin' Home' drawing of 1899, and are exigencies of the *Aran Islands* illustrations in 1906. As a stylistic idiom they come naturally to an artist thinking of the low-lying low-walled stretches of Western Ireland, bleak beneath the expanse of open sky.

He continued to deny the company of other painters, living or dead – he would admit only an admiration for Goya, and this continued until

[1] In the same way the oil landscapes of around 1910 are akin to the landscapes of Barbizon though the artist never expressed any interest in French painting. They seem, rather, to have grown from his own personal sense of realism.

the end of his life. He was studying his work in reproduction as early as 1907, stating ecstatically that 'he was the cords and strands of a painter'.[1] Morland too had a place in his affections, he refers to him repeatedly in his prosewritings.[2]

But the artist who deeply influenced Yeats at this period was Walter Sickert. He could not pass by the work of the leader of the contemporary English painters. As in the case of black-and-white work and watercolour where he had accepted the tradition behind him, Yeats commenced oil painting as an artist of the British school.

. . Yeats and Sickert had a great deal in common, each seeking to describe a certain elemental side of life, in all of its phases, and there was a common approbation, a similar fascination for 'low life' and theatrical fantasy. More important, however, is the stylistic debt: from Sickert Yeats learnt how to apply paint, adopting in the first oils the short thick strokes, and the manner of correlating colour. 'Empty Creels' (1914) is a striking example of the new, temporary influence, not only in its sombre tones, but also in the manner in which he finds colour in shadow. Through Sickert came the impact of Degas at secondhand.

Yeats's work won the wholehearted admiration of Sickert, who counselled young artists to follow his example in painting the people and life of his own country. He liked the dramatic figures in the landscapes – 'Much of our modern landscape has an imported air and the figures are tucked away in corners. They are seldom DOING SOMETHING in the landscape. Indeed, the two elements should be knit together both psychologically and pictorially.'[3] When he saw the Irish painter's exhibition in January of 1924 he wrote to him in a note:

Forgive me for saying that I think your exhibition superb. It fulfils my theory

[1] Letter to John Quinn, 16 September 1907. New York Public Library. Manuscript Collection.

[2] It is of interest too to note that JBY introduced his son to Clausen's *Six Lectures on Painting* at about the time the latter was embarking on his work in oil; and the precepts against dual lights in a composition, for balance of light with shade, of cool with dark, and the stress on emotion of colour did not go unnoticed. There are odd passing references to other artists. In 1950 he describes Ivon Hitchens to Patric Stevenson as 'the painter who used a fine colour which is like a bright bay horse in sunshine and in shadow. . . . I do admire his work' (Letter, 18 November).

[3] Emmon, R., *Life and Opinions of W. R. Sickert*, 1941, p. 246.

that there can be modern painting. Life above everything. The movement of
the figures, true and felt, and the landscapes, water, sky, houses ruffling like
flags in support of them. I cannot find adequate words.[1]

Mrs. Sickert told his wife that Yeats was the only person her husband
would listen to, and the two artists often breakfasted together when
Yeats visited London.[2]

This feeling for life, and now something more than a literal representa-
tion of life is evident in the subject-matter and treatment of the early oils.
The subjects are national ones still, the country point-to-point, the
farmer selecting an ash plant or winnowing chaff from his grain, the
maggie man at the fair nervously collecting his sticks, the moment of
triumph and humour in a local circus act. But there is a dramatic quality
of treatment that escaped the watercolour, a deliberate effort to per-
petuate a definite moment of time, together with a personal expression,
a personal emotion. 'The funeral' (1918), for instance, illustrates this
with a moving beauty.

Yeats's line now, picking out character and detail, enters the spaces
outlined and adds a lively quality to the paint in twists of strokes as well
as in the variations of colour. There is a greater use of the conflict of line
in composition. In 'Actors fencing' (1910) the stout nervous contestant
backs up against an expanse of fence while his lively assailant's gesture
is reinforced with flickering tongues of shadow falling from his direction
towards the fat man and on to the fence. In 'A Lift on the Long Car' the
driver sits upright on his box, straight as the houses lining the sides of
the river, while the awkward slant of the man climbing up on to the
vehicle cuts across the diagonal movement of the water beyond. Move-
ment in these early subjects is expressed both in the deliberately lively
texture of the paint surface, and in the linear composition.

In September 1910, George Pollexfen died. No one in the family was
surprised that the Banshee, the supernatural death-watch, gave notice of
his demise: Lily and the nurse heard the cry one night, and the following
evening at the same hour Uncle George died. The old man with all his
peculiarities was warm-hearted, and had a deep affection for the local
people. He always travelled on the public long car, chatting with his

[1] Unpublished letter. The artist's estate.
[2] White, T. de V., *A Fretful Midge*, p. 120.

fellow passengers, and helping the old women up and down. With his death was lost a representative of the dwindling life Jack Yeats so approved. He appears to have had a deep understanding and sympathy for his eccentric uncle; and unlike WB, who was close to George Pollexfen, but more excited by his psychic gifts than by the man himself, he felt that the family firm would now lose its old-fashioned pace and atmosphere as it changed hands.

WB recorded the affecting obsequies, where family and local inhabitants crowded the church, 'Catholics who had never been in a Protestant church before, and the man next me crying all the time.' Masons threw in Acacia leaves 'into the grave with the traditional Masonic good-bye "Alas my brother so mote it be". '

Then there came two who threw each a white rose, and that was because they and he were 'Priori Masons', a high degree of Masonry. It was as George would have wished it for he loved form and ceremony.[1]

Jack Yeats caught the same spirit in his painting of a few years later, 'Bachelor's Walk: In Memory'.

The Yeatses stayed for some time with Lily and Lolly at Gurteen Dhas in Dundrum, but by November were settled at their new home, Red Ford House, near Greystones, on the east coast of County Wicklow. Yeats had sworn that if he ever returned to Ireland he would live in the West, but he evidently decided that it was not practical. Greystones was within easy reach of Dublin. He had been frequenting it since 1906. The surroundings of mountains and sea may have been what attracted him. The population is predominantly Protestant.

They rented a grey unprepossessing house at Red Ford, looking down over a stretch of fields to the open sea, with a glimpse of the small harbour of Greystones. Behind the single-storey entrance, looking like a cottage, rambles a two-storey house. A thatched cottage in the grounds was still in use. The attractive garden had a glass house which Yeats used as a studio. The Little Sugar Loaf rises behind, and to the north, Bray Head, between Red Ford and Dublin.[2]

[1] *Letters*, p. 553.
[2] The house was properly named 'Cartref' and is so called now; but during the Yeats' tenantship was known as Red Ford House.

Yeats is still remembered with his pencil, watching schoolboys playing snowballs on the hill. In the evening when the old people gathered on the wall by the roadside north of Red Ford House, for their accustomed gossip, Yeats was sketching them too.

Greystones, with the harbour and its bleak outlook, gave some subject-matter for paintings in its landscape and in scenes of local life. Schooners were still occasionally to be seen. Yeats saw wrecks and odd sailor eccentrics. Not far away were Bray and Arklow, also on the coast; and local sports, such as Gaelic football which was greatly encouraged, provided an interest.

John Masefield regretted the life at Snails Castle[1] writing about 'the little house in the lane. I am sad to think of it as neglected now, and all our brown shoots eaten down, just when they might have been glorious; for I suppose that will be one result . . . only the ghosts of old ships and scraps of torch wood in the shallows.' Masefield lamented the jolly times, and the battering of model boats on the stream. Yeats, however, had been contemplating the move for some years, and uprooting himself and returning home meant that instead of enjoying in retrospect the attractive and idiosyncratic features of an ancient way of life, he was now in Ireland, immersed in its problems, and experiencing the uneasiness and instability of the period. His indecisive versatility was exchanged for a new maturity of work. 'Jolly times' continued. Greystones was beside the sea, and visited frequently by Duffy's Circus; and Yeats attended Leopardstown Races, and sport at Jones's Road, and enjoyed the Henry Street Waxworks. But he was present too at the continual Sinn Féin meetings, experiencing at first hand the atmosphere created by a gradually heating political passion. His romantic nostalgia was slowly giving way to a self-dedication as an Irishman. Theodore was dying. A new element is present in the first works after the move. The approach is now subjective. Compared with landscape sketches painted in England, delicately interpreted records of beauty and atmosphere, the plain views of 1911 show a strange personal intensity. Character studies now have a brooding quality. Even the change to a more permanent technique of painting shows a rejection of dilletantism by a man committed to his art.

The early period was rounded off neatly in the poetic appreciation of

[1] Letter to Cottie, 6 January 1912. The artist's estate.

Yeats by Ernest Marriott in 1911. Marriott, who had been a pupil of
Walter Crane, and had worked under Gordon Craig, looked at Yeats
archly, but sympathetically. In his lecture to the Manchester Literary
Club he traced the simple, broad effects of Yeats's cardboard dramas to
Craig, the 'romantic reality'; though he was not satisfied with the draw-
ings for the plays. Not surprisingly he preferred the watercolours, for
their distinctive character, and for what they illustrated to Marriott of
the Celt, the compulsion of Sligo for the artist; and he approved the
refusal to moralize. 'Nothing is to be despised', he said. 'Everything in
his net is counted as fish.'

Yeats continued to visit London; and in the spring of 1911 he took his
customary trip there, travelling up through Wales. He paid a visit to the
Royal Academy, but enjoyed more the Holborn Music Hall, with Arthur
Roberts and his wide smile, and the boxing at Sunnyside and Wonder-
land. He noted a puckish page boy with red hair, and 'Bill Natty taking
something out of other second's eye with a penknife', and 'Englishman
boxing a Frenchman and showing his knowledge of the language'. One
second, to his joy, had a particularly obtrusive belly: 'times must be
good: they all seem to be getting fat at Wonderland', he commented in
his sketchbook, probably thinking in terms of another cartoon.

Life in Dublin continued in some ways as before; and until the end
of his life Yeats attended melodramas at the Queen's Theatre, and music
hall performances, finding in them subjects for his paintings which he
failed to discover in straight drama at the Abbey. He saw WB's plays,
and designed a backcloth for *The King's Threshold*, but otherwise seemed
to steer in another direction. He was constantly sketching the Metal
Bridge, and in Greystones natural subjects, such as bang-the-door boys,
or children stretching a daisy chain across the road, or stringing conkers
together in a chestnut necklace. He sketched tinkers, and scrounging
tramps, and events such as ploughing matches on the farm; and he went
regularly to Punchestown and the Metropolitan Regatta, and to the
Donkey Show at Bray. He painted 'On the Hazard' – men playing cards
by lamplight; and, equally dark and dramatic, 'The Circus Wagon'.
Concentrated light seems to have interested him at this period.[1]

Synge's *In Wicklow, West Kerry and Connemara* was published

[1] Paintings such as these owe something to his study of Goya.

posthumously in 1911. *In Wicklow* describes the life of the vagrant, and the loneliness of farm life; while *In Kerry* presents a more cheerful aspect, comparing the Kerry man with his more romantic counterpart in Aran. Synge liked the practical Southern people, especially those living on the Blasket Islands. The articles from the *Manchester Guardian* were included in the third section. Yeats's illustrations, as those in *The Aran Islands*, tend to express a general view of what Synge described in particular incidents, his figures convey the spirit of generations leading an unchanged life, rather than describing given people at a definite time.

The artist spent some time in Roundstone during the summer. Theodore came with him – he still thought of the pirate in conjunction with drawings for *A Broadsheet* – and there are delightful sketches of the small slight buccaneer paddling in one, discovering to his surprise that his long hair with its receding crownline, his arched back and sticklike legs prove him to be a heron. 'Theo Pompus . . . King of Sparta' is dressed royally, but for the stained boots emerging below the sweeping cloak. Roundstone was a place for fishing boats, known as hookers and nobbies, rowing boats, wild creatures and birds, set in a rocky landscape threaded with twisted loose stone-walled roads: and the visit produced a series of fine pictorial landscapes. 'Dust Play' was inspired by an incident witnessed here.

The following year Yeats was in Donegal and the West. Less meticulous sketches describe with a firm wriggling line the shawlies at Westport station, revolutionary slogans seen on walls in Achill Sound, the landscape of pocket-handkerchief fields, and rocky prominences about Bunbeg and Dunfanaghy, the types of roof or stook which he now examined with a half-scientific interest, graveyards, countrypeople on the road to their devotions; and characters such as the umbrella man, looking sadly out of place in the rural districts. At Roundstone he had seen Lady Dobbin sketching; and Henry Lamb the landscape artist was at Bunbeg, though as always with other artists Yeats seems to have kept his distance. The same figure of a man smoking his pipe graced the station hedge at Scarva as is cut out of the hedge today. Back in Greystones the wriggling pencil line became soft and thick, supple and unbroken, in drawings of Bray Head. The sketchbooks were now notebooks rather than repositories for essays in description; for the artist thought

in terms of a different medium. The sketches from now are very free, jotting down definite themes for oil paintings, though making no effort at preliminary studies.

In July 1912 Yeats took an exhibition to London, and the Dublin show in the spring, and that in London in the summer of 1914 were his last one-man exhibitions of recent work until 1920. 'Here She Comes', a remarkable painting of a trotting-race, the fine composition 'A-Lift on the Long Car', and 'A Summer Day', a recreation of an incident he noted in Kerry, a cripple sunning himself on some porter barrels, date from now. In the interim he was showing the originals of broadside illustrations, or the early oil landscapes, while he groped towards a new expressiveness in his work.

He was still illustrating. *Life in the West of Ireland* (1912) offered an album of line drawings describing the fast disappearing folk life of Sligo and Mayo, together with reproductions of a few watercolours and recent oils. It is a charming and interesting book, full of atmosphere, spirit and sensitive observation. In 1912 he gave some drawings to Robert Lynd for *Rambles in Ireland*. The following year he illustrated *A Boy in Eirinn* by Pádraic Colum.

Pádraic Colum and Yeats had collaborated before, Yeats providing illustrations for *The Irish Review*, and Colum finding poems and traditional ballads for *A Broadside*. Yeats was always a quick worker, and with *A Boy in Eirinn* seemed to be providing illustrations before the book was written. He listed the subjects he wished to include, one being an interior with a fireplace, the boy sitting beside it reading his book; and he wrote to the poet asking him not to contradict any of the details of his drawings in the narrative, but rather to alter the wording of his script:

I sent a drawing of the boy and one of the uncle by the way I had to do the drawing before I got your letter and ms. and I put the turf stack at the *side* of the house. Perhaps you would alter it in the book from the *front* to the *side*. For children it is important that there should be no difference between the pictures and words I think.

Just as he had been able to give Synge advice about the garments of country people in Ireland, Yeats described the customary dress to Colum:

Give your storyteller a swallow tailed coat if you like but I wouldn't give him knee breeches I think if I were you. The swallow tails worn with trousers and a soft felt hat pinched up at the sides is a fine dress, but the knee breeches with tailed coat and a caroline hat was always hideous to all![1]

The artist said he would not care to wear the latter combination, the costume of a stage Irishman, even if he were alone on a desert island.

The drawings of Finn and his experiences are lively compositions in black and white and include a typical bonfire scene and a fair.

Paul Henry's contributions to *Rambles in Ireland*, in particular 'The Old Age Pensioner', and his own reproductions of oil works in *Life in the West of Ireland*, may have inspired Yeats to illustrate *Irishmen All*, by Canon Hannay with oil paintings. Again he worked without the text, using the chapter titles as themes. Canon Hannay (George Birmingham), knew Yeats's earlier illustrations to his stories in *A Celtic Christmas*, and was delighted with what he received, and especially with 'The Country Gentleman' and 'The Minor Official':

'Considering that neither of us saw each other's work,' he wrote from Westport on 15 September 1913, 'the illustrations and text fit together extraordinarily well.' JBY, vociferous as usual on the far side of the Atlantic, signified his approval in several laudatory letters. He spoke of their 'liveliness and their actuality – and a sort of poetic truthfulness – you satirize but with such a kind heart.'[2]

[1] 26 March 1913. New York Public Library. Berg Collection.
[2] *Letters*, pp. 228–9.

Dublin

John Quinn too liked the illustrations to *Irishmen All*. He had heard about the artist's work in oil, and wrote to him in December of 1912 suggesting that he should submit oils rather than watercolours to the coming Armory show, in New York. Some members of the committee had thought that a selection should be made from Quinn's own collection, but Quinn wanted to see some of Yeats's new work on show there.[1] Yeats sent 'Racing on the Strand', 'The Stevedore', 'The Barrel Man', 'The Last Corinthian', and 'The Circus Dwarf', this last a fine study in character. Quinn supervised the transport at the other end, the agent and the hanging of the five pictures. He wrote to Yeats regularly, giving him news of his father and of mutual acquaintances in New York, asked about current events in Dublin, and exchanged opinions on the European war. He was not buying now, his collection was extensive, but he continued to encourage the artist and recommended his work. He was one of the few who heard Yeats's terse remarks on painting, his views on the iniquities of futurism and modern art.

AE found a permanent home for pictures by Yeats, Hone and himself in Wisconsin University, Thomas Bodkin, Dermod O'Brien, President of the RHA, Horace Plunkett and himself forming a committee to choose the works represented. Three works by AE, one by Hone, and 'Sligo Quay' a recent oil, and 'The Diver', a watercolour, by Yeats were bought by the University.

Yeats went to London for his exhibition just before war was declared.

[1] Letter to Jack Yeats, 21 December 1912. The artist's estate.

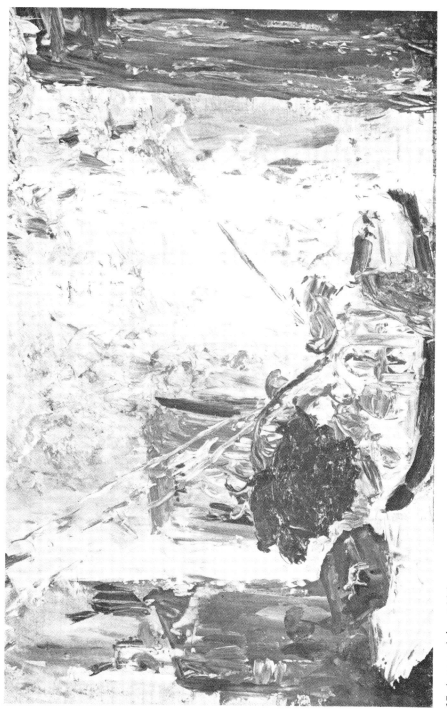

17 A rose dying 1936

19 The mystery man 1942

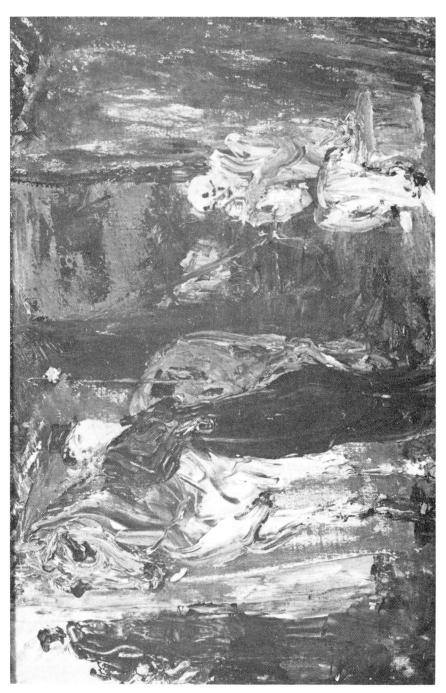

20 This grand conversation was under the rose 1943

Ronald Brymer Beckett wrote to Dr. Bodkin forty years later to say 'I don't think it can have been a success, for I don't remember seeing anyone in the room except for the artist and myself. He had a rather nautical appearance, for he was wearing a reefer jacket and I think he had gold earrings. That was the only time I actually saw him though we used to correspond and exchange our duplicate broadsheets we happened to pick up.'[1] In between his sessions in Walker's Art Gallery, Yeats studied street life. Newspaper men always had a fascination for him, and he noted the anomalous expression of a news vendor, who was advertising 'Great Fire in US. 10,000 homeless' with a broad and cheerful grin.

On his return to Ireland a letter from his father urged him to put his name down for membership of the Royal Hibernian Academy. Yeats's first watercolours were exhibited with the Academy, though for a long period he ceased to contribute, and he had only recently started exhibiting there again. He was elected an Associate immediately, however, and in 1915 became a full member of the Royal Hibernian Academy.

The recognition meant little to Yeats other than that his rather non-conformist art was accepted by a foundation which up to the time had set the standard in painting but which was now slowly losing its grasp. The honour of becoming an Academician instead came at a time when there was a temporary standstill in his artistic career.

It was a time of strain. Yeats had been deeply concerned with Irish internal affairs since his return to the country. He witnessed turbulent political and socialist meetings of the years before and after the Rising and saw in them the beginnings of a new aim in his artistry. He was not a politician, not a fanatic, and life in many ways remained unaltered. It was not a gay, one-sided life, of idiosyncrasy and character, any longer though. A deeper dimension entered, and the depictions of history, for instance 'Bachelor's Walk: In Memory', were fortified with a real and powerful emotion. 'The Dublin Newsboy'; and 'In Capel Street' and 'A Summer Day' give a pictorial view of the working people for whom James Larkin was fighting. Yeats followed the events of the Strike with great interest; and probably to his satisfaction the Tivoli music hall presented a display of boxing in aid of the strikers.

The artist gives evidence of his sympathies in his sketchbook: boys

[1] Letter, 5 May 1957. Bodkin estate.

drilling, or a mask of Emmet in an antique shop, or chalked protests on a goods van: 'YES WE will Home Rule in spite of Carson'; and Pearse, whom he heard addressing a Volunteer meeting in Dundrum in 1914, was the inspiration of his painting 'The Public Orator'. He could sketch rather irreverently a drover with his herd of cattle, reading the war news as he shuffles along – 'as for *Punch*': but he sought out purposefully the scene of the tragic incident on Bachelor's Walk, where Volunteers were mown down, and made what he observed into a moving and important painting with something of the mystic connotation that the tribute of roses evoked in the ceremony of George Pollexfen's funeral. For the same reason he attended the funeral of O'Donovan Rossa on 1 August 1915, and noted in detail the long procession with flags and the silent spectators on street or on balcony, the Volunteers with arms reversed, the Foresters, Madam Marckiewicz's band of Fianna, and the tribute in wreaths, shaped like Celtic crosses. He sketched the lying in state carefully and impressively though this never became a painting.

He was learning Irish, dwelling over the bewildering intricacies of the subjunctive mood and reported speech; and visited Kerry to further his studies in 1913, observing with approval the slogan 'Tír gan teanga tír gan anam' ('A country without a language is a country without a soul').[1]

Yeats was aware of the other war too, and of the tension created in the conflicting propagandas: 'Arrah Glory! Mike O'Leary!' and 'If you to Ireland are true!' He knew whether he was true or not. As he said to Lady Gregory, 'You will never break the heart of the British Empire. You cannot break pulp'.[2] On 11 April he was cut off from the uncertain thunderous atmosphere of mounting political emotion, sitting quietly in his garden at Red Ford House sketching children at play with a rusty bicycle wheel, and to his delight a schooner under sail; Michael, the gardener, clipping the hedge, and a local character, the Monkey woman, passing by. The world appeared peaceful. Two weeks later everything was over and the great half-realized ideal of a nation was no more. Something collapsed inside the artist. At this time, and from now the sketches

[1] In the forties Yeats was objecting to the names in 'The path of Diarmuid and Gráinne' being spelt incorrectly.
[2] Letter, 4 April 1927. New York Public Library. Berg Collection.

in his few notebooks are interspersed with subjective scribbled concepts either in 'dream', or 'half memory', grim faces reminiscent of Kirchner, and even some whirling geometrical abstracts which had never before come from his pencil.

The insurrection was not a triumph for Jack Yeats as it was for his brother. For him it was the still-birth of all that was real. After the Rising the paths of two men who had kept their creative lives distinctly apart were to become even further separated. Nothing would make the artist yield from his vision of a politically free Ireland.

Jack Yeats's patriotism was intense and of a deeply idealistic nature. To him the Free Staters were middle-class, while the Republicans represented all that was noble and free. His patriotism had nothing to do with war or the practicalities of the situation, but was rather a dedication to perfect life, without blemish, where no man was subject to another. When he visited Mrs. Erskine Childers to commiserate with her about the death of her husband, and young Erskine Childers announced 'The Republic goes on', Yeats was shocked at the child's use of the slogan at such a time, betraying in the family an unnatural obsession with political abstractions. He left the house instantly and never returned. Again, when Seán MacBride, a member of the Irish Republican Brotherhood, was on the run and P. S. O'Hegarty asked Yeats to take him in and hide him in Marlborough Road, Yeats refused to do so. O'Hegarty thought that he was timorous. This may have been why Yeats disliked him so much, or it may have been because O'Hegarty was such a vociferous Free Stater. Yeats always spoke of him with contemptuous dislike.

Yeats hated war and evil. His pictures of political subjects do not depict the conflict or moments of sacrifice, but the tragic or removed emotions of those who live on. 'Bachelor's Walk: In Memory' and 'The Funeral of Harry Boland' are elegies. 'Communicating with Prisoners' and 'Going to Wolfe Tone's Grave' show the attitudes of ordinary people to national· concerns. In 'On Drumcliffe Strand' a country woman turns with distrust towards a Volunteer soldier.

Besides the emotional strain overwork caused Yeats's illness in 1916. He had been putting out the monthly *Broadsides* for years, gathering material and colouring his illustrations singlehanded. He had been

painting a good deal in oil and his work received no more attention than it had done when he started out as a watercolourist.

On 18 August Lily Yeats wrote to Thomas Bodkin to tell him that Jack was recovering and that she would bring him to Greystones to introduce him to her brother and to show him Jack's pictures. 'He is very much better but still has to take life quietly – therefore I would like to give him warning of visitors.'

The introduction proved to be the beginning of an important association. The artist found an admirable ally in such an astute critic. Eighteen months after their first meeting Bodkin was writing to Yeats with a list of biographical queries since he hoped to combine in book form a study of his work with essays on Russell and Orpen.[1] He did much to publicize Yeats's painting in illustrated articles and lectures.

Yeats produced comparatively little work during the next five years, and paintings not too different in style from what he had been doing before his illness. But his brush was gradually becoming more free; pictures show an advance in freedom, broader and richer application of pigment, outlines receding; and in these were laid the foundations of the new style to blossom in the mid-1920s, to become the poetic implement of his great period.

Jack Yeats and his wife visited the poet at his newly-instituted but ancient Tower at Ballylee in 1917, staying in the cottage built up against it. They travelled on to Roundstone. In freely described sketches in his notebook Yeats noted children ploughing heaps of mud by the side of the road; a buoy which had floated across to Roundstone and had caused great excitement, which he used later as a motif in his novel *The Careless Flower*; shawlies, and the hookers with their romantic titles. He made several preliminary sketches for paintings. Esoteric scenes and gremlin-like figures sometimes haunt the slim pages of these final volumes of the pictorial diary. Occasionally his objectives seem uncertain. The pencilled lines capture the same effect, in a slight manner, as would his brushwork of eight to ten years later.

In Autumn 1917 the Yeatses moved north from Greystones, and took a house at 61 Marlborough Road, previously occupied by the de Vere

[1] Orpen, however, refused to be associated with AE and Yeats – and the project came to nothing.

White family. To the dismay of Mrs. de Vere White the imitation Morris wallpapers were stripped from the walls, and substituted by paint of 'hideous colours'.[1] John Quinn wrote to Yeats, commenting on the advantages of a move, since it made possible the whittling down of 'irrelevant' and 'useless hordes';[2] though it is difficult to believe that many papers or objects were jettisoned. Yeats, fortunately for a biographer, was not inclined towards the destruction of records.

He found the city less lonely than Greystones and told Colum 'We are glad to be in Dublin, for a while at any rate. We met more friends in a month than we did in twelve months in Greystones. Greystones was neither town nor country nor suburb. Our only link with the spacey world was from the tinkers that passed along the road.' One of his joys was to walk along the canal. 'It was an honour to think that every step was a step nearer the west. Where ever I am I always want to walk towards the west. As well as from a desire to get to an ocean coast, from a wish to be going with the sun.'[3]

For the next few years he studied life about him, listening to orations of historians and literary men, watching beggar and shawlie, and interpolating visits to Courttown, Ballygarrett, Skibbereen, Schull and Tawin. He continued with his Irish studies, working at the southern Irish dialect, and simplifying the exercises with a personal phonetic script. The course he followed used the language in all phases of contemporary life, and had a sad note in the final passages with its fervent hope for a speedy end to the civil war.[4] Yeats probably never became really fluent in Irish; but knowledge of the language gave him more scope for the use of ballad and legend, and helped him better to understand the country to which he belonged.

Even during the final years of his life JBY was advising his son at length on what he should read, or how he should paint. He pronounced repetitiously, but sagely. He wrote to Isaac Yeats on 15 July 1919:

What a loss the Irish Bar had when I turned artist. . . . had I remained – a barrister and become a judge – there would have been no famous poet and Jack would not have been so distinguished – content only to be the wag of the Four

[1] *A Fretful Midge*, 1957, p. 117. [2] 14 October 1917.
[3] Unpublished letter, 26 June 1918. New York Public Library Berg. Collection.
[4] Notebook of the artist.

Courts. To be sure Lollie and Lilly would have married – however we are in God's hands – and I think we are a lucky family – my four sons and daughters have realized themselves though I could have liked to see Lilly married. She was intended for a domestic life – with husband and children.[1]

He was always concerned about his family – 'Lollie & Willie are the hardiest of the whole family – both are *wiry*'.[2] Jack and Lily, in fact, whom he considered the weakest of the four, outlived his other children.

In July 1921, JBY published 'Autumn', a poem four pages long, about Death.[3] He barely survived the winter. Jack Yeats heard the news of his death while he was sitting for Estella Solomons, and the portrait conveys something of his numbed contemplation. John Quinn, fortunately, was in New York and was able to arrange all the affairs. He wrote to Jack Yeats:

Although I feared your father might not go through the Winter, when the last attack seized him, it was a shock. I dread illness, suffering and death more than anything. But when the thing came with your father, I went through with it. I saw the undertaker and arranged things with him, but I did not go to the undertaker's place to select the coffin. A Mrs. Foster and Madame Jais did that. I arranged everything else.

Your father knew that I had sincere affection for him, and I believe that he had a like affection for me, though at times he did weave a web of fiction, or what he would call a romance, which was pure or impure fiction, about me. He was not always a good reporter. For example, he was never able to make a good drawing of me, though he tried it many times. He always made me look like a young Priest, just out of Maynooth; no lines, no modelling of the face.

He was an affectionate lovable man. His talk was more interesting than most books, more brilliant, more amusing. He never preached or cared to instruct or to improve. He followed the gleam. Down to the end, life was still full of interest and mystery. And now that he has sunk into his dream, there ought to be no regrets.[4]

Yeats tended to make his trips outside Dublin down to the south of Ireland now; and was extending his intimate knowledge of the Ireland

[1] JBY to Isaac Yeats, 15 July 1919. The artist's estate.
[2] Letter to Isaac Yeats, 16 May 1921. The artist's estate.
[3] *The Measure* no. 5, July 1921.
[4] John Quinn to Jack B. Yeats, 4 May 1922. The artist's estate.

he sought to portray, perhaps preserving the spirit of Sligo in his work, but including subject-matter from all over Ireland. During the 1920s he painted a great deal in Kenmare, Glengarriff, Parknasilla and the Burren, much of his work consisting of straight landscapes. He was illustrating. In *The Weaver's Grave* (1922), artist and deceased writer, with their imaginative humour, are in complete sympathy. A comparison with Harry Clarke, Rackham, and Dulac show how very advanced Yeats's art had become.

The confidence of his painting at this period is manifest in such works as 'On Drumcliffe Strand' (1918), 'The Sea Captain's Car' (1922), 'The Funeral of Harry Boland' (1922), 'The Liffey Swim' (1923) and 'By a Riverside Long Ago' (1923). He was breaking away from the influence of the print and beginning to disassociate himself from the artist who designed the prints 'Sunset' and 'The Strand Races' for his sisters' press. He began to think of himself in an international context. The reaction against the image of an illustrator went so far that from now on he stated definitely that none of his paintings was to be reproduced. He refused the Tate the right to reproduce his painting 'Back from the Races' except in official publications, for the purpose of copying by students.

I am not a great believer in broadcasted reproductions of pictures. I know it spreads a diluted pleasure in pictures. But I think when anyone sees a picture they should rest on the memory of it. If they buy a little photograph of the picture as they go out, that little photograph stands always between them and the picture.[1]

Next he turned against the prints he had done for Cuala. He told WB that they were retarding his progress as an artist. His art was not a static one, but a living art, and he was a 'living artist'.

I know you are doing a great deal for Lilly and Lolly and it is very good of you. But I can do no more. The last two or three drawings for prints I have given them against my will. These reproductions are a drag, and a loss to me in my reputation. I refused to two different people several years ago the right to reproduce my 'Old Ass'. And last year I would not make a design for Bristol publishers who wanted one similar to the Cuala Prints. If I had the ready money I would try and buy up the copyrights of all the prints of mine which Cuala publishes. It is not any question of personal dignity. As far as that is concerned I would draw

[1] Letter, 30 April 1925. The artist's estate.

with chalk upon the walls. You say my painting is now "great". Great is a word that may mean so many different things. But I know I am the first living painter in the world. And the second is so far away that I am only able to make him out faintly. I have no modesty. I have the immodesty of the spear head.[1]

He wrote to Lolly on 6 February 1926:

I have coloured the proofs and send them now. When you send me the 'Hurley Player' I will colour it also. These reprints from the Broadside are the last I can give leave for.[2]

[1] 31 October 1925.
[2] Some of the Christmas cards are still being reproduced, and he must have relaxed his embargo at a later stage.

Head of a Man (self-portrait)

Chapter 12
Memory into poetry

'. . . Of what is noble and brave in man or beast he is more appreciative than any one I have ever known,' Terence de Vere White writes about Jack Yeats in *A Fretful Midge*. 'He accords to all things their proper dignity. And this is apparent in his manner which, though kind and easy, is not without a certain ceremoniousness.' He was sympathetic to children, and took part in their games with delight. Once, walking up the drive to Mespil House to take tea with Sarah Purser, as he passed under the trees he felt small stones tapping on to the rim of his hat, and bouncing off again on to the ground. Unlike the guests who had come before him, who had looked up into the tree irritably, and hurried on, he assumed an air of mystification, peeping about him, scratching his head in bewilderment, jumping backwards and forwards over the pebbles, to the great delight of the Purser children watching him from above.

One day at a party at Sarah Purser's a Purser child found herself pinioned between the piano and W. B. Yeats's back as he talked to another guest. She was in despair as she wriggled and struggled to free herself without disturbing the great poet. The next moment a head appeared over WB's shoulder and two eyes looked at her: Jack Yeats put out his hand and drew her through, asking her to come into the garden with him and pick gooseberries.[1] Many years later, when he visited Knockraheen to see 'Those Others', prior to an exhibition, he divided the time between playing trains with the youngest child, who

[1] Mrs. Brigid Ganly.

was three, and gazing silently at his picture.[1] A golden-haired child became a frequent motif in his final works.

He turned against hunting in middle age, and deplored predacity in any form. He said to Lady Gregory in 1921:

I wouldn't care for the coursing, I agree all hunting and coursing is horrible . . . there was time when nature did not require the aperitif of cruelty. You may have heard how in India in a long drought when the beasts were tamed by the agony of thirst a young subaltern was sitting by his tent door, having a cup with a little water in it hanging in his hand, and a hare came out of the edge of the jungle, staggered to him, buried its long bony face in the cup and drank. There is not a living man who could look on such a sight without some wrinkling of the emotions.[2]

His humour was yet perverse. A story is told of a nameless lecturer on art, who came to Dublin, and a party was improvised to entertain him.

Yeats was one of the guests. The visitor proved himself a crashing bore and the luncheon was an unhappy affair. Only one of the company exerted himself and the others sat around while the visitor and his local accomplice pontificated about this and that. In the course of their conversation the name of Cézanne came up. They talked about him a great deal in a rather self-conscious way. When they drew breath, Yeats made his first contribution to the conversation: 'Cézanne, Cézanne, Cézanne, sez you.' It was also his last. After so epitaphic an utterance the party could only break up.[3]

He denounced old masters as painters of 'brown pictures', they were 'journalists' – except for Goya; and English painters as a race were dismissed summarily.[4]

Ready as he was to express some view on other matters, Yeats was reluctant to make any direct comment on his own painting. The loosening up of every element in the picture, the breakdown of shapes, the overflow of colour from one part of the picture into another, seems incomprehensible to most people. Yeats was being satirized in *Dublin Opinion* in 1930 in the way Pollock was to be some years later as the

[1] Mrs. Nuttall.
[2] Letter quoted in Lady Gregory's *Journals 1916–30*, ed. L. Robinson, 1946. pp. 18–19.
[3] T. de Vere White. *A Fretful Midge*, pp. 117–18.
[4] *Op. cit.*, pp. 117–19 and account to author.

artist who hurled a bucket of paint at the canvas and stamped on it with his boots.

He allowed no one to see him painting, but shut himself away in his studio within regular hours to work. In Fitzwilliam Place the flat consisted of rooms and a kitchen on one side of the landing, and his studio on the other, where he slept and kept his private papers. Any interruption would break his concentration for the rest of the day; and since Cottie, feeding the birds, would rush in unwittingly to tell him about the latest visitant, he used to remind her of his wish to remain undisturbed by tying a pipe cleaner around the door handle whilst he was at work.[1]

He made two comments, however, which explain the change to some extent, one made years before it occurred, the other when his early manner was almost forgotten. In 1913 he foresaw the change in a letter to John Quinn.

The great good these post-Impressionist and futurist will do will be that they will knock the handcuffs off all the painters.[2]

Years later he supported this statement in an interview with Sir John Rothenstein. Rothenstein asked him why the artist's vision developed all but invariably in the direction of increased generalization, and his handling of paint in that of breadth. 'I believe', he replied, 'that the painter always begins by expressing himself with line – that is, by the most obvious means; then he becomes aware that line, once so necessary, is in fact hemming him in, and as soon as he feels strong enough, he breaks out of its confines.' The artist had become confident. He had liberated himself as he relaxed into a thoroughly equable medium.

In fact the alteration in style is not so radical as it might appear on the first comparison of works of 1915 and 1925. It was a gradual change in an artist outgrowing his old manner. Each stage developed out of the last. Yeats had been painting in oil for fifteen years before the marked stylistic break. The first works carry on straight from the watercolours, with strong images silhouetted for emphasis, these giving way to the compact compositions of 1912 to 1917, still descriptions, in firm decisive

[1] Miss Anne Yeats.
[2] 14 June 1913. New York Public Library. Manuscript Collection.

brushwork. The brush begins to stray after this, in such fine creations as 'The Sea-Captain's Car' and 'The Island Funeral', broad and expressive, though the palette is still fairly conventional. By 1920 images are expanding. In 1923 the outline vanishes. At this point a painterly quality commences in representational works which have a freedom and a lyricism that is new, rich broad strokes hinting the colour to come, with soft expressive power rejecting the former constrictive outline. A flood of poetic masterpieces from 1925–7, including 'The Bus by the River', 'We are leaving you now', 'The Breaker-Out', parallel the esoteric 'Those Others' and 'The Scene Painter's Rose', in the first of his great periods. In the thirties paint is used even more abundantly, ignoring the brushstroke, tamed with a scoring knife in relatively few but memorable compositions, 'From Portacloy to Rathlin O'Beirne' in a galaxy of sober and gleaming colours, 'About to write a letter' magnificent in its purity of tone. With the forties proliferation returns. The brush leaps into action from the start and draws and draws. It is a brush transcended, at times a paint tube transcended. The impatient hand ignores the palette and squeezes pigment direct from the tube on to the canvas, or applies it with thumb and fingers. The last large canvases, for instance 'Shouting' and 'Glory', have a freedom and an aristocratic poetry where canvas texture combines with impasto to express a final abandon.

There was reason for Yeats's change in manner other than a purely stylistic development. He had always been interested in the concept of memory. 'No one creates,' he wrote to Joseph Hone; '. . . the artist assembles memories'.[1] Memory had an emotional root for him when he was living away from Ireland. He expressed something of this in his watercolour 'Memory Harbour'. By 1920, after the first 'Half-Memory' and Dream sketches, brief psychological scribbles in his notebook, memory had become an obsession, and memory and dream as mind stores had become inseparable. 'Half-Memory' for him meant a state where memory was stimulated and transcended by the imagination. He was freed from the past. The new state allowed memory to develop and fluctuate after it first gripped the mind, to distort the original experience. It gave licence for the inclusion of extraneous forces, or for the addition of detail not necessarily relevant, but carried in by a fresh emotion at the

[1] 7 March 1922. University of Kansas Libraries. Department of Special Collections.

moment of painting. In this way the original experience was translated into a newly created and visionary happening.

The idea of 'half memory' is similar to that in the romantic definition of poetry. According to Keats 'poetry should surprise by a fine excess, and not by singularity; it should strike the reader as a wording of his own highest thoughts, and appear almost a remembrance.' Then Wordsworth: 'Poetry is the spontaneous overflow of powerful feelings: it takes its origin from emotion recollected in tranquillity.' 'The spontaneous overflow of powerful feelings': thus were created the late masterpieces. 'Emotion recollected in tranquillity'. This is Yeats's half-memory.

Yeats always believed that paintings should be of incidents witnessed by the artist, and he insisted on the instantaneous quality of a painting, the event recurring: 'each painting is an event. . . . A creative work happens.'[1] The 'half-memory' paintings of the middle and late periods invariably refer to some particular incident in the past, or look to past events experienced emotionally by the artist. The latter half of the nineteenth century was the heyday of the small circus, the minor music hall, the travelling melodrama players, of amateur boxing and races, of the nigger minstrel and the thrill of the Wild West: and Yeats looked to those days in retrospect, enjoying fully the adventurous characters whom he knew from seeing them in the flesh, or from reading books. He knew and met Mark Twain, he admired Bret Harte. Even his fascination for ballad and folk-song drew him to the late nineteenth and early twentieth century rather than to traditional Irish music.

The titles tell of the past –

'A Summer's Day near a City long Ago'
'The Old Days'
'The Show Ground Revisited'
'In Memory of Boucicault and Bianconi'
'An Evening in Spring'

– and subjects, literary and pictorial, personal, impersonal, on every level, are culled from the past at a fresh moment of inspiration, and through imagination converted into a painting which binds all elements together in a poetic complex, with words and with paint.[2]

[1] Quotation printed in the catalogue of the exhibition organized by the Boston Institute of Contemporary Art, 1951-2.
[2] For his use of words see *Irish Arts Review*, Summer 1986, 36ff.

Memory becomes poetry. The poetry of words works through the suggestive titles. 'The Death of Diarmuid' – The Last Handful of Water' (1945) pinpoints the dramatic and emotional climax in the story of Diarmuid and Gráinne. In 'Queen Maeve walked upon this strand' (1950) the artist makes an ancient character live in the present moment. There is poetry of expression in 'Welcome' (1943), where an advancing figure salutes a gracious still silhouette with the bond of a handshake, scarcely a movement in the peaceful landscape about them; in 'The Whistle of a Jacket' (1946), where paint in the sky and grass urges a magnificently depicted horse and its eager rider on their way. The poetry of paint expresses all that could be desired, with a rich imagery of colour and of tone, and of lighting, of detail, of sheer dancing pigment.

Once the new mode of expression had taken hold of him Yeats planned its course in a strange fashion, as before training his brush not through the study of other artists but by turning to printed prototypes of the figures he wished to incorporate in his painting. He had been collecting newspaper photographs of everything quaint, and of all the topics that had permanent interest for him. Cuttings of musical instruments, or acrobats and boxers, line reproductions of early nineteenth-century portraits, of old figureheads, and of dogs and other animals were amassed in profusion. 'The Old Sea Road' (1932), may have been inspired by a photograph in his possession of the head of a grey donkey with a wall in the background. Through these he discovered the relationship of line to mass. He sorted out 'photographs of groups for contrasting lines', 'for curves and angles'.[1] He cut out photographs of groups at dances and dinner parties, of dock scenes, cranes, lorries, of spring lambs on a farm, and with an ordinary crayon outlined the general mass of bodies or form, for instance the rounded line of the jaw broken as it joins the cranium by the ear, and then the contrasting line sweeping down from forehead or shoulder; the horizontal plane of the ground, and the solid horizontal, the vertical round, of a well-covered sheep; rounds of lorry top and of wheels opposed to the angularity of metal bridges, of steamers, of machinery, about the quay at Alexandra Basin by the mouth of the Liffey. In the curves of rigging, he saw diagonal curves, both broken and parallel. In groups of people he was interested in the curves of lines of the

[1] His own words marking bundles of cuttings which date from about 1930 to 1940.

shoulders, behind and in front, in heads starting up from the main mass, in the angles of each head and of individual arms as they combine in number. The results of the exercises are clearly seen in the linear quality of his brushwork and scooping palette knife strokes.

Subject-matter in the late painting varies little from that in his early work. He draws on the same records of experience, his numerous sketch-books, his memories and his emotions. He paints the sunset in Dublin, from Aston's Quay, where the bridge between reality and exaltation is very narrow. Muldoon and Rattlesnake, the prodigious pair commemorated in an early watercolour, appear again in a vigorous oil of 1928 where the restless paint embodies the moment of tension before the start of a race. An Irish village is the background for several paintings, packed with people in 'Above the Fair' (1946), with a child surveying all from the broad back of an enormous horse. 'The First Ferry' (1947) pivots on its romantic title, and the central figure of a young girl, rowed with a companion across the river in the morning mist. There are ticket offices, piers, cottages, the river ferry in the city, a tram crossing a bridge.

Sometimes names and phrases peculiar to Ireland can create an effective image. 'A Race in Hy-Brazil' (1937) is a race in the Blessed Isle purported to be off the west coast of Ireland; and the light treatment, in the weightless figures, as well as in the pale colouring, catches the vanishing land perfectly. Boucicault and Bianconi, names now that are accompanied by footnotes, were known generally when he lived in Sligo. The first play he saw was *The Shaughraun* by Boucicault. He travelled to and from Rosses Point on a 'bianconi car'. In 'In Memory of Boucicault and Bianconi' (1937) he includes hero, villain, Harvey Duff, Danny Mann climbing up by the waterfall, together with a long car halting while the players strike attitudes in the shallow water of Glencar. Grania, the fickle lover of Diarmuid, is recalled in a painting of a sunset – 'And Grania saw this sun sink' (1950).

Melodrama is still a part of the pattern. 'The Avenger' (1928), a tale of tropical clime, is predecessor to 'He Will Not Sign' (1952), another moving scene in some unknown romance, where one single moment captures the portentous spirit of an intricate drama. There is a theatrical urgency in the painting 'Now' (1941), depicting the point at which the

conductor raises his baton, and a team of horses prepare to prance on to the stage.

With the addition of the dream element, however, subjects acquire a symbolic meaning. Thus the well, in 'The Face in the Well' (1939), is used metaphorically as a store for memories from which inspiration may be drawn. 'Rise up Willie Reilly' (1945) is not merely a picture of a ballad singer entertaining a listener. It symbolizes something deeper. The young man, kneeling, clasping his hands, feels some inner response to a life of freedom and exaltation. The veil of the ballad singer may be interpreted as a religious symbol. She may be Cathleen ni Houlihan. The picture may be explained on a variety of levels. It was painted just as the Second World War came to an end.

The landscape, now, no longer the complementary setting for the main character, is rather a setting that transcends the emotional theme. There is something of the pathetic fallacy in the treatment of 'The Un-forgetting Background' (1949), and 'The Violence of the Dawn' (1951) and a host of other works. The straight landscape is rare, and is generally superseded by a scene transformed through the emotion it arouses in the beholder.

'The Haute École Act' (1925) is a haunting tragedy of a comic man in love with a beautiful but disdainful equestrian. He is gay for a moment in 'When the cat's away' (1949). In 'This Grand Conversation was under the Rose' (1943) the *haute-école* rider and the clown have descended to the same level, but they are both beings in isolation still, drawn together *sub rosa*. The circus presents a structure of imagery for life, for its tragedy and comedy. 'The Clown among the People' (1932) is both personal and universal in its reference, portraying the loneliness of the artist and all men. Similarly, 'The Tinker's Encampment, the Blood of Abel' (1940) and 'Grief' (1951) are works citing particular incidents of horror and violence which bring their force to bear on human kind in general. 'Humanity's Alibi' (1947) depicts the Sligo barrel man of gayer days, now Man, ducking from the slings and arrows of Fellow Man, without the hope of safety in a protective barrel. In 'The Face in Shadow' (1946) the familiar seaman stands on a hillside turning away from the seatown below him: his facial expression, and that of the man watching him tell a more poignant tale than that of a fisherman leaving home for a spell.

In a less sombre way 'The Scene Painter's Rose' (1927) captures the personal side of Yeats's art in the depiction of the symbol he adopted for himself. He always painted with a rose pinned to his easel, or placed on the table beside him, and it appears in the latter fashion in the painting. Yet the painting embodies the spirit of art in general, the private thoughts of all image-makers seeking something inexpressible. 'My Beautiful, My Beautiful' (1953), the Arab embracing his steed in the desert, expresses delicately the peak of affection in all mankind.

The paintings, even in his most abstract works, are straightforward to the viewer who is willing to enter into the fantasy, and to create the painting for himself. The tale, the details, the emotion, are there; Yeats insists alone on the capitulation of his viewer. He would talk about his paintings, providing a story as a background, with the greatest facility, and charming anecdotes which shed light but to which he himself attached little importance, generally turning to his listener when he had finished and saying, 'Now you tell me what the picture is about.'

A painter who had begun by being completely objective now came full circle and was thoroughly subjective in his approach. He was the channel through which inspiration and experience poured. He even stepped into his paintings.[1] In 'Morning after Rain' (1923) he paints himself leaning on the wall of Sligo Bridge, looking into the water, contemplatively. Two years later he appears in the painting 'O'Connell Bridge', hurrying over with Cottie, rejecting the advances of an importunate beggar. His likeness flits in and out of his work, in the 1940s the tall ascetic figure exploring the former scenes of his youth, brooding with loneliness in the Banquet Hall paintings (1942, 1943), and 'Where Fresh Water Meets Salt Water' :1947); in 'A Silence' (1944) filled with anticipation; with resolution in 'People walking beside a River' (1947); with acute desolation in 'The Great Tent has collapsed' (1947). They are emotional, often nostalgic works, joyous, grave, lighthearted, melancholy, reflective, inspired, despairing, works of immediacy and drama, works of a deeply personal nature with a very far reaching significance: and in the final works emotion itself, rather than event becomes the subject of the paintings.

[1] Cf. p. 153, Mr. No. Matter and Bowsie in *The Charmed Life*. During the 1920s he was producing a number of pen self-portraits; and his image is included in a great number of his paintings thereafter.

Several types of composition repeat themselves regularly in Yeats's work, particularly in the late phase.[1] Interiors of theatres were common before, but now interiors of rooms are a frequent theme. The confined space is often joined to the landscape outside through an open door or a half-door, in such works as 'Am I on the right road for the sea?' and 'The Lake Window' (both 1950), where a figure looks in from outside.

One trick the artist uses to draw the spectator into the picture is to place a half-length figure in the side foreground of a landscape, looking down at the view below or, as in 'The Expected' (1948), gazing at the group who approach him. The eyes then may be carried further into the picture by a peninsula extending in the centre ('Many Ferries' (1948), 'Men of Destiny' (1946)), or by a row of receding houses, as in 'The Music of the Morning' (1951).

Groups of figures are as common as the single figure or horse skipping away into space, and they are treated as emotionally, sometimes in a great uplift of joy, sometimes breaking away from one another as in 'The Parting of Three Ways' (1950), 'On the Move' (1950), and 'We shall not meet again' (1952). Occasionally the groups are scattered into every corner of the canvas, and these are some of the strongest compositions.[2] Another favourite theme is that of reflection in a pool, perhaps a tramp on a moor, or a child, as in 'The Sea Anemone' (1948). The child as a symbol of youth appears in a great number of Yeats's late paintings, very often sailing the toy boats he had enjoyed for so long.

The frequent recurrence of similar kinds of composition virtually undeveloped, may be a limitation. Occasionally the pictures consist of a single evocative figure set in a plain stretch of landscape. It is not the compositional structure but the emotion the figure conveys and the poetic treatment of colour which carry the picture.

Another weakness lay in his disinterest in technique. This has meant that his paintings have not always been durable.[3] The artist worked on

[1] All of his paintings after 1918 are horizontal in shape.

[2] 'A Race in Hy Brazil' (1937), 'The Blood of Abel' (1940), 'The Last Dawn but One' (1948).

[3] Methods of conservation now formulated are proving satisfactory. I am indebted to Mr. Malcolm of the Victoria and Albert Museum, and to Mr. Matthew Moss of the National Gallery of Ireland for advice on matters of technique.

prepared canvases and panels, sometimes adding his own priming, and he disliked using varnish. He said that he would paint all of his pictures on wood were it not for the danger of warping in larger pictures, which obliged him to use canvas.[1] His canvases are fine and smooth. This has had attendant dangers in shrinkage, and an inadequate use of oil has sometimes caused shrinkage of paint.

His approach to colour, however, is sensitive, and imaginative. He used only six colours, though he employed several shades in each, which mixed together produced different hues and tones. In his paintbox[2] he kept a little Flake White, though mainly Titanium; Ivory Black; Winsor and Cobalt Greens; Winsor Yellow, Cadmium and Aureolin; Scarlet Lake, Alizarin Crimson, Scarlet Vermillion and Rose Doré; Chinese Blue, Cerulean Blue, New Blue and Winsor (which are royal and navy), Manganese and Prussian Blues. His emotional feeling towards paint is very evident in his writings as well as in his pictures:

I know that indigo is not a primary colour. But it's an axle, the top of a Giant Stride, from which the ropes dangle in quietude, but swing out wide in movement, when from the end of each a strong young boy floats. Indigo was the strongest colour in the old pictorial theatre posters which used to decorate two or three corners in the Seaport Town in the West of Ireland, where I first saw a stage play . . .[3]

Indigo was a theme colour of many of his paintings during the 1940s.

Yeats, perhaps because he disliked being described as 'the poet's brother', clung to his individualism, and never attempted to form a school of painting, or to join any group of artists. There was an inevitable interchange of ideas, despite his inclination to remain independent. His work around 1915 is akin to that of Paul Henry, as part of a general trend.[4] Sir Kenneth Clark has noted the stylistic similarity at different periods to Daumier, Monticelli, and Mancini.[5] There are hints of

[1] Dr. F. McGrath.

[2] He told several people that he used only five colours in his paintings, but there appear to have been six, not five. He used Winsor and Newton paints.

[3] 'Indigo Heights'. *The New Statesman and Nation.* 5 December 1936, pp. 899–900.

[4] The influence of Sickert is mentioned in Chapter 10. J. B. Yeats was sending him prints of contemporary American painting about this time, but they had little effect on him.

[5] *Horizon* V, no. 25, January 1942, pp. 40–2.

Previati and Steer in his lighting; and the phenomen of Turner nearly a century before should not go without comment, though light and subject-matter bear little comparison. He has been compared to Ensor. Mr. Beckett has suggested a suitable parallel with Watteau: the dream world of 'L'Embarquement pour Cythère' is recalled by 'Tír na n-Og' and 'A Race in Hy Brazil'. Among contemporaries there are Kokoschka, whose emotional approach is in some ways like Yeats's, and who was very much struck by the Irish painter's work, and Topolski, the latter's brushwork resembling that in Yeats's drawings of the forties. But no one can be described as the formative influence of his late style. Yeats's art was his own.

His paintings have the breadth and spirit of the great. He kept alive all of the qualities of the Irish people of his time, in legend, in folk life, in real event; the love of tale, of the sound of words, of the half-said, even of the quarter-said statement. Then he combined his creative with his intuitive faculties to bring about an individual revolution in Irish painting that broke through the barriers of nationalism and raised Irish painting into the forefront of twentieth-century art. His art is the poetry of vision.

Heading to Prologue of *The Green Wave*

Chapter 13
Sligo

Yeats made an enormous impact with his new style of painting. In 1929 he held his London exhibition at the Alpine Club Gallery, which he described to Lady Gregory as 'the biggest gallery I have had for myself in London. So I will have room to hang my pictures not "high" but "wide and handsome"'.[1] His pictures were now receiving good notices. Everyone was getting 'more intelligent'.[2] Mrs. Shaw, who had thought of his last year's exhibition that he had 'gone mad' retracted the statement, now; and GBS with his namesake 'aircraftsman Shaw (Lawrence, Arabia Lawrence)' visited it, 'both thrilled by the pictures'.

He became in the thirties a public figure. He was kept on the move visiting and opening exhibitions all over Ireland. He was invited as guest speaker to dinners and receptions.[3]

But the period when a blank public through pressure of critical opinion was beginning to accept him as a leading artist were years when Yeats was turning again to what he regarded as an inferior medium to painting, the spoken word. He painted comparatively little during the thirties, he held only two one-man shows and was chiefly to be seen in group exhibitions.

Yeats's prose writings are original, penetrating and engaging works, one of their first delights being the unaffected spontaneity and the simple

[1] Letter, 26 January 1929. New York Public Library. Berg Collection.
[2] Letter to Lady Gregory, 11 March 1929. New York Public Library. Berg Collection.
[3] He named the last ship in the Sligo Steam Navigation Company before the business passed from the family into other hands.

joy of the writer in the sound of words; this though he described *Sligo*, the first book he published, as 'likely to be the last book in the world', and constantly lamented the weakness of literature as a means of expression. 'No more word painting', 'Bury speech', 'Language is failing', he wrote.

There were three kinds of prose. *Sligo*, *Ah Well* and *And to you also* are reminiscences of a scattered nature, without any consecutive thread, where he jotted down stories and notes of odd and interesting things he had seen, digressing freely, writing 'to jettison some memories', and in *Sligo* giving the impression that he was setting out, in so far as he wished, to write an autobiography. The novels are broad and free, each one different from the other, the provocative simplicity of *Sailing, Sailing Swiftly* altering to the elusive esotericism of *The Amaranthers*. They are Victorian tales – leisurely detailed descriptions where character and idiosyncrasy play important parts – but tales related by a twentieth-century writer. The third kind, plays, where he was something of an innovator writing before his time, are paradoxically both realistic and fantastic in their inconclusiveness. Yeats's sense of finality, however, is not the stark satire of Beckett; he writes of events that have already happened, small sections in an over-all pattern, and does not suggest that tragedy involves the unseen future.

As with his painting it is difficult to name a direct influence. Yeats had been taking a great interest in Joyce and Joyce criticism. Joyce had bought two of Yeats's paintings,[1] and declared that their creative methods were similar.[2] The paintings looked down from the wall in his Paris apartment, 'pictures, I need hardly say', wrote Conn Curran, 'of Anna Liffey. . .'[3] Yeats was reading D. H. Lawrence, but he also enjoyed Griffin, Lever and Lover and the American adventure stories of the nineteenth century. He owed the original inspiration for the Rope family, in *Sligo*, to *Erewhon*; and Bowsie of *The Charmed Life* and Baron in the story 'A Fast Trotting Mare' to Baron Munchausen; while the man of 'grey air' in the opening pages of *The Charmed Life* is reminiscent of the enchanted corpse in Stephens's *Deirdre*. Colourful expressions were taken straight from George Borrow.[4]

[1] 'Porter Boats' and 'Salmon Leap, Leixlip'. [2] Yeats, W. B., *Letters*, p. 764.
[3] Obituary, *Irish Times*, 14 January 1941. [4] Letter to Ria Mooney, 10 May 1939.

Conrad he dismissed as conventional, a 'slave' writer,[1] and he com-
pared him unfavourably with George Moore, whose *Spring Days* he read
when it was reissued about 1916. Moore's characters lived for him, had
known life. The matter-of-fact narrative with the touch of satire has
much in common with his own prose style.

> The novelist, who respects his workshop more than life, can make breasts heave,
> and arms wave, and even eyes flash. But he cannot give his people pulses. To me,
> man is only part of a splendour and a memory of it. And if he wants to express
> his memories well he must know he is only a conduit. It is his work to keep that
> conduit free from old birds' nests and blowflies,

he said. Yeats worked parallel to the direct stream of modern prose
writers, in his colloquial approach and 'chain' thinking,[2] though these
were natural tendencies. Joyce, and his own brother, probably, gave the
impetus; and the rest followed automatically. The books express Yeats's
personality, his full mind, and imagination overflowing in words. He rose
instantly to another plane, conjuring up situations, and the new medium
extended his vision, bringing to his painting a more precise literary
quality.

Yeats had no particular reason for writing, other than the unburdening
of his very active mind. He had no particular message, except for his
message of charity. 'Never have a narrow heart.' His characters live their
individual lives, coming together, then separating through a change of
circumstances, perhaps meeting again, parting through death. The works
are books of living and of life. The one common likeness in his characters
is that they are all active forces of one kind or another, innately benign,
whether crook or idealist, according to their own principles. Phénicie and
the magistrate in their tropic home, where 'everything was graceful, ease,
and an air filled with a continuous murmur of quietness', forswear the
eating of flesh: '. . . no living animal, fish or bird, died to make a meal
in that place.'[3] Their visitors James and 'O' appreciate the atmosphere
of long living peace during the evening they spend there, but there is no

[1] Letter to John Quinn, 17 November 1920. New York Public Library. Manuscript
Collection.
[2] *Sligo*, p. 28.
[3] *Amaranthers*, p. 200.

suggestion that they abandon their own way of life for the new one after they leave.[1]

Sligo was published in 1930, when Jack Yeats was fifty-nine. It opens with a visual image, the writer sitting on a hill looking down at the Regatta. Spoken word and pictorial are inextricably interlinked; and from this the never-ending flow of thought and association grows. There is no explanation for the title during the first thirty pages, though the book is set in Sligo, and the content pivots about life there: thence ranging by implication and metaphor to America and New York, London, Devon, Dublin and its quays, and every place the writer has known, and inevitably returning to Sligo. Then:

About a name for this book. I was making some notes one day while travelling in a train through a boggy country in Ireland when a melodeon player opposite me asked me if I wouldn't stop writing and 'give out a tune' and he handed the melodeon towards me. 'I have no ear', I said. 'Ah, to hell with ears', he said 'I play it with my body. Are you writing a book?' he said. 'Well, I am making notes for one', I said. 'What are you going to call it?' he said. 'I don't know yet,' I said. 'Call it Sligo. It's the name of a town,' he said, 'the only town in Ireland I never was in. I was near it once but I stopped on the brink and took the long car with a unicorn yoked to it for a town called Ballina. Call it Sligo, it ought to be a lucky name.' So Sligo it is.

The matter swings between Life, at the Regatta and so on, and Death – daisies by the road – touched on lightly.

... from daisy chains to graves They follow us; and give us our chance to wheeze at the big melancholy talk. With laughter we come, with laughter we go. Arms reversed. Muffled drums when I lie under the daisies.

But life goes on – 'Drinks for the watchers.'

Yeats is back with memory in a house in Sligo, recalling with all of his senses the old life he knew, and further back still, to historical times. He turns to the races on the strand, but draws close, leaving the hill top. Colouring is vivid. Sligo is seen in the context of the world.

This is in the autumn and the sun sinks so early that when it is rolling away from

[1] As in his miniature theatre where Yeats indulged his private humour so there are still personal allusions. 'O' comes from Yeats's friend Captain Warner whom he dubbed 'O Warner O!'

our bay it is waking up brothers and sisters of this land in their homes under the Star Spangled Banner.

Racing makes him think of boxing and ballads, circuses, fairs, and 'crook drama' or melodrama:

A little while ago I saw a stage door, I mean a door on the stage, open and a rotund corpse with a knife sticking up in its back come full whack on the floor and bounce, and I was glad. I was seeing a Crook Drama, I do not go to Crook Dramas to learn anything: I wonder do crooks go there for that purpose, to see how to do things. Rather useful that. But then detectives probably go to see how stage detectives work, very useful that also.

He remembers barrow racing, sculling, rain, and a committee meeting.

How electric the air is, when the Chairman flops into his seat, trying to make his face look as much like the back of a spoon as he can, and the Secretary reading the Minutes of the last Meeting in a hurried mutter like family prayers in a morning when there are two bad headaches in the room. With what delight the boys sat up when the Secretary I am thinking of hit the first Minutes that had any bearing on the carnivorous business of the day. Then each man looked at his neighbour, if he was not already certain of him, to see how his eyelids flittered. Then suddenly the real moment came. The meeting took two deep breaths, particularly deep, from the man who had been reading a book about deep breathing and success in life. And then up floundered the wrong man, wrong from his side's point of view: he got up to bellow out his speech before he forgot it, and so that he could clear himself of it and enjoy the rest of the bloodshed . . .

In the midst of all Yeats sets a gentle parody of evolution in his account of the history of the Ropes family. It is a rich tapestry of memories and thoughts, woven skilfully from a single mind. The future is absent, the pattern of life is what has already been experienced and makes up each human being with an enigmatic gap for what is to come. The question mark is inevitable in Yeats's writing. His personality dominates, the love of nonsensicality and stories, his conception of a continuous existence of successively changing people where life and death interlock is presented with impish quizzicality. *Sligo* he states was written to secure him a place in the millionaire class. He quotes from an Irish song to round off his book, finishing on the stream of continuity he recognizes:

'As well forbid the grasses from growing as they grow', and so do I.

Those who knew Jack Yeats felt that *Sligo* expressed his personality. He sent copies to his closest friends. Sarah Purser thought she would like him to explain certain obscure passages.[1] Tom MacGreevy admired his literary style, and lent the book to Beckett. To John Masefield it was a 'jolly book'. 'I took it out and read it through as soon as it came, with the feeling that I was having a long talk with you. It gives me a wonderful sense of being in the West of Ireland in the days of horses and sails. . . . I say to *Sligo*: "Soar on, blithe book." ' Another friend, Miss Vida Low, wrote to him from Penzance recalling memories of even older days, London buses with oil lamps and straw on the floor, sweeps dancing Jack in the Green on May Day, and a French Man of War chasing a Prussian ship.[2] WB told his brother it showed more of the 'true mind and life of Jack Yeats' than his biography would ever show.[3] His brother was glad, and replied that he had liked 'running alongside (or inside) Sligo' when he was writing it.

The other two small books of reminiscences were published ten years after *Sligo*, and have a detachedness and a slightly more sombre quality. Dream and fantasy are more in evidence, joining forces with memory. In *Ah Well: a Romance in Perpetuity* (1942) words float away 'like paper money of an inflated coinage', the images are even closer and more relevant to the paintings. A small boy robbing a wild bird's nest gives back an egg to a distressed bird.

He went a few paces from the tree and he turned his head and saw the bird rustling back to her eggs, and his face was dyed a purple black with the sudden flow of his wild childhood.

As elsewhere two opposite characters create a tension that keeps the ball of thought rolling. Imagination conjures up the 'old brown man' of clay who sits on the studio table and converses mentally with Yeats, muses, interpolates tales and reminiscenses. Two main unfinished stories are included, that of the E-shaped town and its inhabitants and theatre, the other about a group from the town, Pigeon, the Turk, the Absolute, Pizzarro, Carmine and Foley, who ride on the heights to view the town

[1] Letter to Jack Yeats, 15 June 1930. The artist's estate.
[2] Letter to Jack Yeats, 4 June 1930.
[3] Letter to Jack Yeats, 18 July 1930.

from above and after relating their personally interpreted pasts to the old brown man part company leaving him to draw the threads together as he leaves the E-shaped town and journeys to another. Like Beckett, in *Waiting for Godot*, Yeats represents all creeds and castes. Each interacts upon the other, and the symbols converge on an enhanced plane where emotion embraces thought: then the old brown man returns to earth quietly in the traditional Irish storyteller's way:

. . . I was thinking of nothing, when a man came out of a gateway to the West and he led a brown stageen of a horse, by a straw halter, and he looked up at me, and he said 'Come down out of that, sir, it isn't meet that two should ride the one horse into our old town. Take this horse of mine and let him take you up the path, up through the whins, a short way to the town'. I got down. I held the hand of the man who rode the red horse a moment, and I mounted the brown and rode up the hill and that's my story, sir.

Memories were jettisoned finally in *And to You Also* published in 1944. Here Bowsie, of *The Charmed Life*, written a few years before, joins the writer again and helps him to fill in gaps. Bowsie, 'the old brown man' and Thady O'Malley, are Yeats's Sancho Panzas, with the intuitive vision of the untutored, solid, down-to-earth man; they are his artist's licence, and through them are expressed some of Yeats's most moving thoughts.

The book opens with reminiscences about the lost friends of the artist's imagination. Then, inevitably, Bowsie comes to life again, the artist must have some one to talk to. He decides to say goodbye to Ginger, and Baron, the shirtless man, and with them emanates the Good Boy. Soon all four are together with an actress, talking, musing in high flown fancy as they stroll through St. Stephen's Green in Dublin. A keeper, dodging them in the trees, reminds them that it is closing time; but one member of the party was foresighted in borrowing the keeper's key the day before on a false pretext and making a mould of the key on a sandwich while he engaged him in talk: so they sit in the park on the summer's night and talk about love, pictures and death (in that order). At dawn they depart over the railings, and 'farewell, farewell, farewell, farewell', 'Farewell to you also,' says Yeats.

It is not surprising that Yeats's first book after *Sligo* should be entitled *Sailing, Sailing Swiftly*, even though it is not a novel about the sea. The

name is taken from a line in the Irish poem, 'The County of Mayo', and sets the pace of life, infecting character after character, as in *In Sand*, life revolving about County Mayo whether the action takes place there or not.

The opening pages describe the journey of two horsedealers northwards in England in the late 1860s, to take the waters in a spa town. Jasper Newbigging plans to marry off his Irish friend in order to keep him in England. Thady O'Malley has not the time, and explains, 'I'm busy and to spare, putting old horses and cars on to the road, and buying oats for the old horses, and generally supplying the commestibles of life, as the old schoolmaster used to say, for man and beast.' Jasper persists. The first sample is rejected, but he is more fortunate with a Miss Dunaven who between her duties in a newsagent's and bookshop reads below the counter Lever's novel *Charles O'Malley*. Thady's untimely demise does not bring the tale to a close. After the first events have been described the book seems to become a fictional reconstruction of personal memories, a return to and enjoyment of the physical happenings long past. Thady's son, Larry, grows up with his widowed mother and follows life as the active Yeats did, swimming, attending music hall and racing track, and he turns his artistic ability profitably to carving furniture. The old uncles in Mayo are recreations of the Pollexfens and Middletons with their monopoly of business in long cars and side-cars. There are amusing incidents. Edward Tarleton, out of curiosity, sets out to the funeral of a man who bears the same name as himself, and leaves in hasty confusion when he sees two former lady friends, one from Brussels and the other from the East Coast, advancing to the obsequies fired with the same curiosity. The book ends tragically and unexpectedly with Larry's death in a drowning accident. A funeral balances the wedding at the beginning, and Tarleton's drunken drive away afterwards brings the words to an end in a pathetic anticlimax. But life goes on. The events described cover the years from 1868 up to the 1920s, and leave an impression that the tale has not ended yet.

Sailing, Sailing Swiftly is a leisurely book, full of detailed observation and sensitive realistic colouring – a ship, 'one pale brown shade', or a street 'filled with a pale white light', and skies rendered visually in the paintings.

The day was very beautiful with clear light sky with glints of blue, and a pale yellow light to the west, when the February evening closed in.

No conflict occurs. Yeats describes a one-sided life because with this inborn willingness to accept life no event can prove completely disastrous. The philosophy is projected from the first. Annette faints when she realizes she is seeing Thady and Jasper borne back dead on the stretcher, but is herself again in a moment. 'At that time she never seemed to falter, nor at any time after.' Each moment in the Yeats novel is lived and accepted to the full, whether joyous or tragic. His frequent references to death or disappointment have no tinge of bitterness. Such sad occurences are inseparably chained to life and joy. Death is complementary to Life.

Delicacy, and a minute scrutiny and memory of the visual are conspicuous tools, with the deep affection for what is observed. The tempo of *Sailing, Sailing Swiftly* is close to that of a classical ballet, continuous narrative arrested by incident or touches of effective impressionism and illustrative movement. Descriptions can vary, a pair of girls being started at the feet and working upwards, a man appearing first with the crown of his head, growing downwards. The artist uses subtleties of colour and names of paints, sprinkled with somewhat stronger and authentic nautical and horsey terms. The visual is linked with his dramatic feeling in a Hardyish fashion, as for instance in the description of Josiah Oldbain reading his book as the figure of a man climbs up the hill towards him. He seeks to revive the actual moment and perpetuate the experience.

It was all very pleasant for those six people, the waning year softly drawing away into the down-run of the stream of all years, each one in his or her own way knew that when that holiday was over they would have a right to some private eddy in that long stream.

In the same year, 1933, Yeats published three plays, plays for performance rather than for reading, where he had definite ideas about presentation.[1] The setting of *Apparitions*, which deals with the laying of a ghost, is similar to that of a circus ring. It is to be performed in the centre of a theatre with the audience sitting around, and a gangway

[1] His first play *The Deathly Terrace*, a melodrama, satirizing artificiality and advocating unfettered life in the old-fashioned style, was never published.

with a curtain at the end, admits performers; for *The Old Sea Road*, an ambiguous murder plot, a structure must be built on the stage, with a heather slope in the foreground, a space for the bog hole behind, and the road rising behind the bog hole. *Rattle*, a narrative in three acts about a business man and a trip to the tropics, is more simply laid out, though the first scene implies three levels of stage. Later Yeats realized that the elaborate scenery and mechanical devices were impracticable, and not essential;[1] but at the time such details were important. Moods are set with nineteenth-century overtures, and each play ends with an ironical twist, reacting first on players, and then producing a side effect on the audience. They are amusing with the bathos and the compassion typical of the author, and the first two – *The Old Sea Road* is the better with its fantasy and the scope for performance – show a brilliant sleight of hand that owes something to his proficiency in model stagecraft.

Yeats's metaphysical irony anticipates Beckett by some twenty years, though with an enigmatic humour and a calm forbearance that hindered his popularity. They knew each other. Beckett as a young man visited Yeats in 1930, and continued to keep in touch. 'I'm glad you liked him,' Thomas MacGreevy wrote to Yeats.[2] 'He was completely staggered by the pictures and though he has met many people through me he dismissed them all in his letter with the remark "and to think I owe meeting Jack Yeats *and* Joyce to you!"'.[3] Yeats however did not take to Beckett's writing, his outlook, he said, was 'amoral';[4] and the moral structure of life was important to Yeats even though he would not preach it.

[1] Letter to Ria Mooney, 26 April 1949.
[2] 22 December 1930.
[3] Letter from MacGreevy to Yeats, 22 December 1930.
[4] Letter from Alan Denson to Anthony Piper after an interview with Yeats, 30 September 1954. For similarities between Yeats and Beckett, see 'Solitary companions in Beckett and Jack B. Yeats' by Marilyn Gaddis Rose in *Eire-Ireland*, Summer 1969, pp. 66-80.

Chapter 14
More books

Yeats was an active member of the Dublin United Arts Club, sometimes keeping aloof, reading in a corner quietly, gliding out of the door silently:[1] but often taking part socially. Once he suggested improvements. There should be a Mootery, he said, where questions might be mooted. When a swimming pool was added to the club building it would have to be placed on its side as there was no room horizontally.[2] Mrs. Lennox Robinson lamented the heaviness of modern traffic and said that she hated having to cross a road; and Yeats rejoined that, on the contrary, he enjoyed the experience, it was such an achievement to reach the other side. He was greatly opposed to motor cars. One day as he walked in front of Brendan Ellis the architect's car he shook his fist at it (he and Ellis were not acquainted).

He composed amusing epitaphs for certain members of the Arts Club, including the President Dermod O'Brien, George Russell, Professor Bodkin, and himself: he told Dr. Bodkin ruefully, 'I think they sound better than they look.'

The artist was working at a series of drawings in wax crayon and ink, and in about 1939 finished the final volume of seven books which he called 'Lives', giving in a visual way what he was trying to express in his prose, the hustle and adventure and melodrama he superimposed on life, lives overlapping on one another, and above all the continuity of life and its fulfilment.[3] As all his drawings, these anticipated coming oils. Lives no. 1 describes a fast active existence, racing, sailing, pistols, gambling,

[1] Arthur Power. [2] Mrs. Brigid Ganly. [3] Coll: the artist's estate.

boxing, sleep, singing, several incidents grouped into the same drawing, the last showing among other things a death by shooting. It is followed by a series of single events, intimate or exciting; while Lives no. 3 shows life as a stage, scenes observed by the artist or lone onlooker. Lives no. 4, in pen and ink only, includes many close-ups of heads in solitary reflection, one with a spider's web near it, one shouting with other heads about him; and ink is added with a brush or finger, dragged lightly over the lines indicating the veil. Lives no. 5, brief incidents, again of boxing ring, dancing, racing, add yellow or blue wash to lyrical scenes of vision and fantasy. Fantasy is even greater in the next group, different characters in emotional crises, almost abstract, or fantastical beings, nude forms on clouds, in wax crayon, with brief flicks of watercolour. A series of battles occur among the spirits, in magnificent swirling movements and attitudes – one produces a pistol with a half-tragic smile – above reality. Finally come a series of almost wholly mystical landscapes, in brief pen and ink, or wax crayon with wash touches, perhaps a whimsical note in a toy boat, or rabbits near a statue-like form seated on a rock. There is a great sense of completion in these last.

These drawings had little relevance to his paintings of the period, but rather presaged what was to come. Compositions of the mid-thirties have a definite narrative quality. 'A Visit' (1935) shows a lady and gentleman in an old-fashioned dogcart driving through the gateway of a country house. 'Donnelly's Hollow' (1936) commemorates the epic fight of the Irish pugilist with the English champion Cooper at the Curragh, Kildare, in 1815; 'Helen' (1937) rises above the ships churning in the dark sea below her; in 'An Evening in Spring', the artist gathers with his family for a dinner at Sligo. With the final years of the decade comes a great upsurge in romance in such lovely paintings as 'Once on a Day' (1937) where a girl dreaming in a donkey carriage conjures up the light men punting skiffs over the waves that billow in the distance. 'High Water: Spring Tide' (1939) depicts figures and swans on a wooded pathway.

His perversity increased. Though he himself delighted in ceremony and in a dignified way of life, approving WB's pose and poetic dress as necessary to him as a poet, he dismissed people like Richard Best, the librarian, and his wife, who consorted with the Governor-General. They

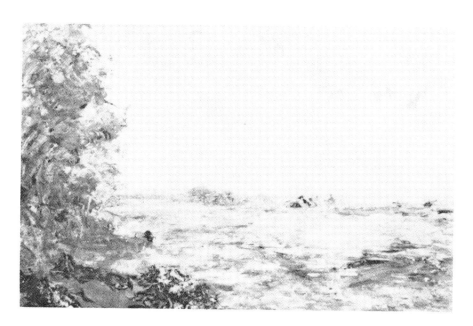

21 The lake at Coole 1943 *22* Rise up Willy Reilly 1945

23 Men of destiny 1946 *24* The great tent has collapsed 1947

26 The evening sparrow 1948 27 The lake window 1950

were the kind of people, he said, who would keep a piano in the studio. They were 'courtiers'. When Elizabeth Bowen, the writer, called at his studio with Terence de Vere White one day, she found it difficult to communicate with him and hardly a word was exchanged. Afterwards the artist announced that she looked as though she was in dread all the time of having to buy a picture. He talked about an acquaintance, a town planning officer. He said he did not like men with no backsides. They looked as if they were expecting a kick.

His talk with his friends varied between the charming, realistic down-to-earth and a muddled monotone slipping from subject to subject and even with the greatest concentration from his listener very difficult to follow. He seemed to be completely self-contained and he did not mind whether he was comprehensible or not. Yet he could be completely lucid. On one occasion the Stroller's Club met at the College of Physicians for dinner, and the chairman, Dr. Kirkpatrick, without any warning, called upon Yeats to speak. He rose without hesitation and delivered an impressive and amusing speech, whimsical yet completely in command of himself and objective in his comments.

The small octogenarian, Sarah Purser, was still a friend, providing hospitality, and a wireless 'on painful or gay subject' when the Derby was run.[1] Sarah Purser celebrated her ninetieth birthday on 31 March 1938, with a dinner at the Shelbourne Hotel organized by the Friends of the National Collections of Ireland, for which the menu heading was designed by Jack Yeats. Dungarvan, where Sarah Purser grew up, formed a background. Trees bent to form a mirror, with chased artistic emblems on it, and the spirit of eternal youth (Sarah Purser), in pink spotted dress with a bunch of flowers in her hand, danced and gazed at herself in it. A bird shot up into the sky in the gay sketch, all freedom, wind and lightness. Professor Bodkin, who wrote a rhyming eulogical toast, was not so successful, for though the rhyme of 'Sarah' with 'Éire' was considered appropriate by the committee, it was felt that Miss Purser's sensitivity at being so addressed precluded his taking the liberty as generously as he did in the poem; and eventually the ode was proclaimed to her at a more private gathering. The chef baulked at the idea of ninety candles on a cake, but recovered himself; and Con Curran read

[1] Letter from Yeats to Sarah Purser, 23 May 1932. National Library of Ireland.

the ballad, apologizing for not singing it, to the old lady and a select audience while Miss Purser, in flowered chiffon and a velvet coatee, cut the cake, pretending to be busy with the cake all the time, but chuckling happily.[1]

When Sarah Purser died Terence de Vere White mentioned it to Richard Best, saying how sad he was to hear it. Best replied simply that he could not bear her. The former crossed the street to Jack Yeats's house to be met with exactly the same remark. The story would finish properly with a visit to Mespil House, the old lady's domicile to hear what she had to say. She was not always a congenial character.

Stephen MacKenna was a personal friend of Yeats's and the latter left a touching anecdote about how MacKenna passed the time when his wife was ill. Yeats called one day at the house in Merrion Square to be met on the staircase by faint strains of music.

He mounted, but study and living-room stood empty. Guided by the muffled music he tried another door. The bedroom to which it led was also apparently empty; but on the bed was a strangely shaped heap of rugs and blankets, and from the interior of this heap proceeded sounds as of a concertina being played very softly. He poked it and a head was protruded: 'Come in under here, Jack,' whispered MacKenna, 'the way we won't disturb my old lady, and I'll play you a grand tune'.[2]

Professor Bodkin had left the Directorship of the National Gallery to go to the newly founded Barber Institute, in Birmingham, but he corresponded with Yeats, and they met when he visited Dublin. In 1940 he asked Jack Yeats to illustrate a book he had written about his uncle, Dr. Francis MacMahon, and Yeats assented gladly, saying that he knew the area where Dr. MacMahon lived well.

Besides illustrating his own articles and stories Yeats contributed excellent drawings to the classical children's story, *The Turfcutter's Donkey* by Patricia Lynch (1934), *Sean-Eoin* (1938), and *The Lament of Art O'Leary* translated by Frank O'Connor (1940). In 1935 and 1937 he was illustrating poems and songs in the new series of *A Broadside*, edited

[1] Letters of Mrs. Hilda Nolan to Thomas Bodkin, March 1938, and 14 April 1938. Bodkin Estate.
[2] *Journals and letters of Stephen MacKenna* ed. E. R. Dodds. London, Constable, 1936, p. 71.

by his brother with first F. R. Higgins, and then Dorothy Wellesley. It may have been now, or a little later when his fingers were getting stiff, that the artist used a pencil holder formed by hollowed corks that did not need such a tight grip, and contributed to the free quality of his linework.

In the meantime he published a second novel *The Amaranthers* (1936). It is not an easy book to read, it is a mixture of so many different elements, straightforward narrative, a personal version of stream-of-thought, the melodrama of a thriller, and painter's notes; where threads halt and sway or fall obliquely in what looks like a new design but proves in fact to be an ornament to the original theme. The visual element and thoughts on picture-making are predominant. The Secretary walks through the city in the early morning:

She threaded her way quickly through the crowds of demure-looking young men and women. Then to the left up a very broad pavement beside a broad roadway. A narrow tall building on the left, as she came to it, took to itself the appearance of a water-fall. Fifty boys, all in pale mauve linen, with black letters printed across their breasts, and carrying pale green newspapers, poured down the four broad steps and sprang away in every direction, crying out with piercing voices. A Stop Press was coming out from the office of *The Shepherd*, a paper in virulent opposition to the Government.

Characters lying in abeyance, as before, rise up and take the centre of the action, and then suddenly are defunct. References are dropped and picked up again unexpectedly. The tale must be well known to enjoy it; and then it is admirable, full of life and allusions, with variations in texture and tone.

The scene opens on an island, an 'only-just island',[1] that survives through tourism, with its ship-in-bottle industry and secret recipes for powerful drinks, and through an organized social scheme whereby all islanders return entries to newspaper competitions with every permutation and combination of answer possible to ensure a successful win. Disaster strikes when speculators suggest a railway connecting the island with the mainland. A newspaper reporter manages to avert the accident, and thence the plot shifts to a communist club calling itself by the name

[1] Probably inspired by Coney Island in Sligo Bay.

of the amaranth, an imaginary flower that never fades. The six club members spend life constructing a model empire with toy ships, docks and towns, but never populated with toy people.

The story of James Gilfoyle, a restless Irishman, something of a self-portrait, follows from this and links with the first plot when James goes to the hurricane-smitten island with a rescue party at the end. He persuades the Amaranthers to abandon their political dream and finds parts for them in a film.

The novel is first and foremost a satirical entertainment. Development of personality hardly interests Yeats. He meets his characters as they are, good or bad, and is interested in the kaleidoscope of experiences and impressions coming to each, impressions on whatever level. He likes to tell a good story, setting it in a mundane background of business and routine affairs, adding a suitable percentage of melodrama and romance that lift the story to a different plane. Life flows on. Death as always plays its part and is accepted. It is a novel of sentiment. James returns to Dublin, to O'Connell Bridge.

. . . in a moment he longed for his bridge and the sky over it and away from it. He crossed the Irish Sea once more. He stood and looked up the river, the same sun time as when he first stood there, and he felt there, fanned out within the reach of a long arm, stood all the round towers, the green hills, the mountains, the monuments, the little lakes, the little colleens by the lakes, the sea bays, the sea islands, the lake islands, the fiddles, the dancing floors, the shamrocks of the fields, the leaping salmon in the rivers. A warm sea of fancies loved, so close that he could dabble the fingers of the hands of his long arms in the little waves breaking among the infant sedges. He could have taken a train away into that heaving place of his own heart. . . .

There is a gentle prick of satire, mocking the arrogance of the scientist in an impish suggestion that happiness might be attained through making moulds of happy men, and standardising the shapes of all others thereby. The artist jokes about his own tendency to hoard newspaper photographs by justifying them as a means of communication when language is a barrier – the more hoarded the greater possibilities for communication through illustrations. The book like its fellows draws its matter from Yeats' own experience. It is a fantasy of irony.

The Charmed Life was published two years later, WB called it 'my

brother's extreme book. . . . He does not care that few will read it, still fewer recognize its genius; it is his book, his "Faust", his pursuit of all that through its unpredictable, unarrangeable reality least ressembles knowledge.'[1] The book presents the philosophy Yeats had formulated for himself succinctly.

Seeing funny things is a protection, but when the curtain falls on fun, what then my children? Then we, you and I, must take what comes. And here comes Chance leading a horse by a hay rope, but the horse in a sudden lurch of his stride breaks the hay rope and passes by me like a wind. The man stands foolishly with the broken rope in his hand, he says to me, 'That horse was the star horse of all the world and what will I do now? I know what I will do.' And so he makes a slipping loop in the end of the rope, and the other end he throws over a low branch of a tree, jutting out convenient to his hand, he brings the end down and makes it fast to a fairy's archway of a root that comes above the ground, then he put his neck through the noose, makes himself up into a spider's ball, and launches for eternity. He signed to me to pull up his legs, but I wasn't ready to do that, so I went to hold them up, to take the weight of his body off his neck, but lo, there was no weight in his body, he was just grey air. So I blew at him, and he went up among the leaves, and I cut the hay rope with my penknife, and my responsibility was ended.

Mr. No Matter is a philosopher and introvert, and a man of deep emotion; while Bowsie lives his creativity with hidden intuition: extrovert, clown, rogue, hero he is Don Quixote and Sancho Panza rolled into one. They represent the opposite sides of the artist's personality, as he travels through life, viewing, musing, creating; the soldier of fortune 'feeling' Ireland. (Both appear in Yeats's later paintings, in 'The Last Voyage', and in 'Glory' (1952); Bowsie alone in 'The First Away' and 'Meditation', Mr. No Matter is Yeats himself revisiting the scenes he knew in The Banquet Hall and Showground paintings.)[2]

I propose, Bowsie, now that we each take a stroll apart – one to this low headland, the other to that. West or east – choose! You take the westerly head – good. Though I had thought of it for myself. But I gave you choice and I stand by it. No changing now. We will be pleased to see each other's small dots of heads, on bodies that will look like sucked comfits across the blue and tinkling waters of the

[1] *On the Boiler*, Dublin, Cuala Press, 1939, p. 36.
[2] See also J. Pilling in *Journal of Beckett Studies*, Spring 1979, pp. 55-65.

bay. Each of us will commune with our own nonsensical souls, which at these times will not be said nay to, but peak up in their squeaky voices, which it amuses them to think are like the human ones. Good-bye, now, and for the present; take care of yourself. You may see me illuminated by the sun shining behind your back, and through the pink of the ears. While I will see but a silhouette, a little gloomy silhouette, relieved only by the round blushes of the ears.

There is one climax, in the feared drowning of Bowsie; but Bowsie is indestructible, and attends the funeral that would have been his had his body been found. The prose can be stilted, or flows with a colourful poetry and depth, or a cracking drama, a manner comparable only to the music of Sibelius in his premeditative symphonies.

On 5 June 1939, to his satisfaction, one of Yeats's plays was at last performed. The Abbey Experimental Theatre had been founded in April 1937 under the direction of Ria Mooney, then in charge of the school of acting, with the object of encouraging young playwrights and producers, and scenic designers, and for performing plays not considered suitable for presentation in the Abbey. *Harlequin's Positions*, a 'play of war's alarums', was probably written in 1938 or not long before, and accepted for performance in the following January.

Rehearsals started in April. Yeats took a great interest, apologizing that the notes for production might be over elaborate,[1] but leaving his niece, Anne Yeats, free to work out her designs for the set. For him the players made the play. 'I was in the theatre four times,' he wrote to Hertha Phyllis Eason, 'and each time with more respect for the way the company carried the days along'.[2] Audience and actors were slightly baffled by *La La Noo*, his next play to be performed, by the National Theatre Society, in the Abbey, three years later.[3] Reviewers felt the talk flowed so lucidly and easily that something was lost in the effortless of its motion. But Yeats insisted that if the play was acted it was fatal: dialogue must flow from one actor to another each becoming nothing but an agent and putting all of Yeats into his words.[4]

His ideas too about staging were his own. He had a passionate desire that the audience should see the feet of the players and he preferred a small theatre for this reason. Symmetry was a thing that he disliked, and

[1] Letter to Ria Mooney, 19 January 1939. [2] Letter 20 June 1939. [3] 3 May 1942.
[4] See Joseph F. Connelly in *Eire-Ireland*, Winter 1975, p.140, etc.

no design was repeated on both sides of the stage.[1] Eve Watkinson, who played the 7th Woman, had to sit on a shooting-stick for which a suitable anchoring hole was provided on the stage. Groping behind her back she was unable to find the hole at all, and for her the performance was considerably uncomfortable.

In Sand was offered to the Abbey Theatre in December 1943, again with suggestions for production and settings;[2] but it was refused. 'I do believe that any audience whose skulls weren't filled with crumpled cellophane alone, and were well shepherded into a not-too-big theatre, would get entertainment out of any of my plays that were produced as well as La La Noo was produced', Yeats wrote sadly to Miss Mooney.[3] The play has the continuity and gentle rhythm of *Sailing, Sailing Swiftly*, but differs in its express theme and definite optimism, which the book conveyed diffusely. An old man lies dying and asks his friend to have a message inscribed for him on the sand at the lowest tide level, 'Tony, we have the good thought for you still.' Through a succession of different characters the charitable sentence shows its effect. *In Sand* was performed by the Abbey Experimental Theatre with certain cuts in April 1949, without the companion prologue, *The Green Wave*, which Yeats thought was very relevant to the play, and which was included in the performance in 1964.

It seems to me to have more to do with the play than I thought. I think it would get the audience settled and dumb as all audiences should be, before the opening of the play itself. . . .[4]

The Careless Flower, Yeats's final novel, though first issued in instalments in the *Dublin Magazine*, in 1940, was also slow in coming into print, and was not published as a whole until 1947. 'Words, words, words . . . ' again the constant strumming and pulse: and words now, since the first prose works, become a realized instrument of drama and emotion, atmosphere and tension, still more personal than Joyce. James Gaw runs for a train:

[1] Miss Ria Mooney.
[2] Letter to Miss Mooney, 18 December 1943.
[3] 3 February 1944.
[4] Letter, 11 November 1948. The play was broadcast in the 3rd programme, BBC, 19 February 1956, repeated 24 February 1956, and 7 May 1965. The producer was Frederick Bradnum.

As he ran by the clock he said, 'seven minutes to do it in'. He had once done it from the very watchmaker's window in five – some years ago. 'Never mind, pick up your feet, the good God will put them down again, it's picking them up that does it, swing them low, crouch to it. Slide the traffic at an angle, don't try and zig-zag it, whish, that was near, these motorists don't care, like the sailors in the songs. But this is fate, that yellow bill, the paper just out, that advertisement never came out before, I'd never have missed it. Did it in five, oh glory, I had a return ticket then, now I've got to get a ticket; oh, mangy legs, do your work, come on, come on . . . This is written, the bill, the paper, the train, all in a chain, my legs chained. Ironed, oh iron, iron, iron, iron, irony. Oh, loose its chain, cometh up like a flower in the midst of life we are in death, oh, stick it, stick it, stick it, old son of the roads, oh God, no more clocks, running blind, second wind, second leg, turn again Whittington, Whit, Whit, Whit, ing, Ton. . . .'

The story is set first in England, a middle-aged out-of-work man looking up a younger acquaintance, who has been successful, and finding an ideal job as a guide on a small cruising vessel. Reality is related to dream. The book is divided into four parts, reaching different levels of consciousness: the preparation for the voyage on the *Scrutineer* and the voyage; the marooning of the four main characters on an island, and their attempts to learn a new way of life, exploring the possibilities through the traces they find of a man who has lived there before; the thoughts of the marooned people in swift melodramatic images, reaching sublimation in the rejuvenation of Gaw and Mark, who drink from the spring of the Careless Flower; then rescue and anticlimax as they return to convention and death.

Yeats told a friend that he wanted to be remembered for his writings and not so much for his paintings. He enjoyed making books.

In my writing, as in my painting, my inspiration has always been affection wide, devious, and, sometimes, handsome . . . in every book there is somewhere in it a memory of Sligo . . . to which lovely place the beak of my ship ever turns, as turns the beak of the rushing carrier pigeon of the skies to his old harbourage.[1]

WB wrote 'handsomely' to his brother about *The Charmed Life* in 1938. Jack Yeats mentioning this in his reply described the funeral of Arthur Jackson, who had succeeded George Pollexfen in the business at Ballisodare. 'It was one of those ancient "pet" sun shiny days the par-

[1] *Eason's Bulletin*, October 1948. Vol. IV, no. 5. p. 3. *Irish Authors: 36. Jack B. Yeats.*

ticular handhold of Sligo, that brimming cup among hills.' Lily Yeats had foreseen the death, and that of Aunt Jenny Yeats who died shortly afterwards. She wrote to their cousin, Olive Jackson,

. . . for sometime before Aunt Alice's death I used to hear but never see, someone in full silk skirts walking lightly and quickly about the house, Grandmamma I thought. She wore a full silk dress and walked very lightly and rather quickly. Then it came again some time before Arthur's death. I said to Mary that I thought Aunt Jenny Yeats must be dying and so she was, but it meant Arthurs going I am sure. Aunt Jenny was 92. I just hoped it was for her . . .[1]

In the letter, Lily Yeats mentioned Willy's wish to be buried at Drumcliffe. He had been unwell but said in March, '. . . now that I have created nothing for a good many days and have ceased to read my brother and Milton I begin to feel that I can face my fellow men again.'[2] Jack Yeats saw him for the last time in the summer of 1938, full of mental vitality with a few years left to him, he thought;[3] but in the New Year W. B. Yeats died. His brother made arrangements for his interment at Drumcliffe. WB would travel from Liverpool by sea to Sligo, along the route originally opened by the Pollexfens, for a private funeral, attended only by friends coming as individuals and not as representatives of public bodies. September seemed a good month, since old people in Sligo would come to meet him at the quay, September, before the cold and wet set in;[4] but everything had to be postponed because of the outbreak of war, and W. B. Yeats did not come home until 1948.

At the beginning of 1940, scarcely a year after Willy's death, Lolly died. Jack Yeats wrote to Professor Bodkin to tell him that at Christmas they had all been worried about her sudden failing in health, 'and then, in a little while, the sadness of her death. All through her life she brought with her the gaiety and the quickly troubled spirit of a young girl, so it seemed to me. I am glad she did not have much pain or that for long'.[5]

[1] 15 November 1938. [2] Letter to E. S. Heald, 15 March 1938. *Letters*, p. 907.
[3] Letter to Alan and Madeleine Stewart, 6 February 1939.
[4] P. McCartan. *Yeats and Patrick McCartan: a Fenian Friendship.* Dolmen Press 1967, p. 419.
[5] 5 February 1940.

Chapter 15

Honourable rust

'By Streedagh Strand', an evocative Sligo landscape, and 'Tinkers' Encampment – the Blood of Abel' were painted soon after Lolly died. Yeats was beginning to feel himself one of the 'not-so-youngs'; though he said to Bodkin, '. . . be warned by Shaw's false step. Pipe down on age. Don't be any age. It will be long years until they (the years) can get in your way. But if you begin, as Shaw did, drawing attention to his birthday when he was only in the eighties, you will land yourself as he has, on the slab of a tomb, sitting there 'interrupted' every time he speaks by the cry of "hear the great unburied one: Isn't he just wonderful! Ain't he cute". The Artist has no age.'[1]

He was sympathetic towards young painters (and writers), and during the forties was having a considerable influence, in particular on Daniel O'Neill. With the institution of The Irish Exhibition of Living Art in 1943 he was happy to be represented there as well as in the Royal Hibernian Academy. He was friendly too towards the group of foreign artists, the White Stags, who were gathered in Dublin during the war, and he used to gaze intently, and with amusement at their pretentious efforts. The Friends of the National Collections of Ireland, newly founded and avidly exploring every avenue however unconventional that might lead to the appropriation of funds, caused him great joy as well.

Many people, Dubliners and foreigners, called at his studio. Terence de Vere White recalls the typical welcome; the pause after the bell was rung, then a sound of furniture moving, the door opening slowly showing the artist framed in the gap, his arm held back, his head at a slight

[1] Letter, 30 October 1946.

angle with bright eyes appraising his visitor. Callers were regaled with tea and nasturtium leaf sandwiches, or sipped madeira with a twist of lemon peel in it, all proffered by the artist with gracious ceremony. When he was 'incubating' a picture he became silent, his mind withdrawn, and after a while, as the scheming ceased, he became more talkative and re-turned to his normal manner.[1] Louis MacNeice, in his autobiography, describes Yeats's studio as 'the tidiest studio possible, a high eighteenth-century room with elaborate mouldings on the cornice':

He found them a great standby; when he had nothing to do he just watched those mouldings, all of them were animate. See there, he said, that is the Pompadour, that is Elizabeth Barrett's little dog, and these are some little men having a walking race. He gave us Malaga and with a deft oldmaidish precision squeezed some drops of orange into each glass. An old lady present, who collected modern French paintings, was talking about her childhood in Ireland – how many carriage-horses the neighbours had, how many hunters, etc. 'But now,' she concluded sadly, 'Now there are no neighbourhoods.'[2]

Ernie O'Malley, the Irish patriot and intelligence officer to Michael Collins, now retired from politics, took a great interest in contemporary Irish painting, and had built up a fine collection of art works with a number of Yeatses. He was there on the occasion of MacNeice's visit to Yeats; and artist, poet and ex-gunman walked out into Fitzwilliam Street together, looking up at the mountains framed between the end houses. A flower woman offered them some violets, and Jack Yeats bought a bunch for each of his visitors, telling them the family history of the old woman and anecdotes about various notable beggars in Dublin.

Sir John Rothenstein was struck by Yeats's 'gentle demeanour' and his mild self-assurance, typical he said of the Anglo-Irish, and com-manding respect though without the 'consuming pride' of his brother. Yeats made tea for Sir John, and afterwards brought his pictures out singly from behind a screen. He emphasized the importance of subject-matter in each painting.

The more broadly handled the later pictures, the more insistent he was that their subject should be clearly comprehended, and none of the accessory details, at first difficult to distinguish in a maelstrom of brush-strokes should be missed.[3]

[1] Harold Leask. [2] *The Strings are False*, 1965, pp. 313-4.
[3] *New English Review* no. 1, July 1946, pp. 42-4.

Yeats identified the haunts he had known since he was a boy, now transformed in his new depictions. To the artist, Derek Hill, this was his most memorable quality, the ability to talk about his own pictures, bringing every detail to life, involving his hearer to such an extent that he soon felt unable to live without the picture.[1] The artist's loose garments, his long serious face, careworn, with his pink and white complexion, his 'lean and hungry' appearance,[2] his gestures, his slow way of speech, gave the impression of a man of dedication and had nothing of the flamboyance generally associated with an artist;[3] and his nautical neatness was a contrast to his wife, rather plain, wearing her dark hair in a straight fringe across her forehead, as she had done since the 1920s. She usually wore a short brown velvet jacket, decorated with an artificial orchid.[4]

Yeats was often at the Church of Ireland service in St. Patrick's Cathedral and other cathedrals in towns he visited; but he attended the first mass celebrated by Father Jack Hanlon, a fellow artist, in his house at Templeogue in the early forties, an unusual gesture for a Protestant at that time. In his slow deep voice Yeats pontificated afterwards on French art, so influential on his contemporaries. 'They're all talking about French art. They're all saying who the blazes is Glazes (Gleizes)'.[5]

Another story comes from Lady Hanson, who was looking at a painting of a lamb at an exhibition, with a background of parkland, sitting holding a conventional bouquet of flowers between its forelegs. She said to Yeats, 'It is a fine picture, but why is the lamb introduced with the incongruous bouquet?' He thought for a moment, then said, 'Perhaps he won it,' an explanation which quite satisfied her.[6]

During the forties Yeats was widening his acquaintance of provincial Irish towns. He was in Waterford in 1942. The following year, in October, he 'did' Drogheda, where he and his wife first met the sister of his friend, Professor Bodkin. They shared a sitting-room. Jack Yeats would go out to parties, while Cottie stayed at home, and Miss Bodkin heard the artist at one gathering expatiating on mother-of-pearl buttons, and discussing the difference between real and imitation mother-of-pearl. This may have given him inspiration for 'The Grafter' (1944).

[1] Letter to author, 6 June 1967. [2] M. H. Franklin.
[3] Dr. R. R. Woods. [4] H. P. Eason. [5] Father Jack Hanlon.
[6] Letter to author, 10 March 1967.

He was not always optimistic. While in Waterford he wrote to Niall Montgomery, the architect, in a negative depression:

I think architecture is a splendid peg on which to hang shining thoughts but for pegs nix on farmers nix on music. If we were faultlessly fundamental in our occupational bambooslems, there would be seasonal-painting in the autumn about Saint Luke's Day – Architecture in the Spring – the nesting season. Your mind is not lined with twigs or feathers, or bricks and mortar.[1]

He used to say that this was an age of 'spoof', suffocating people. The next stage would be one of laughter – an era of laughter, and after that would come the end of the world.[2]

He liked Niall Montgomery's verses and wrote 'In this crooked tongued, woolly eared year of a half snuffed candle, such ringing innocence is a cork belt in a murky sea.'[3] Two years later he was sending an example of his own poetry still low in spirit, though on a different track, commenting that 'as with the ancients the first line is everything . . . a good sounding locomotion in front, followed by a string of rumbles, bumping joyfully along the rails, was their idea – and very handy too.' He achieves the remoteness into which the drunkard is enveloped after 'bathing' in the 'fountains of the light'. His late night confidante is the 'long throated man', a stranger converted into a friend, until he disappears off on his own way.

Hells Bells are ten in Number
They clang out to the night
 And their clanging meets the clanging
Of the gates that shut so tight,
On the fair fields of Elysium,
Where the fountains of the light
Make rosey cheeks more rosey
And bright eyes still more bright.
 The Draw Bridge goes up,
 The Portcullis it comes down,
The Curtain has descended upon our ancient town:

So you butt into the Last Bus
With that long throated man

[1] 7 September 1941. [2] H. P. Eason. [3] 20 August 1940.

Who now, of all times, starts to sing
'The Smashing of the Van'.

So you say goodby to him
 And roll your homeward way.
But before you hit the hay
Your Hopeful Heart sobs to you
'Tomorrow at ten AM,
Begins Another Day.'

With his return to full-time painting and lesser interest in writing Yeats returned to his practice of sketching regularly wherever he went, and included among his sketches from observation a certain number of memory drawings. They are casual jottings, sometimes simply vague lines, sometimes heads, figures or brief scenes with pink or yellow wash over the pencil. He wandered about Dublin with active pencil. In the poorer streets by the Rotunda, in Henrietta Street he sketched tall houses and the children playing about them, scooting, running. He saw an old sedan-chair stand. As he looked a child with a bow in her head came up to him and asked, 'Are Yez expecting anybody?' He drew a turnip artist on several occasions and noted street sellers with their characterful faces in Henry Street at Christmas time, turned from them to see Santa Claus in Woolworth's. Thence he strolled up Liffey Street to the Quays, over past the Bank of Ireland to Grafton Street and the world of fashion, Stephen's Green, people walking, a child being dragged along by an enormous stuffy man: Kildare Street, Greene's lending library, Fitz-william Square again. He sketched the harpist and violinist in Baggot Street as he moved northwards once more. At the Flower Show he watched from a position on the balcony a professional photographer taking a picture of a girl surrounded by flowers. He himself saw only her head. He used to attend the Spring Show too, and walked in the Botanic Gardens, and Herbert Park in Ballsbridge, where children were sailing toy boats.

In a dream drawing his friend J. M. Hone, seated, presents an object to a figure beside him, and other figures dash away into the background. He sketched frequently by the canal, and went to Lucan to sketch, saw the Tolka in flood, and a flood at Clonskea. He noted blue tits,

sparrows, ice-cream men, scribbled a drawing entitled 'Nasty People drinking in a Bar', and 'Senators' – two rather untrustworthy char-women staring at each other. Friends too appeared in incidents real and fantastic.

During the 1940s paintings pluck drama, incident, characters from former experiences and float event above reality. Humour embellishes the fantasy. 'A Paris comes to Judgement in the West' (1944) shows a small boy wearing a cap, gazing thoughtfully at three splendid local women in shawl and cap. A dashing figure in cowboy garb doffs his hat to his steed – a rocking horse: There are serious paintings, the disturbing 'The Banquet Hall Deserted' (1942), and 'Men of Destiny' (1946), who moor their boat and walk up Rosses Point in the sunset; or moments of sheer joy – 'Among Horses' (1947) – dancing in the street – watching 'A Blackbird Bathing in Tír na n-Og' (1943); pleasure at 'The Good Grey Morning' (1948), where a figure looks at it from his attic window; of sensitivity to others: a child 'Opening the Parcel' (1946) absorbedly, a whistle player stroking his instrument, 'An Old Timer Reading' (1947). Every kind of subject is represented.

Yeats's real success came with his recognition at the National Gallery in January 1942, an exhibition he shared with Sir William Nicholson. Soon his pictures were selling so quickly that there was little choice except among the largest size, this though collectors of his work were still mainly Dubliners. Numbers flocking to his private exhibitions soared to a thousand each day, and the streams flowed on.

It was logical to show him with Nicholson when their beginnings are considered; and their exhibition had been planned to follow up the show of Sickert's work at the National Gallery in London. The three artists provided a neat impression of the conventional, the anti-academic and the visionary elements developed in British art of the twentieth century. Both Yeats's and Nicholson's prints were exhibited, the only work by both artists which was hung side by side, as Yeats said 'especially for those happy people who have decided that pictures, except in looking glasses, are for ever painful'.[1] He was disappointed that their work was separated, and wrote to Hone, 'The exhibition in London is someway strange – because I will have my room or rooms and Sir William Nicholson

[1] Letter to Sarah Purser, 28 January 1942. City of Dublin Public Libraries.

his, and any point of view where we are the same is hidden. I used to admire every painting I saw of his years ago.'[1] He had not seen Nicholson's work of late, but he approved of the still life 'of silks and an old hat and feathers' he knew in the Municipal Gallery in Dublin. Of his own works on show only one or two were painted before 1925. 'A Clown among the People', 'A Race in Hy Brazil' and 'An Evening in Spring', of the thirties, were included.

The exhibition had an extraordinary effect on people who hardly realized Yeats's existence as a painter until then. The shadow of WB, and the tendency of those who had heard of Jack B. to confuse him with his father was remarkable. J. B. Thorpe in *English Illustration: the Nineties* claimed to have been identifying the styles of black-and-white artists since his boyhood and yet gave the very Victorian and academic Defoe illustrations to the younger Yeats, instead of to JBY. His publishers listed JBY's *Essays Irish and American* among Jack Yeats's works in the beginning of *Apparitions* (Jonathan Cape, 1933), presumably without consulting the artist: and even today, outside of Ireland, there is often uncertainty as to whether there were two artists named Yeats instead of one. The younger artist very early insisted on being known as 'Jack B. Yeats' instead of J. B. Yeats. His monogram arose out of the confusion with his father's abbreviated signature 'J.B.Y.' Sarah Purser thought that he did not push himself enough, and that this was why he fell into obscurity. Few other artists knew him – he does not seem to have wanted to know them as artists – and he rarely appears in the autobiographies of his contemporaries other than in brief mentions, because of his elusive disposition and tendency to remain apart. Replying to a mystified admirer who said he had heard that Yeats contributed to *Punch*, Yeats brushed aside his pseudonym and any explanations with 'Hymph! Who told you? A little bird told you'[2] and left his interrogant even more bewildered.

Yet there had been a constant stream of approbative criticism of different kinds since the beginning, first the accepted niche among black-and-white workers, hard won, and then certain supporters for the water-colours. AE, among others, was impressed by his 'Gaelic' quality and wanted him to be a nationalist artist. He called him 'a millionaire of fancy'. He detected similarities to Millet and De Quincey, and, as one

[1] 20 December 1941. University of Kansas Libraries. [2] *See* p. 41.

might expect, Blake. His commendation of the colouring rings of self-identification: the pastelly colours were what he favoured for his own painting.

These blues and purples and pale greens – what crowd ever seemed clad in such twilight colours? And yet we accept it as natural, for this opalescence is always in the mist-laden air of the West; it enters into the soul to-day as it did into the soul of the ancient Gael, who called it Ildathach – the many-coloured land; it becomes part of the atmosphere of the mind. . . .[1]

The critic in *Les Ecrits Français* speaking of the exhibition of the Independent Artists in 1914 saw Goya in the 'tons blafards' of 'The Rockbreaker'. *The Dublin Magazine*, in its first issue in 1923, printed a leading article by Masefield on Jack and not on WB. Masefield wrote rather nostalgically about the artist's 'boyishness' and approved the artist's romantic view of a toiler's life, his delight in depicting contest and vivid characters of a rough world. The first professional critic was Thomas Bodkin, as Yeats threw conventionalism to the winds. Bodkin rejoiced in Yeats's ease and fluency, the 'lyric quality of colour, a suavity and elegance of tone that is extraordinarily distinguished'. 'A critic confronted for the first time with one of these paintings might be excused for seeing in the rapid, seemingly haphazard brushwork a pictorial accident of the happiest kind. But in the presence of thirty-two successful efforts he would perforce recognize that here is a talent as sure as it is original.'[2]

Another eminent ally was Dr. Constantine Curran who wrote of the rivalry created with Nature, the riot and excitement, 'wild faces set in the last ecstasy of rapid motion . . . large and noble outlines . . . and beside these wild horsemen, quiet and lovely figures;'[3] and he later analysed his development from local to broken impressionistic colour. He advocated the use of the term expressionist, to categorize the hidden energy activating itself on the canvas.[4] Again he said Yeats was the artist who had aroused the interest of rather apathetic Irishmen in art during the Gaelic Revival: they suddenly realized that what was in the Academy

[1] *Freeman's Journal*, 23 October 1901, p. 5. See also *Booklover's Magazine*, vol. VIII (1909), pp. 132–8.
[2] *Studio*, 1927, vol. 93, pp. 362–3.
[3] Introduction to catalogue of Memorial Exhibition of AE, 1936.
[4] *Studies*, March 1941, pp. 75–89.

was not art. He stressed his innate and wise understanding of life, which rose above satire and sentimentality, quoting Yeats's own words, 'The false picture is most often the picture painted not from nature but from other pictures . . . The true artist has painted the picture because he wishes to hold again for his pleasure – and for always – a moment, and because he is impelled by his human affections to pass on the moment to his fellows and to those who come after him.'[1]

Sean O Faoláin on the other hand found Yeats 'odd', 'difficult' and 'wilful' both in writing and painting; but he was captured by the enchantment, the power to recreate youth in those who saw his work.[2] Some Irish critics pronounced the late painting to be 'chaos'[3] and left him to the intellectuals.

Then in 1942 the English critics launched in seriously, Herbert Read an avid supporter, approving the vitality and intensity, recalling Rouault and Delacroix, and stressing Yeats's comic spirit rather to the detriment of his more profound qualities – 'Yeats, who is an Irishman, does not pretend to a tragic sense of life.' Sir Kenneth Clark and Sir John Rothenstein journeyed to Dublin to meet the artist. In June 1945 came the first formal tribute to Yeats from his country in the National Loan Exhibition. On its heels followed an invitation to exhibit with the Society of Scottish Artists as special artist in the Royal Scottish Academy Galleries in 1946 (his father also was represented); and in 1948 a second large exhibition, this time he alone was represented, was staged in the Tate Gallery.

Looking at the pictures in the Tate – the earliest example shown there was 'A Lift in the Long Car' of 1914 – Patrick Heron declared that Irishmen by their nature took to literature rather than to art because their visual perception was bewildered by the rapidly changing light and found nothing tangible to grasp. Georgian architecture according to him was extrinsic – he did not deal with Celtic art, but perhaps the weather was less capricious in those days – and Yeats, he said, was interesting, because he remained true to a setting which hardly permitted art; so it was natural that his colour should be toneless and his design practically non-existent, since he had no more than a nodding acquaintance with

[1] *Capuchin Annual* 1945–6, pp. 102–22. [2] *The Bell*, vol. 1, no. 4, January 1941.
[3] Arthur Power in *The Bell*, vol. 4, no. 2, May 1942.

pictorial matters. John Berger, on the contrary, saw this dancing sky light as the substance of strength in his work:

The land is as passive as a bog can be. The sky is all action . . . a dancer, tender and wild alternately, and then furious, ripping her clothes and parading her golden body to get just one glimmer of response from the peat. And she gets it. For in the ruts and bog puddles and along the wet shoulders of a tarpaulin the water flashes back, seeming by contrast with its surroundings even brighter than her. And it is this wild dancing and wilder response that Yeats has painted . . .

Not that Yeats has ever been a literal landscape painter. He transforms everything within his imagination. And if I had to give a single reason why I believe he is a great painter I would cite the constancy of this power to transform. Like Giorgione or Delacroix, he can cast his spell even over the foreground of his pictures. Most modern romantics because they do not live their philosophy can never bring their romantic vision nearer than the middle distance: the foreground simply remains a frame. Yeats – and in this he is unlike his brother – has never stepped out of his vision. He has continued to embrace mortality in the face of every moral warning. But he has been able to do this because his vision has its roots in his country; visually in the Irish landscape: poetically in Irish folklore, and ideologically in the fact that Ireland has only up to now been able to fight English imperialism with the image of the independent individual Rebel.[1]

In Brussels J. P. Hodin traced the Continental forbears of Yeats, decided that he was an expressionist and not a Fauvist, because, like Munch, Chagall, Van Gogh and Kokoschka his pictorial conceptions reached deep into reality in a symbolic and metaphysical fashion. He saw traits of Bonnard, Turner and Ensor in the Irish artist, of Goya in his drama and tragedy. The French critics have been mystified about the origins, then found the clue in the image of sorcerer and magician, the transformer. In general the English are suspicious of the late colour, and 'slapdash' manner, and prefer the descriptive work; while in Ireland romance is all, and the down-to-earth qualities are ignored: his work 'rises above the dull tyranny of things as they are, liberating the spectator through the emotional intensity with which another world is realised.'[2]

Yeats appeared at the 1945 exhibition wearing a rose in his buttonhole. The exhibition had been organized by a large committee of friends

[1] *New Statesman and Nation*, 8 December 1956, pp. 741–2.

[2] *Dublin Magazine*, January-March 1952, 41–2.

and associates, and showed one hundred and eighty of his paintings. Public honours followed in quick succession. Dublin University offered him an LL.D. in July 1946, and celebrated with his artistic genius his gracious manner and his courteousness; and University College followed suit the next year. Dr. Browne proclaimed the classical quality and serenity of his work.

Cottie died at the end of April 1947. She suffered for a long time, at first Yeats was optimistic, but on 25 March he wrote to Hertha Eason to say that she was passing away slowly 'without pain, quiet and peaceful'. She lingered on for a month. One day Ria Mooney waiting for a bus at the top of Grafton Street saw him approaching, silent and bemused. He had walked down Harcourt Street through the Green from the Portobello Nursing Home. He crossed the road and came over to her, saying quietly, 'It is finished', and walked away. Two weeks later he wrote in a more composed mood:

Masefield told me to remember that 'the hearts of those who are dead are finished with sorrow'. I think to everyone left on earth who has lost some one there are three great words for ever-and-ever-and-ever. My dear one is 'finished with sorrow'.

Yeats did little work about this time. Taking up his brush again he completed among others the moving elegies 'The Great Tent has collapsed', 'People walking beside a River', 'The Night has gone'. With the lifting of the cloud subsequent works with their life and gaiety pave the path to the final visual poems on a large scale, freely inspired, floating on a plane released from bonds. Lily, the remaining member of the immediate family died in January 1949, leaving him the feeling that he was to mark time in an interim: 'the last but one of a small band. She was so brave and full of cheerful interest', he told Hertha Eason, 'that in spite of her being so long laid aside, I thought she would stay with us keeping memory green a little longer'. Later in the year he presented the portraits of Lily and himself, by his father, to the National Gallery of Ireland.

The final years

The Diploma Culturale Adriatica of Milan was awarded to Yeats in 1949, and in 1950 he was made an Officer of the Legion of Honour. He held his first one-man show in Paris in 1954; and this was enthusiastically received.

The artist was still painting a great deal, though his health was deteriorating, and about 1950 he began retiring into the eighteenth-century nursing home at Portobello, originally a hotel for travellers on the Grand Canal. He first withdrew when he pulled a rib muscle, and wrote humorously to another artist, Patric Stevenson, 'I was of course held up from painting so long in Portobello House that I had to hurry the paint on to my nose as soon as I got back.'[1]

Next he would retire from painting for the winter, in November, knowing when he heard the birds sing that spring had come and in May, he returned home to the fray. He chose a room at the top of Portobello House that overlooked the rooftops. He would read, he walked along the banks of the Grand Canal, stopping to admire the swans, and when he grew more frail and was permanently confined to Portobello House he travelled about in a taxi, accompanied by one of the nurses, who was his constant companion. He autographed books for his visitors with amusing pen sketches, and he sent Christmas and New Year Cards with personal sketches printed on them, a headless scarecrow and a winged horse appearing in succession in situations of fantasy.

He was proud and conscious of the name Yeats, but also impressed the

[1] Letter, 2 June 1951.

nurses with his simplicity and his interest in the other inhabitants of the nursing home. He abhorred unkindness or coercion, and hated pomposity. His humour was paramount, gay and simple with a quick patter –

Would you like to be a twin? – 'No, I'd only be half a person'.[1]

He rarely moved from the nursing home in his last years, but had a constant stream of visitors, each received with his typical courtesy and charm. Ria Mooney, who had produced his plays, brought him a paper sheaf one day, and handed it to him with a non-committal remark, and he took it gravely. He examined it carefully, turning it over in his hands, and opening the newspaper roll deliberately slowly; then when he saw the bunch of daffodils inside a beam of delight spread over his face.

Thomas MacGreevy spent every evening with him in his later years. After the theatre or a dinner he would don his coat and remark that he was going to visit Jack Yeats. The story is told that his voice continued into the night with such regularity that a patient next door to Yeats in the Portobello complained that the artist never turned off his wireless, even after twelve o'clock at night.

Brigid Ganly, the artist, visited him when he was growing deaf, but he listened with attention to the tale she told. She described with amusement a recent play, full of clichés and conventionality that had succeeded through the zest of the players. It travelled to England, where it was exceedingly popular, and its pretensions evaporated as the actors encouraged the audience to participate, and at certain points of the play instead of repeating the obvious dialogue called on the audience to do so, which they did with gusto. The nameless playwright, present one night, was overwhelmed with horror, and rose up, crying out, 'It is not meant to be played like that!' Yeats saw no humour in the tale and felt the closest sympathy for the playwright.

Sketchbooks were in operation until about 1953, and included humorous sketches in blue pencil, such as the old joke of the horse flitting away from a man and leaving the cart upturned, and when finally trapped riding away in the cart as the man pushed it. He scribbled single limbs and features in the book in a purposeless way, legs and eyes jotted down. Into another notebook, containing lists of pictures, he pasted brief notes in

[1] Miss T. O'Sullivan.

lead pencil, crayon and ball-point pen, initial plans for the late composi-
tions, wild compositional swirls forming rising and subsiding shapes
usually embodying human figures. There are sketches for 'My Beautiful,
My Beautiful', 'A Student of Drama', 'The Drama Lover' and others;
'The House of a Young Man Dying' was conceived first as 'The House of
the Dying'. The drawing for 'Let there be no more war' is much more defi-
nite and has explanatory notes here and there. It might be an initial idea
for 'Grief' though the composition is in no way similar. Two figures are
scribbled in the centre with a note: '2 old men tattered with old wounds',
and women and children with weapons lying near them occupy the left
and right foregrounds. A snake creeps to the left, beside a spear and a
shield, and mist prevails. The last workbook includes notes and sketches
for fifty-six paintings some of which were never embarked upon.

The last exhibition of his work at which Yeats was present was held in
the Waddington Galleries in February 1955. He called it 'in all sorts of
happy ways, the best I ever had',[1] and with the show in Belfast the fol-
lowing year it was to be the final exhibition during his lifetime. Just
before it he completed two particularly impressive works, 'Man with a
secret' and 'His Thoughts are Far Away'.

He continued to paint until September. His last paintings were
'Entrance of a Lady with Attendants', 'Out of the Mountainside' and
'Sleep Sound', a picture of two figures lying on a moor beneath a heavy
sky.

Yeats appears to have left Fitzwilliam Square for good in the winter of
1955. John Berger visited him in the following September, and published
an impressive interview a few months later.[2] He was chiefly struck by his
age and dignity and his opposition – though partly it must be pointed
out with a humorous unwillingness to be precise, his opposition to fash-
ioned morality.

He is an old, very tall, thin man. His face is that of an old, tall, upright man; no
literary image should be used to describe the face of this life-long image maker.
And when I told him, thinking of how many tinkers and horse traders and wan-
derers he had painted, that Léger had said that the artist was in the same class as
the *clochard* because in their common desire for the danger of maximum freedom

[1] Letter to T. de Vere White, 8 March 1955.
[2] *New Statesman and Nation*, 8 December 1956, pp. 741–2.

they backed the same horse . . . he smiled, . . . and added like an old man . . .
- except that he was attentive enough to nod at the speed with which I was
drinking his Irish whiskey – he added, 'Yes, but some of the best people are
losers. I've known some terrible brilliant men – all brilliance on the outside, and
all morality inside, as a second line of defence'.

Yeats also gave a demonstration of conjuring tricksterism at horse
fairs, and of boxing and sang an old song of Marie Lloyd's for his inter-
viewer.

In November the artist Oskar Kokoschka, who was a great admirer,
wrote to 'Jack B. Yeats the great painter (may-be the last!)' begging him
not to leave his brush idle.

Please, after having had your rest, let your unruly soul for another turn out in
the wonderfull [*sic*] world of your sagas and take up painting again! You alone
can to-day tell in painting such touching stories![1]

But Yeats was growing tired. He was eighty-five years of age. Appro-
priately, the last time he was seen in public, the artist was walking alone,
with his unmistakable sailor's gait down the south quays of the Liffey,
completely absorbed in the river and the ships that he loved.[2]

He died on 28 March 1957. His last drawing, a tiny gay swirling sketch
of two roundabout ponies on writing paper, was drawn two days before.

The funeral was held two days later at St. Stephen's Church, in
Upper Mount Street, and Yeats was buried at Mount Jerome Cemetery
with ceremony. There were no flowers, only a single laurel wreath on his
coffin.[3] Representatives of all professions and walks of life accompanied
him to the grave. Even now it is difficult to see him in perspective. Time
must elapse. But he left his epitaph with a friend shortly before he died,
repeating the words in a semi-chant like the ballad singers he knew in
early days:

I have travelled all my life without a ticket: and, therefore, I was never to be seen
when Inspectors came round because then I was under the seats. It was rather
dusty, but I used to get the sun on the floor sometimes. When we are asked about
it all in the end, we who travel without tickets, we can say with that vanity which
takes the place of self-confidence: even though we went without tickets we never

[1] 11 November 1956, the artist's estate.
[2] 'Irishman's Diary', 30 March 1957, *Irish Times*.
[3] R. Plaistowe.

were commuters.[1]

His earlier 'epitaph' is worth quoting:

Under no stones
 Nor slates
Lies Jack B.
 Yeats.
No heaped up rocks.
Just a collection box,
 And we thought a Nation's folly
 Would like to be jolly
 And bury in state
This singular Yeat.
But they were not so inclined
Therefore if you've a mind
To slide a copper in the slot
 'Twill help to sod the plot.[2]

His poetry was not as visionary as his painting.

[1] T. de Vere White, *A Fretful Midge*, 1957, p. 121.
[2] Recited to the United Arts Club, 16 February 1933.

From a Christmas card

Bibliography

Books written and illustrated by Jack B. Yeats

James Flaunty or the Terror of the Western Seas. London, Elkin Mathews, 1901.

A Broadsheet, edited by Jack B. Yeats. Illustrated by Pamela Coleman Smith, Jack B. Yeats, and others. London, Elkin Mathews, 1902, 1903.

The Scourge of the Gulph. London, Elkin Mathews, 1903.

The Treasure of the Garden. London, Elkin Mathews, 1903.

The Bosun and the Bob-tailed Comet. London, Elkin Mathews, 1904.

A Broadside, edited and illustrated by Jack B. Yeats. Dublin, Dun Emer and Cuala Presses, 1908–15.

A Little Fleet. London, Elkin Mathews, 1909.

Life in the West of Ireland. Dublin, Maunsel, 1912.

Modern Aspects of Irish Art. Dublin, Cumann Leigheacht an Phobail, 1922.

Sligo. London, Wishart, 1930.

Apparitions. London, Jonathan Cape, 1933.

Sailing, Sailing Swiftly. London, Putnam, 1933.

The Amaranthers. London, Heinemann, 1936.

The Charmed Life. London, Routledge, 1938.

Ah Well. London, Routledge, 1942.

La La Noo. Dublin, Cuala Press, 1943.

And To You Also. London, Routledge, 1944.

The Careless Flower. London, Pilot Press, 1947.

In Sand. Dublin, Dolmen Press, 1964.

Contributions by Yeats to Periodicals

'A Cycle Drama'. *The Success*, 7 September 1895.

'The Great White Elk'. *Boy's Own Paper*, Christmas Number 1895.

'On The Stones'. *Manchester Guardian*, 28 January 1905.

'Racing Donkeys'. *Manchester Guardian*, 26 August 1905.

Review of *Sea Life in Nelson's Time. Manchester Guardian*, 25 September 1905.

'Shove Halfpenny'. *Manchester Guardian*, 4 October 1905.

'Life in Manchester: The Melodrama Audience'. *Manchester Guardian*, 9 December 1905.

'A Canal Flat'. *Manchester Guardian*, 31 March 1906.

'The Jumpers'. *Manchester Guardian*, 7 April 1906.

'An Old Ale House' *Manchester Guardian*, 14 April 1906.

'The Concert-House'. *Manchester Guardian*, 21 April 1906.

'The Glove Contest'. *Manchester Guardian*, 5 May 1906.

'The Cattle Market'. *Manchester Guardian*, 19 May 1906.

'The Flat Iron'. *Manchester Guardian*, 26 May 1906.

'A letter about J. M. Synge'. *Evening Sun* (New York), 20 July 1909. (With alterations, as 'Memories of Synge' *Irish Nation*, 14 August 1909; 'With Synge in Connemara' *Synge and the Ireland of his time, with a note concerning a walk through Connemara with him by Jack B. Yeats* by W. B. Yeats, Dublin, Cuala Press, 1911.)

'How Jack B. Yeats produced his plays for the miniature stage', by the Master himself. *The Mask*, July 1912.

'A theatre for everyman'. *The Music Review*, Autumn 1912.

'Ireland and Painting', Parts 1 and 2. *Ar n-Eire : New Ireland*, 18, 25 February 1922. (In a revised form as *Modern Aspects of Irish Art*, 1922).

'A Symposium on a Design from San Gallo' (Replies from Bruno Brunelli, John Masefield, Gordon Craig, Allardyce Nicoll, Jack B. Yeats, Max Beerbohm, etc.) *The Mask* (Florence), October 1925.

'Dustbins: to the Editor of the Irish Times' by "Constant Riser". *Irish Times*, 8 May 1931.

'When I was in Manchester'. *Manchester Guardian*, 2 January 1932.

'A Cold Winter and a Hot Summer in Ireland'. *The Stork* (Putnam), March 1933.

'Beach made models'. *London Mercury*, September 1936.

'Indigo Height'. *New Statesman and Nation*, 5 December 1936.

'A Painter's Life'. *Listener*, 1 September 1937.

'The too early bathers'. *New Alliance*, April 1940

'A fast trotting mare.' *Commentary*, December 1941.

'Jack B. Yeats by Jack B. Yeats. Irish Authors: 36.' *Eason's Bulletin*, October 1948.

Illustrations by Yeats other than those for his own books and articles

BOOKS ILLUSTRATED

Rhys, E., *The Great Cockney Tragedy*. London, 1891.

Yeats, W. B., *Irish Fairy Tales*. London, Fisher Unwin, 1892.

A London Garland. London, Macmillan, 1895. (Tailpiece to 'Molesey Hurst' by J. H. Reynolds.)

M'Intosh, S.L., *The Last Forward*. London, R. Brimley Johnson, 1902.

Borthwick, N., *Ceachta Beaga Gaeilge*. Dublin, Irish Book Company, 1902–6.

Rhys, G., *The Prince of Lisnover*. London, Methuen, 1904.

Russell, G. W., ed., *New Songs*. Dublin, O'Donoghue, 1904.

Masefield, J., *A Mainsail Haul*. London, Elkin Mathews, 1905.

Reynolds, J.H. *The Fancy*. London, Elkin Mathews, 1906.

Synge, J. M. *The Aran Islands*. Dublin, Maunsel, 1907.

O Beirn, S., *Paistidheacht*. Baile Atha Cliath, Blacie, 1910.

Synge, J. M., *In Wicklow, West Kerry, and Connemara*. Dublin, Maunsel, 1911.

Lynd, R., *Rambles in Ireland*. London, Mills and Boon, 1912.

Mitchell, S., *Frankincense and Myrrh*. Dublin, Cuala Press, 1912.

Colum, P., *A Boy in Erinn*. New York, Dutton, 1913.

Birmingham, G. A., *Irishmen All*. London, Foulis, 1913.

O'Kelly, S., *Ranns and Ballads*. Dublin, Candle Press, 1918.

Gogarty, O. St. J., *The Ship and other poems*. Dublin, Talbot Press, 1918.

The Book of St. Ultan. Dublin, Candle Press, 1920.

O'Kelly, S., *The Weaver's Grave*. Dublin, Talbot Press, 1922.

Colum, P., *The Big Tree of Bunlahy*. New York, Macmillan, 1933.

Lynch, P., *The Turf-cutter's Donkey*. London, Dent, 1934.

A Broadside (new series), ed. by W. B. Yeats and F. R. Higgins. Nos. 1, 3, 6, 12. Dublin, Cuala Press, 1935.

A Broadside (new series), ed. by Dorothy Wellesley and W. B. Yeats. Nos. 1, 4, 6, 7, 10, 12. Dublin, Cuala Press, 1937.

Duggan, G. C., *The Stage Irishman*. Dublin, Talbot Press, 1937.

Cregan, M., *Sean-Eoin*. Baile Atha Cliath, Oifig an tSolathair, 1938.

Yeats, W. B., *On the boiler*. Dublin, Cuala Press, 1939.

O'Connor, F., *A Lament for Art O'Leary*. Dublin, Cuala Press, 1940.

Bodkin, T., *My Uncle Frank*. London, Hale, 1940.

Colum, P., *The Jackdaw*. (Dublin Poets and Artists – 2). Dublin, Gayfield, 1942.

Outriders. Dublin, Runa Press, 1943.

MAGAZINE ARTICLES AND STORIES ILLUSTRATED

'Elves' Polo Match'. *Vegetarian*, 7 April 1888.

'Diary of Diogenes Dustbin, F.R.S., while staying in a country house in the year 1887'. *Vegetarian*, 16, 30 June 1888.

Childrens' Corner: Cloudland!' *Vegetarian*, 10 November 1888.

Yeats, W. B., 'A Legend'. *Vegetarian*, 22 December 1888.

'Hanasaki Jiji: the old man who made the dead trees blossom!' *Vegetarian*, 5, 12 January 1889.

Yeats, E. C., 'Scamp, or Three friends'. *Vegetarian*, 9, 16, 23 February 1889.

Phillips, H., 'Herbey Hudson'. *Vegetarian*, 30 March 1889.

Evans, T. H., 'That Ninny of a husband of mine'. *Vegetarian*, 25 May 1889.

Waylen, H., 'Mr. Chiselwig's Impressions of Vegetarianism'. *Vegetarian*, 10 August 1889.

White, E. E., 'Sally Simple's dream'. *Vegetarian*, 5 October 1889.

Evans, T. H., 'A beau with a grievance'. *Vegetarian*, 2 November 1889.

'The Hunter Hunted!' *Vegetarian*, 21 December 1889.

Quiddam, R., 'Jemmy's Cricket on the Hearth'. *Vegetarian*, 21 December 1889.

Evans, T. H. 'The People next door'. *Vegetarian*, 4, 11, 18, 25 January; 1, 8, 15, 22 February; 1, 8, 15, 22, 29 March; 5, 12, 19, 26 April; 3, 10, 17 May 1890.

'Horse Flesh and the Preparation of Cocoa'. *Vegetarian*, 3 May 1890.

Hermit, P., 'Poor Miss Jebb'. *Vegetarian*, 16, 23 August 1890.

Report on Lord Mayor's Show. *Vegetarian*, 15 November 1890.

Evans, T. H., 'Defeated inspite of himself'. *Vegetarian*, 18, 25 April 1891.

Hawkins, E., 'A week at sea'. *Vegetarian*, 13 June 1891.

'Edison's great joke'. *Vegetarian*, 13 June 1891.

Telford, A., 'Front-Door Echoes from Juniper-Street'. *Vegetarian*, 26 September; 3, 17, 24 October 1891.

'Ye golden pig and ye golden Pippen'. *Vegetarian*, 5 March 1892.

'Ancient Egypt'. *Vegetarian*, 12 March 1892.

'A warm corner'. *Vegetarian*, 8 April 1893.

Pinder, P., 'The Apple Dumplings and a King'. *Vegetarian*, 9 December 1893.

Hood, T., 'A Butcher'. *Vegetarian*, 9 December 1893.

Yeats, W. B., 'Michael Clancy, the Great Dhoul and Death.' *The Old Country Christmas Annual*, December 1893.

'Seasonable Sonnet by a Butcher'. *Vegetarian*, 6 January 1894.

Hyde, D., 'The Hag's Gold'. *Celtic Christmas*, December 1899.

Gregory, A., 'Rival poets'. *Celtic Christmas*, December 1900.

'An Gruagach Uasal'. *Celtic Christmas*, 7 December 1901.

Purdon, K. F., 'Match-making in Ardenoo'. *Celtic Christmas*, 6 December 1902.

Purdon, K. F., 'A settled girl'. *Celtic Christmas*, 5 December 1903.

Purdon, K. F., 'An American visitor'. *Celtic Christmas*, 3 December 1904.

Synge, J. M., 'In the Congested Districts'. *Manchester Guardian*, 10, 14, 17, 21, 24, 28 June; 1, 5, 8, 19, 22, 26 July 1905.

Masefield, J., 'Whippet-racing'. *Manchester Guardian*, 19 August 1905.

Purdon, K. F., 'The Furry Farm. *Celtic Christmas*, 2 December 1905.

Gregory, A., 'The Travelling Man. A Miracle Play'. *Shanachie*, Spring 1906.

Synge, J. M., 'The Vagrants of Wicklow'. *Shanachie*, Autumn 1906.

Birmingham, G. A., 'For the famine of your houses'. *Celtic Christmas*, 1 December 1906.

Birmingham, G. A., 'Saints and Scholars'. *Celtic Christmas*, December 1907.

Birmingham, G. A., 'The Banquet'. *Celtic Christmas*, December 1908.

Birmingham, G. A., 'The University Senator'. *Celtic Christmas*, 11 December 1909.

Stephens, J., 'The unworthy princess'. *Celtic Christmas*, 17 December 1910.

Pike, M., trans., 'Meli'. *Slainte*, January 1911.

PRINTS FOR CUALA

Hand-coloured prints

1	Evening	14	The Wren Boys
2	The Post Car	15	St. Patrick at Tara
3	The Start of the Race	16	The Packman
3A	Strand Races	17	The Fiddler
4	The Finish	18	The Star in the East
5	The Village	19	Mountain Road
6	The Mountain Farm	20	The Crib
7	The Island People	21	The Message
8	The Pookawn	22	The Hurler
9	The Shanachie	23	Rune of Hospitality
10	The Old Slave	24	Leafy Munster
11	The New Ballad	105	The Bog Road
12	The Ballad Singer	152	The Side Car
13	The Fair Day	153	The Jockey

Christmas Cards (with verses)

11	'Rune', by K. MacLeod
12	'Day closes', by Susan Mitchell
13	'The Star is Risen', by Susan Mitchell
14	'The Star is in the East', by Susan Mitchell
16	'Mourn Not', by Susan Mitchell

37 'Child's Thought', by Nancy Campbell
50 'Connaught Toast'
51 'Midland Toast'
60 'The Dove', by K. Tynan
61 'Mile Failte', by Douglas Hyde
62 'The Wild Duck'
63 'Cronan Mna Sleibe', by Padraic Pearse
69 'To these high Lands', by Susan Mitchell
72 'Christmas Holly', by K. Tynan
85 'Though Riders', by Douglas Hyde
88 'Now Twine', by K. Tynan
89 'A Cradle Song', by W. B. Yeats
90 'Set the Hearth', by K. Tynan
92 'Rann Nodlaig'
99 'Ancient Mare'
110 'Child at Window', by K. Tynan
111 'Christ's Coming', by Padraic Pearse
113 'O Friend', by Douglas Hyde
119 'Dublin Quays'
122 'Time', by Susan Mitchell

Calendars

1911 Dublin Quays
1916 The Ballad Singer
1933 Farmers at the Fair
1935 Fair Day
 The Star is in the East
 A Small Fair
 A Western Ocean Beau
 A Long Time Ago
 The Hurley Player
 The Play Boy
1939 Lovely Hill Torrents Are

Manuscripts consulted

Private papers, including some manuscripts of writings. Sketchbooks from 1894 to early 1950s.

Letters and papers in the National Library of Ireland; City of Dublin Public

28 Meditation 1950

29 The show ground revisited 1950

30 Grief 1951

31 My beautiful, my beautiful 1953

32 His thoughts are
far away 1955

Libraries; University of London Library; New York Public Library; University of Kansas Libraries; Archives of American Art.

Criticism

PUBLICATIONS ABOUT JACK B. YEATS

Marriott, E., *Jack B. Yeats: being a true and impartial view of his pictorial and dramatic art.* London, Elkin Mathews, 1911.

MacGreevy, T., *Jack B. Yeats: an appreciation and an interpretation.* Dublin, Waddington, 1945.

Rosenthal, T. G., *Jack Yeats*, 1871–1957. London, Knowledge Publications, 1966. (*The Masters* – 40).

ARTICLES IN PERIODICALS

General

Article on the Yeats family. *The Lamp*, (U.S.A.) June 1904.

'Irish saints at Dun Emer'. *Irish Homestead*, 13 February 1904.

'A Dublin home of art industries'. *Irish Independent*, 25 March 1905.

'Jack B. Yeats', by AE. *Booklover's Magazine* (Edinburgh), 1908–9.

'Jack B. Yeats: Pictorial and Dramatic Artist' by Ernest Marriott. *Manchester Quarterly* July 1911.

'Lady Gregory and the Abbey Theater', by John Quinn. *Outlook* (New York), 16 December 1911.

'The Art of Jack B. Yeats: the artist brother of the poet Yeats', by P. Colum. *TP's Weekly*, 18 July 1914.

'Native art. Advantage of cultivating national style', by Kevin J. Kenny. *National Volunteer*, 9 January 1915.

'The Cuala industries', by G. W. Turner. *Lady's Pictorial*, 2 September 1916.

'Cuala industries'. *Irish Life*, 23 February 1917.

'Mr. Jack B. Yeats and the poets of "A Broadside"', by Eugene Mason. *Today*, October 1917.

'The Cuala Press and its bookplates', by W. G. Blaikie Murdoch. *Bookplate Booklet* (third series), May 1919.

'The education of Jack B. Yeats', by J. B. Yeats. *Christian Science Monitor* (Boston), 2 November 1920.

'A talk with Jack Yeats', by Trevor Allen. *Westminster Gazette*, 21 December 1921.

'Tendencies in Irish art', by P. Colum. *Survey Graphic*, December 1921.

'The Cuala Press', by W. G. Blaikie. *Bookman's Journal & Print Collector*, July 1922.

'Snapped by Shemus – no. 49. Mr. Jack B. Yeats.' *Freeman's Journal*, May 1923.

'Modern Irish art', by J. W. Good. *Manchester Guardian Commercial*, 10 May 1923.

'Some Irish artists XII. Mr. Jack B. Yeats', by Bruyere. *Irish Times*, 16 June 1923.

'Mr. Jack B. Yeats', by John Masefield. *Dublin Magazine*, August 1923.

Correspondence between T. Bodkin and T. MacGreevy regarding the respective merits of Nathaniel Hone and Jack B. Yeats. *Irish Statesman*, 27 September; 18, 25 October 1924.

'Jack B. Yeats, artist', by S. Hunt. *The Bookplate: a book-arts miscellany* (new series), 1926.

'Distinguished Irishmen – XXIII. Mr. Jack B. Yeats and his art', by R. S. W. *Daily Express*, 12 October 1929.

'Irish painting. A school inspired by Orpen.' *Irish Times Supplement*, January 1932.

'Jack B. Yeats: Painter', by Elizabeth Curran. *Cosmopolitan* (Edinburgh), November 1936.

'Jack B. Yeats R.H.A.', by C. P. Curran. *Studies*, March 1941.

'Contemporary Irish Artists – VII: Jack B. Yeats R.H.A.', by Mairin Allen. *Father Matthew Record*, December 1941.

'Three historical paintings by Jack B. Yeats', by T. MacGreevy. *Capuchin Annual*, 1942.

'Jack B. Yeats', by Theodore Goodman. *Commentary* (Dublin), July 1943.

'Jack B. Yeats: the man and his work', by Kathleen Brennan. *The Leader*, 18 December 1943.

'MacGreevy on Yeats', by Samuel Beckett. *Irish Times*, 4 August 1945.

'A painter of Ireland.' *Times Literary Supplement*, 18 August 1945.

'Art' by M. Collis. *Observer*, 16 December 1945.

'Jack B. Yeats (poem)', by Donagh MacDonagh. *Irish Times*, 27 April 1946. (Reprinted as 'The Painter's Rose (for Jack B. Yeats)' *Irish Times*, 29 March 1957. From *The Hungry Grass*).

'Passages from a diary of E. C. Yeats.' *The Wind and the Rain*, Autumn 1946.

'Visits to Jack Yeats', by John Rothenstein. *New English Review*, July 1946.

'Jack B. Yeats: an appreciation', by D. Shields. *Irish Monthly*, December 1949.

'Art and artists: the art of Jack B. Yeats', by E. Sheehy. *Social and Personal*, August 1949.

'People by Pyke. Jack B. Yeats R.H.A. (cartoon).' *Sunday Press*, 12 March 1950.

'Culture in Ireland', by S. Arnold. *The Arts and Philosophy* (*A Quarterly*), Autumn 1951.

'Irish painter, Jack B. Yeats', by Brian O'Doherty. *Irish Monthly*, May 1952.

'The Cuala Press', by R. M. Fox. *British Printer*, January–February 1953.

'Two Beloved Vagabonds reach the end of the road: "Good-bye, 'Chips'!" After sixty years', by Alfred Byrne. *Manchester Guardian*, 19 September 1953.

'Humanisn in art: a study of Jack B. Yeats', by Brian O'Doherty. *University Review*, Summer 1955.

'Jack Yeats', by John Berger. *New Statesman & Nation*, 8 December 1956.

Obituary. *Manchester Guardian*, 29 March 1957.

'Jack Yeats'. *Irish Times*, 29 March 1957.

Obituary. *Times*, 29 March 1957.

Obituary. *Sligo Independent*, 13 April 1957.

'Jack B. Yeats 1871–1957.' *Eire: Ireland: Weekly Bulletin of the Department of External Affairs*, 29 April 1957.

'Memories of Coole', by Arnold Harvey. *Irish Times*, 23–4 November 1959.

'Sketches from letters of Jack B. Yeats', by Arnold Harvey. *Irish Times*, 23–4 August 1960.

'Ireland: the Easter rising – Ireland's troubles through the eyes of Jack Yeats.' *Illustrated London News*, 23 April 1966.

'Jack B. Yeats', by James White. *New Knowledge*, 24 April 1966.

Reviews of exhibitions

1897 *Saturday Review*, 20 November.

1899 *Pall Mall Gazette*, 24 February, by R. A. M. Stevenson; *The Artist* (London), 25.

1899 *Dublin Independent*, 19 May, by M. A. Manning.

1900 *Weekly Independent*, 3 March.

1901 *Morning Leader*, 8 February.

1901 *Freeman's Journal*, 23 October, by AE; *Irish Times*, 23 October; *Leader*, 2 November, by A. Gregory; *Claidheamh Soluis*, 2 November.

1902 *Leader*, 30 August, by Spectator; *Freeman's Journal*, 20 August; *United Irishman*, 23 August, by AE; *Express*, 19 August.

1903 *Morning Leader*, 13 February 1903.

1903 *Leader*, 5 September, by R. Elliott; *Sligo Independent*, 26 September.

1904 *Lamp* (U.S.A.), May; *New York American*, 1 April, by H. P. du Bois; *New York Times*, 5 April; *Irish World*, 11 April.

1905 *Nationist*, 5 October, by William Buckley.

1908 *Tribune*, 6 February.

1909 *Irish Times*, 11 May; *Irish Independent*, 11 May, by K. M. O'B.; *Gaelic American*, 20 June.

1910 *Irish Times*, 8 December; *Irish Homestead*, 17 December.

1912 *Manchester Guardian*, 11 July; *Weekly Irish Times*, 3 August.

1914 *Evening Mail*, 24 February, by P. Colum; *Irish Times*, 25 February; *Christian Science Monitor*, 1 April.

1914 *New Witness*, 7 July, by E. Storer.

1918 *Irish Times*, 25 March; *Evening Telegraph*, 6 April.

1919 *Nationality*, 3 May, by D. Figgis; *New Ireland*, 26 April; *New Ireland*, 10 May, by G. N. Plunkett.

1919 *Manchester Guardian*, 12 June.

1920 *Irish Statesman*, 17 April; *New Leader*, 17 April; *Irish Times*, 9 April.

1921 *Old Ireland*, 26 February; *Ireland's Own*, 2 March; *Evening Telegraph*, 23 February.

1922 *Freeman's Journal*, 25 April; *Irish Times*, 26 April.

1923 *Freeman's Journal*, 26 April; *Irish Times*, 28 April.

1923 *Dublin Opinion*, June.

1924 *Manchester Guardian*, 14 January; *Morning Post*, 9 January.

1924 *Irish Statesman*, 5 April; *Irish Times*, 28 March.

1925 *Vogue*, late April, by Clive Bell.

1926 *Connoisseur*, June.

1927 *Studio*, May, by T. Bodkin.

1928 *Apollo*, May; *Christian Science Monitor*, 23 April; *Times*, 15 March.

1929 *Manchester Guardian*, 15 February; *Times*, 6 February.

1929 *Dublin Opinion*, May.

1929 *Irish Times*, 2 October.

1930 *Dublin Opinion*, May.

1930 *The Times*, 1 July; *New Statesman*, 5 July, by T. W. Earp; *Apollo*, August.

1931 *Irish Times*, 22 April; *Manchester Guardian*, 22 April.

1931 *Dublin Opinion*, May.

1932 *Brooklyn Tablet*, 7 May.

1932 *Connoisseur*, December; *Apollo*, November.

1934 *Dublin Opinion*, May.

1937 *American Art News*, 27 May.

1940 *Burlington Magazine*, February; *Irish Independent*, 27 January.

1940 *Irish Monthly*, April; *New Statesman*, 13 April, by Clive Bell; *Spectator*, 5 April, by John Piper.

1941 *Irish Times*, 28 October, by Patrick Kavanagh.

1942 *Burlington Magazine*, February; *Artist*, March; *Studio*, March; *Spectator*, 9 January, by John Piper; *The Times*, 2 January; *Listener*, 8 January, by Herbert Read; *Horizon*, January, by K. Clark.

1943 *Observer*, 14 November, by Osbert Lancaster; *Commentary*, December.

1945 *Irish Times*, 2 March; *Leader*, 10 March, by Stephen Rynne.

1945 *Father Matthew Record*, June, by C. P. Curran; *Irish Times*, 12 June; *Leader*, 23 June, by K. Brennan; *Bell*, June, by E. Curran; *Sunday Independent*, 3 June, by C. P. Curran; *Irish Worker's Review*, June, by S. Barret; *Irish Times*, 9 June, by Monk Gibbon; *Capuchin Annual*, 1945–6, by C. P. Curran.

1946 *Sunday Times*, 24 February, by E. Newton.

1946 *Leader*, 9 November, by J. MacNeill.

1947 *Irish Times*, 3 October; *Arts*, 7 November, by Charles Sidney.

1948 *Leeds Art Calendar*, Summer, by E. I. Musgrave; *New Statesman*, by Patrick Heron; *Arts Plastiques*, 9/10, by J. P. Hodin; *The Times*, 14 August; *Dublin Magazine*, July–September, by E. Sheehy.

1949 *Arts News and Review*, 22 October, by Jack White; *Irish Times*, 7 October.

1954 *Dublin Magazine*, April–June, by E. Sheehy; *Lettres Nouvelles*, April, by Samuel Beckett, etc.; *Le Peintre*, 15 February; *La Terre Bretonne*, 18 February; *Le Monde*, 12 February.

1958 *New Statesman*, 22 March, by J. Berger; *Manchester Guardian*, 10 March, by S. Bone; *Art News & Review*, 15 March, by R. Watkinson.

1961 *New Statesman*, 21 April; *Guardian*, 6 April, by E. Newton; *The Times*, 10 April.

1962 *Irish Times*, 19 November, by A. Cremin.

1963 *Apollo*, April, by D. Sutton; *Burlington Magazine*, May, by K. Roberts; *The Times*, 3 April.

1966 *Irish Times*, 10 June, by B. P. Fallon.

1967 *Illustrated London News*, 30 September, by A. Causey; *The Times*, 10 October, by T. G. Rosenthal.

General bibliography

Arnold, S., *Symbolism in art*. London, 1957.

Berger, J., *Permanent Red*. London, 1960.

Boucicault, D. L., *The Dolmen Boucicault* ed. D. Krause. London, 1964.

Chesterton, G. K., *Autobiography*. London, 1936.

Clausen, G., *Six lectures on painting*. London, 1904.

Clemens, S. L., *The writings of Mark Twain*. London, 1899–1900.

Craig, E. G., *Bookplates*. Surrey, 1900.

Craig, E. G., *Nothing or the Bookplate*. London, 1931.

Disher, M. W., *Blood and thunder*. London, 1949.

Elton, O., *Frederick York Powell: a life and selection from his letters*. Oxford, 1906.

Emmons, R., *The life and opinions of Walter Richard Sickert*. London, 1941.

Furniss, H., *The confessions of a caricaturist*. London, 1901.

Gregory, A., *Journals 1916–1931* ed. L. Robinson. London, 1946.

Harte, F. B., *Complete works*. London, 1880–1900.

Hindley, C., *The true history of Tom and Jerry*. London, *c.* 1889.

Hone, J., *W. B. Yeats 1865–1939*. London, 1943.

Hodin, J. P., *Oskar Kokoschka; the artist and his time*. London, 1966.

Irish art handbook. Dublin, 1943.

Irish art. Dublin, 1944.

Jeffares, A. N., *W. B. Yeats; man and poet*. London, 1949.

Kilgannon, T., *Sligo and its surroundings*. Sligo, 1926.

Krumbhaar, E. A., *Isaac Cruikshank: a catalogue raisonné*. Philadelphia, 1966.

Masefield, *Salt-water ballads*. London, 1902.

Masefield, J., *Ballads*. London, 1903.

May, P. W., *The parson and the painter by Joseph Slapkins*. London, 1892.

May, P. W., *Humorous masterpieces*. London, 1907.

Moore, G., *Modern painting*. London, 1893.

Newton, E., *In my view*. London, 1950.

Observer Revisited 1963–4 compiled by Cyril Dunn. London, 1964.

Price, R. G. G., *A history of Punch*. London, 1957.

Pyle, H., ed., *The Buccaneers and Marooners of America*. London, 1892.

Rothenstein, W., *Men and memories*. London, 1931.

Russell, G. W., *Imaginations and Reveries*. Dublin, 1915.

Skelton, R., and Saddlemyer, A., ed., *The world of W. B. Yeats*. Dublin, 1965.

Speaight, G., *Juvenile drama*. London, 1946.

Stevenson, R. L., *Memories and portraits*. London, 1927.

Stone, J. H., *Connemara*. London, 1906.

Synge, J. M., *Collected works*. London, 1962, 1966.

Thorpe, J., *English illustration: the nineties*. London, 1935.

Tynan, K., *Memories*. London, 1924.

White, T. de V., *A fretful midge*. London, 1957.

Wilson, A. E., *Penny Plain: Twopence Coloured; a history of the juvenile drama*. London, 1932.

Yeats, J. B., *Letters to his son W. B. Yeats and others 1869–1922* ed. J. Hone.

London, 1944. New York, 1946 (includes Elizabeth Yeats's diary 1888–9).

Yeats, W. B., *Letters*, ed. A. Wade. London, 1954.

Yeats, W. B., *Autobiographies*. London, 1955.

Some portraits of Jack B. Yeats

As a child, by J. B. Yeats. Sketch dated 18 November 1875. Rep: Marriott, E., *Jack B. Yeats* 1911. (frontis.)

As a boy, by J. B. Yeats. Oil. *National Gallery of Ireland.*

As a young man, by J. B. Yeats, Oil, c. 1890. *National Gallery of Ireland.*

Half length, by J. B. Yeats. Pencil, dated July 1899. *National Gallery of Ireland.*

Head and shoulders, by Pamela Coleman Smith. Two pen and ink sketches dated, 22 October 1901, executed on the title page of Lady Gregory's copy of *Samhain* I. *New York Public Library.*

Half length seated, by Estella Solomons. Oil. 1922. *Sligo County Library and Museum.*

Portrait, by Clare Marsh. Oil. *Drogheda Municipal Art Gallery.* Ex: October 1923 Dublin St. Stephen's Green Gallery (45).

Portrait, by Sarah Purser. Oil. *Royal Hibernian Academy.* Ex: 1927 Royal Hibernian Academy.

Head and shoulders, by Sean O'Sullivan. Charcoal dated November 1929. *National Gallery of Ireland.*

Head, by Brenda Gogarty. Bronze. *Mr. and Mrs. Desmond J. Williams, Tullamore.*

Portrait, by Patrick O'Connor. Oil. *Miss T. O'Sullivan, Dublin.* Ex: June 1940 Dublin Gorry Galleries (2).

Seated, by Sean O'Sullivan. Pencil, dated 1942. *Dr. K. O'Malley, Dublin.*

Portrait, by Sean O'Sullivan. 1942. *Sligo County Library and Museum.*

Portrait, by James Sleator. Oil, dated 1942. *Cork Municipal Art Gallery.*

Seated, by Sean O'Sullivan. Pencil, dated 1943. *National Gallery of Ireland.*

Half length, by G. de Gennaro. Crayon, 1944.

Portrait, by Lilian Davidson. Oil. *National Gallery of Ireland.*

Head, by Laurence Campbell, Ex: 1945 Royal Hibernian Academy.

Seated, in his studio, by Jacques Gaillard. Sketch 1949.

Sketch, by F. Topolski. Rep: *Art News and Review*, 22 October 1949.

Portrait, by George Campbell. Oil. *Victor Waddington, London.*

Head, sleeping, by Niall Montgomery. Pencil, dated 21 March 1955.

Public collections containing works by Jack B. Yeats

National Gallery of Ireland.

Municipal Gallery of Modern Art, Dublin.
Ulster Museum.
Sligo County Library and Museum.
Limerick Municipal Art Gallery.
Cork Municipal Art Gallery.
Waterford Municipal Art Gallery.

Tate Gallery, London.
Victoria and Albert Museum.
Windsor Castle.
Temple Newsam House, Leeds.
City of Birmingham Art Gallery.
City Art Gallery, York.
Cecil Higgins Art Gallery, Bedford.
Aberdeen Art Gallery.
Scottish National Gallery of Modern Art, Edinburgh.
Cyfarthfa Castle Museum, Merthyr Tydfil.

National Gallery of Canada.

Smithsonian Institute, Washington.
Phillips Collection, Washington.
Toledo Museum of Art.
Cleveland Museum of Art.
Seattle Art Museum.
Boston Museum of Fine Arts.
Boston College, Bapst Library.

Musée d'Art Moderne, Paris.

Tel Aviv Museum, Israel.

National Gallery of South Africa.

Contributions by Yeats to illustrated papers

The Vegetarian

Vol. I, 1888: 14 April. Sketch of man and boy feeding birds.
Vol. II, 1889: 23 March, *188*. Unsigned sketches.
– 30 March, *204*. Sport.
– 21 December, *805*. Christmas advertisement for *The Vegetarian*.
Vol. III, 1890: 16 August, *523*. Signed sketch.

– 13 September, *587*. Sport.
– 11 October, *651*. My pet cat.
– 25 October, *683*. A whip or a word.
– 29 November, *761*. A fragment (an illustrated verse about eating horse flesh.)
– 20 December, *806*. Sketch.
Vol. IV, 1891: 10 January, *25*. Drury Lane Pantomime: Beauty and the Beast.
– 21 March, *177*. Sketch.
– 28 March, *188*. The Oxford & Cambridge Boat Race.
– 11 April, *217*. Sketch. *219*, 'After a Vegetarian Dinner'.
– 18 April, *223*. Unsigned sketch.
– 25 April, *243*. Sketch.
– 6 June, *309*. Sketch.
– 13 June, *321*. With the Bus-Men.
– 14 November, *581*. Unsigned sketch.
– 28 November, *605*. Off to the Show.
– 5 December, *624*. (1) Mr. Compton in 'The Liar'. (2) The Terrible Vision of the Future.
– 19 December, *644*. 'Buy, Buy, all fresh joints, just killed, warm and quivering.'
Vol. V, 1892: 23 January, *44*. Philo Ingarfield, and Jawle the Cynic Philosopher (drawings from *The Crusaders*).
– 30 January, *56*. Two illustrations of *The Commission* (play).
– 20 February, *89*. The Sport's nightmare, or Drinking the dregs of a 'Waterloo Cup.'
– 27 February, *100*. First fruits of the NHUS Vegetarian lecture at the Broadway Hall. *103*, 'Serial' food.
– 5 March, *112*. Sketch.
– 19 March, *137*. The Middleman Sly.
– 26 March, *149*. Che-ops – The Maddened Butcher.
– 16 April *183*. Opium smoking. *185*. The Oxford v. Cambridge Boat Race.
– 23 April *195*. A quiet corner.
– 14 May, *237*. Sketch.
– 21 May, *247*. The Return of the Wild West.
– 4 June, *266*. Sketch.
– 23 June, *355*. Venice in London.
– 8 October, *482*. Sketch.
– 5 November, *531*. A gondolier.
– 12 November, *542*. At a Vegetarian Restaurant. *548*. Free Trade and Commonsense.
Vol. V, 1892: 19 November, *553*. Sketches. *559*, Sketches.

– 10 December, *599*. A Tragic Story.

– 17 December, *618*. Sketch.

Vol. VI, 1893: 11 February, *68*. Sketch.

– 8 April, *159*. 'Arry and 'Arriet at 'Am'stead.

– 15 April, *178*. Sketches.

– 29 April, *200*. Sketch.

– 15 July, *331*. With & Without the Bearing-Rein.

– 30 September, *468*. Sketch.

– 7 October, *479*. Which is the Mistress and which is the Maid?

– 21 October, *503*. Boots (taken by surprise): Don't Wegetarians shave?

– 4 November, *527*. Professor Hygiene.

– 18 November, *551*. A Little Sermon.

– 2 December, *575*. Cartoon.

Vol. VII, 1894: 13 January, *26*. Wanted, a Doctor.

– 10 March, *121*. 'A Curious Feat!'

(There are also numerous incidental sketches, correspondence and Children's Corner section headings, figure embellishments for capital letters, and reprints of small sketches.)

Daily Graphic

Vol. III, 1890: 29 August, *14*. An Irish race meeting (a letter from 'J. B. W.', Rosses Point, Sligo, Ireland, describing the Drumcliffe Back Strand Races, a £4 15*s*. race.)

Ariel or The London Puck

Vol. V, 1891: 3 January, *4*. Five Smokes.

– 17 January, *40*. Illustration to 'A Dangerous Ditty'.

– 14 March, *171*. 'A hint to Parsons who cover too much ground.'

– 21 March, *188*. 'After the Vegetarian Dinner.'

– 4 April, *214*. ' 'Arry's (after) holiday dream'.

– 11 April *232*. 'Frightened by false fire.'

– 18 April, *243*. Ariel's illustrated idioms.

– 25 April *267*. ' "She's by the head. Get furtheraft, Bill" . . .'

– 2 May, *277*, 'Neck to Neck'. *280*, Merrymaking. *283*, 'I'me not half-s drunk-s I look Constable.

– 9 May, *291*. 'Sitting by his own fireside. *299*, Something like a break.

– 16 May, *307*. 'He Played with Expression'. *316*, Breaking the Journey'.

– 23 May, *325*, Whit Monday – and Wisdom Tuesday. *331*, 'Tis the anguish of

the Singer Makes the Sweetness of the song'.

– 30 May, *338*. She entered into an engagement with him.

– 6 June, *358*, Mary had a little Lamb. *360*, 'Buy Buy'. *363*, (1) Our two pair back has gone in for elocution. (2) Illustration to 'Lessons from our hoardings'.

– 13 June, *374*, Bust of Homeric Laughter. *378*, 'It's a coming young-un'. *383*, Making a clean breast of it.

– 20 June, *392*. Whetting his appetite.

– 27 June, *408*. The Washerwomen's Strike. *413*, Round the town, I. The Coster's Saturday Night.

Vol. VI, 1891: 4 July, *3*. 'Sudden fall of temperature on the river.' *11*, 'It's all very wells for him to shay' . . .

– 11 July, *27*. Round the town, II. The East End Theatre Saturday Night.

– 18 July, *38*. A Day with the British Workman. *40*, The Race for the Claret Cup.

– 25 July, *51*. The dry season after the heavy wet. *59*, Ariel up the River. *63*, A cross country rider.

– 1 August, *75*. Round the town, III: At Tattersall's: At Aldridges.

– 8 August, *85*. Terrible scenes on the upper Thames. *88*, With the four-wheelers.

– 15 August, *107*, Round the town V: Mile End Waste. *108*, Taking his name and address.

– 22 August, *120*, Round the town, VI: With the buses. *122*. The Law is carried out.

– 29 August, *134*. 'Yes my boy I always took a leading part in my playfellows' sports'.

– 5 September, *151*. The Electrical Key-hole finder.

– 12 September, *167*, With the policemen. *171*, 'Well, I didn't think your cab was as old as that.'

– 19 September, *182*, The man who was always in the way. *188*, It's all right, policeman . . .

– 26 September, *198*. (1) His face was his fortune. (2) Returning to dust. (3) The terrible 'rush' at the exhibition.

– 3 October, *211*, 'Have you had an accident, sir? . . . *214*, Chestnuts.

– 10 October, *227*. To the Trains. *230*, (1) This style twenty-five guineas . . . (2) The new burglar foil. (3) This style two guineas . . . *237*, The stuck up artiste.

– 17 October, *243*. Ish thish the way you drive . . .

– 24 October, *261*, The Last girl of summer. *262*, (1) A bolt from the blue. (2) What's up. *269*, Out on Strike.

– 31 October, *279*. (1) Illustration to *The Crusaders*. (2) Amateurs.

– 7 November, *291*, The Black Maria, or the Force of Habit. *298*, A slip of a girl. *302*, (1) The Dog Show at the Crystal Palace, (2) Then always patronize the old firm.

Vol. VI, 1891: 14 November, *307*, Both Busy. *311*, 'Now, if nothing don't happen we'll beat the lot'. *318*, Hardly what he meant.

– 21 November, *325*, Pick-a-back. *334*, A bit off.

– 28 November, *339*, There's a 'orse for you! Look at his legs! . . . *341*, He went through the mill. *348*, The omnibus of the future.

– 5 December, *357*, Forced. *359*, In the chamber of horrors. *363*, The horse was all right.

– 12 December, *373*, (1) He underwent a severe training. (2) His turn next. *380*, What was seen when the fog lifted.

– 19 December, *389*, Clear as crystal. *394*, (1) A screw loose. (2) M'Ginty sits out. *396*, 'They said sthep out of the windie into the garden . . .'

– 26 December, *403*, Tommy's opportune moment. *411*, (1) The hired ghost. (2) A family affliction. *413*, 'I've done it Charlie! . . .'

Vol. VII, 1892: 2 January, *7*, 'It's all right guvonor, I'm sleep walking so don't wake me up sudden.' *11*, 'Oh yes! me take wine with you, Massa!'

– 9 January *24*, (1) A near thing on the track. (2) Illustration to 'In praise of fog' by A. W. T. *26*, An Emerge-ncy exit at Venice. *28*, The Boxer. Who's his backer?

– 16 January, *45*. He kept it from the little ones.

– 23 January, *59*, (1) The surprised showman. (2) He pressed his suit with fervor. *60*, (1) The race at Covent Garden Fancy Ball. (2) Time is money.

– 30 January, *69*, 'Blank the ice! Double dash the skates!' . . . *71*, Heap big caravan! . . . *72*, There aint no sorter pleasure in bashing one of them Oprey 'ats. *74*, The police again at fault. *78*, Without a ticket.

– 6 February, *85*. (1) All screws. (2) Such a shy young man. *86*, The referee of the future. *92*, McGinty sits out too long.

Paddock life

Vol. III (new series), 1891: 26 May, *2*. 'Outsiders'.

– 2 June, *4*. (1) 'The man who "got off" the old joke about Friday's Race being a Hoax.' (2) 'The armorial, bearings of a gentleman whom I know.'

– 9 June, *3*. 'The men who know most about "Chances"'.

– 16 June, *2*. 'Directions: You wind up the Clerk, and the Bookie "goes"!'

Vol. III, 1891: 16 June, *4*, 'Cup Day at Ascot.' *5*, 'Hedged'. *7*, Civil Service Sports at Stamford Bridge.

– 23 June, *3*, 'Are Yez Dead, Mike Mickey. Not dead; but kilt.' *5*, 'Mickey Muldoon's idea of a Platter'. *6*, At the Rollers.
– 30 June, *3*, Horse training by steam. *5*, (1) 'Trotting at Alexandra Park'. (2) 'A Roaring Trade.'
– 7 July, *3*, A Stayer. *4*, 'A Bad un to beat'. *5*, Lawn Tennis Championship, Baddeley.
– 14 July, *3*, 'Heavily backed. *6*, 'Thursday night at Henley'.
– 21 July, *3*, 'Rogue and Vagabond'. *6*, 'The first rounds in a punishing mill'.
– 28 July, *5*, The Long Distance Amateur Championship. *6*, Bedfordshire (cricket).
Vol. IV, 1891: 4 August, *3*, On the Turf. *5*, On the Threatened Browds.
– 11 August, *3*, Trotting at Aintree. *5*, The Dull Season. *7*, (1) 'Come on Mick I've Strruck Somethin''. (2) 'Another record breaker.'
– 18 August, *3*. The Seamy Side. *5*, (1) Ballywhack Corner. (2) Soft Going.
– 25 August, *5*. A Western Race Meeting.
– 1 September, *1*, The Dublin Horse Show. *5*, Leopardstown Second Summer Meeting.
– 8 September, *3*, Catch Weights. *5*, The Opening of the Football Season. *6*, The Arsenal versus Sheffield United.
– 15 September, *5*, Sketches at Doncaster Races. *7*, The Surrey BC at the Oval.
– 22 September, *5*, (1) Derby County Notts County (football). (2) A Very Soft Thing.
– 29 September, *5*, Sam Blakelock's Benefit. *6*, A Referee's Lot is not a Happy one. *7*, (1) LAC Autumn Meeting. (2) Cub Hunting.
– 6 October, *6*. Hard Pressed (3 parts).
– 13 October, *6*, Sketch. *7*, The Southern Counties Amateur Swimming Association.
– 27 October, *6*. Ranelagh Harriers 2½ miles steeplechase (2 parts).
– 3 November, *3*. Outside Paddock Life waiting for the Cambridgeshire Winner. *7*. Casuals versus Blades at the Oval.
– 10 October, *6*, London-Scottish, Blackheath. *7*, London v. Counties at Richmond.
– 17 November, *4*, 'Isn't it a knobby one'. *6*, 5 Miles Steeplechase at Putney. *7*, A Spoilt Pupil.
– 24 November, *4*, A small turn out. *6*, Catford Annual Dinner.
– 1 December, *6*, Hinting's latest. *7*, London v. Oxford & Cambridge at the Oval.
– 8 December, *7*. Hockey: Claton v. Putney.

– 15 December, *4*, A Rum-Un to Follow. *6*, (1) The Cattle Show. (2) Faces at the Cattle Show.

Vol. IV, 1891: 22 December, *7*. Here's to Good Fellowship.

– 29 December, *5*, (1) The Very Latest from Father Time's Stable. (2) For Winter Wear. *7*, At the Aquarium.

Vol. V, 1892: 5 January, *6*, England versus Wales. *7*, Sketch re 'numbering'.

– 12 January, *5*. (1) 'Well out of it'. (2) 'Weight for age'. (3) Heathens versus London Scots.

– 19 January, *7*. Football Weather.

– 26 January, *6*, The latest fashion in Football Costume. *7*, 'An East End Mill.'

– 2 February, *5*, 'Very trying'. *7*, Sketch of a boxer.

– 9 February, *5*, 'Fox Terrier coursing'. *6*, Sketch.

– 23 February, *3*. A Dream of the (Regulation) Ditch.

– 1 March, *3*, Reliable information. *7*, The Tykes versus Blackheath.

– 15 March, *5*, The Stepper. *6*, Where Weight Tells.

– 22 March, *2*, Hurrah for the flat. *7*, At the Oval: Something like a Gate.,

– 29 March, *6*. 10 Miles Amateur Championship.

– 12 April, *7*. Drawing of a rowing race.

– 19 April, *5*. Profession Double Skulling on the Thames.

– 26 April, *7*. Rackets at Queen's Club.

– 3 May, *5*. Our Artist's Nightmare.

– 10 May, *2*, Lucid. *5*, Enniskillen Races, Ireland (3 drawings).

– 17 May, *5*. The Roping of the 'Tough'.

– 24 May, *2*. Leopardstown Races.

– 31 May, *2*. The Derby Road: Penny Plain, Two Pence Coloured.

– 14 June, *2*. 'Manchester: The Bumping Finish.'

– 19 July, *5*. "Not Out Anyhow." *6*, Bradford Trinity Harriers. *7*, Salford Harriers.

– 26 July, *5*. The Liverpool Cup.

– 2 August, *2*. At Portsmouth Races.

– 9 August, *5*. A Manchester Wheeler's Gate.

– 23 August, *2*, 'Unsolicited'. *6*, Water Polo.

– 30 August, *5*. The Dublin Horse Show (3 parts).

– 6 September, *5*. The Opening of the Football Season.

– 13 September, *5*. Off the Pedestal.

No. 238, 1892: 20 September, *3*. 'Has it come to this? The Race Goer of Today'.

No. 239, 1892: 27 September, *2*. At Manchester.

No. 242, 1892: 18 October, *3*. A starter's difficulties.

No. 245, 1892: 8 November, *2*. His first Outrigger.

No. 248, 1892: 29 November, *3*. The Paddock at Manchester.

No. 251, 1892: 20 December, *3*. Shadowed.

No. 252, 1892: 27 December, *3*. 'Chootles is invited into the country to dine at Christmas.'

No. 254, 1893: 10 January, *3*. The Topic of the hour (two parts).

No. 256, 1893: 24 January, *3*. 'Something like a "starring tour" '.

No. 257, 1893: 31 January, *4*. A Great 'Skuller'.

No. 259, 1893: 14 February, *2*. 'Going for Corbett's Scalp'.

No. 271, 1893: 9 May, *3*. Odds On.

No. 272, 1893: 16 May, *3*. (1) Roping. (2) The Pillowcase Patent.

No. 273, 1893: 23 May, *2*. The Cracks at Exercise. *3*, How Some People Enjoy a Holiday.

No. 274, 1893: 30 May, *2*. (1) The Eve of the Great Race: The Backer's Dream. (2) On the Road: A Mixed Team.

No. 275, 1893: 6 June, *2*. (1) A Tip for Bath. (2) On the Hill.

No. 276, 1893: 13 June, *2*, An Interesting Finish of the Cup. *3*, The Bookmaker's row at Ascot.

No. 277, 1893: 20 June, *2*. Hugging the Rails. *3*, A Screw Driver.

No. 278, 1893: 27 June, *3*. (1) Mugs. (2) The Dark Division.

No. 279, 1893: 4 July, *2*. Off to Henley.

No. 280, 1893: 11 July, *2*. The Reduced Jockey.

No. 281, 1893: 18 July, *2*. A Racing Fixture.

No. 282, 1893: 25 July, *2*. Going Soft.

No. 283, 1893: 1 August, *2*. On the Free List.

No. 285, 1893: 15 August, *2*, Beaten on the Post. *3*, Right on the Premises.

No. 286, 1893: 22 August, *3*. (1) Numbers Up! (2) Operating on the flat.

No. 287, 1893: 29 August, *3*. (1) Catching the Judge's Eye. (2) An Old Plater.

No. 288, 1893: 5 September, *2*, A Walk Over. *3*, They're off.

No. 289, 1893: 12 September, *2*. A Maiden Allowance.

No. 290, 1893: 19 September, *2*. Half-way up the Straight.

No. 291, 1893: 26 September, *2*, Bolting a mile. *3*, Ringmen.

No. 292, 1893: 3 October, *2*. The Starter.

No. 293, 1893: 10 October, *2*. Having a run for their money.

No. 295, 1893: 24 October, *3*. Overweighted.

No. 296, 1893: 31 October, *3*. A Big Entry.

No. 297, 1893: 7 November, *2*. 5 to 1 Against.

No. 298, 1893: 14 November, *2*. A Nursery Handicap.

No. 301, 1893: 5 December, *2*. Between the flags.

No. 302, 1893: 12 December, *2*. Cutting out the work.

No. 303, 1893: 19 December, *2*. Report from a training stable.
No. 304, 1893: 26 December, *2*. A Private Trial.
No. 306, 1894: 9 January, *2*. Unplaced.

Lock to Lock Times and Flood and Field

Vol. V (new series), 1891: 4 July, *902*. The pleasures of training.
– 11 July, *921*. The picnic.
– 18 July, *938*. Rockets at the Richmond Fete.
– 25 July, *952*. The man who loses his temper when the kettle won't boil.
– 8 August, *987*, A Bank Holiday incident. *988*, (1) The man who never forgot anything. (2) The Hat as now Worn.
– 15 August, *1*. Houseboat Hospitality.
– 22 August, *2*, Our New Club Uniform. *4*, The young man who talked to the Bargee: The young man whom the Bargee talked to.
– 29 August, *6*. At the Lock.
– 12 September, *5*. A Houseboat Reception.

Judy

Vol. 51, 1892: 3 August, *50*. The Demon Horse.
– 19 October, *188*. 'The World's End'.
Vol. 52, 1893: 28 June, *310*. ' "Rumbo!" the Circus Horse.'
Vol. 53, 1893: 30 August, *104*. 'Eh? Ah! (Johnsong's story about the nightmare)'.
– 29 November, *200*. 'Major Spriggins's Jump in the West of Ireland'.
Vol. 54, 1894: 11 April, *170* Trotting.
Vol. 57, 1895: 17 July, *30* ' "She doesn't look like it, but she did it!".'
– 20 November, *249*. ' "Billy, what's opium?". . .'
– 27 November, *257*. ' "Did the horse pull up sound?". . .'
– 18 December, *291*. Police Constable Fresh.
Vol. 58, 1896: 8 January, *325*. '(On the stage): "Me long lost cheeild, let me gaze upon thy poor wan face ". . .' *328*. 'Whash I wash to know ish – whasha massher missey wash?'
– 22 January, *353*. 2 cartoons.
– 5 February, *374*. 3 cartoons.
– 12 February, *392*. Cartoon.
– 19 February, *400*, Cartoon. *405*, 'Sorry! is that your pet corn?'
– 26 February, *419*. Cartoon.
– 11 March, *444*. 'Overheard at Kempton'.

- 18 March, *454*. Cartoon.
- 1 April, *471*. Cartoon.
- 27 May, *574*, Circus cartoon. *576*, Cartoon.
- 10 June, *592*, 'Fall soft'. *593*, Cartoon.
Vol. 59, 1896: 1 July, *627*. 'To do'.
- 8 July, *638*. Cartoon.
- 5 August, *693*. ' "Shear, Boys, Shear." – At Our Agricultural Show.'
- 7 October, *795*. 'The Attitude of Man towards his amusements, past, present, and future.' *797*, Cartoon.
- 14 October, *807*, Cartoon. *813*, 'A patent medicine.' *816*, Cartoon.
- 21 October, *827*. 'The X Rays.'
- 18 November, *872*. 'Up to Snuff'.
- 2 December, *896*. Johnnie B, is seeing life in the East End at a donkey race.
- 9 December, *908*. 'The Water Jump'.
- 16 December, *921*. Cartoon.
- 30 December, *941*, 'A Green Christmas makes a fat Churchyard.' *946*, Alphonso has just asked his bookmaker to show him something warm for winter wear.
Vol. 60, 1897: 6 January, *10*, Cartoon. *12*, Cartoon.
- 27 January, *48*. Cartoon.
- 10 February, *65*, 'The very newest helmet.' *70*, Johnnie B. is seeing life in the East End at a boxing-booth. ' 'Ave a go along 'me, guv'nor!'
- 24 February, *94*. Cartoon.
- 3 March, *104*. Johnnie B. seeing life in the gallery, witnessing a Dagonet drama.
- 24 March, *143*. 'Pleasure of the Recruiting Sergeant.'
- 31 March, *152*. Cartoon.
- 7 April, *166*. Johnnie B. seeing life at a boxing show.
- 14 April, *178*, 'At the dinner to new M.P.' *180*, Johnnie B. seeing life on the race-course.'

Illustrated London News

Vol. 101, 1892: 10 September, *335*. Sketches in the Metropolitan Cattle Market, Caledonian Road, Holloway.

Chums

Vol. I, 1892: 19 October, *85*. 'Buttered on both sides'.
- 26 October, *108*. 'Photography under difficulties.'
- 9 November, *135*. 'How to create a crowd.'

- 7 December, *199*, 'Tubby or not Tubby'. *208*, 'The Pillows of the Deep!'
- 14 December, *221*. Cartoon.
- 21 December, *227*. 'Starting on a new tack'.
- 28 December, *249*. 'The Automatic Artist'.
- 1893: 4 January, *263*. 'Poetry – Prose'.
- 11 January, *288*. 'The painter's ladder.'
- 18 January, 'That full stop'.
- 25 January, *311*. 'Unexpect(r)ed'.
- 8 February, *352*. 'The Latest in Sells'.
- 22 February, *371*. 'A pitched battle'.
- 8 March, *416*. 'He stirred him up'.
- 15 March, *432*. 'Too good to be true'.
- 22 March, *435*, 'Been in the crush'. *439*, 'He fell soft'. *448*, 'Football as she is played.'
- 29 March, *461*. 'Handsome is that Hansom does'.
- 12 April, *487*, 'Sour Grapes'. *493*, 'The (Un)Romance of Chivalry'. *496*, 'Plucked'.
- 3 May, *535*. 'The Wild Man of Borneo'.
- 17 May, *576*. 'Punt Puzzle'.
- 31 May, *608*. 'He picked it up'.
- 12 July, *692–3*. 'The New Candidate, or the Bullet-Proof Suit: A hint for the next elections.'
- 19 July, *719*. 'Davy Jones' Locker.'
- 26 July, *731*. 'Stealing a tow.'
- 16 August, *771*, 'He fixed him with his eye.' *777*, 'The wonderful expanding bag.'
Vol. II, 1893: 30 August, *3*, 'Across the Herring Pond.' *8*, 'Mr. Toddleby's "Aerial Flight".'
- 13 September, *35*. 'A Painful Affair.'
- 18 October, *120*. 'Made him cross'.
- 1 November, *148*. 'Rather a tall story'.
- 8 November, *166*, 'Cooking their goose.' *168*, 'A Moving Incident.'
- 15 November, *192*. Cartoon.
- 22 November, *205*. 'This Hill is Dangerous.'
- 13 December, *248*. 'As from a catapult . . .'
- 27 December, *280*. 'Pulled up short'.
- 1894: 3 January, *296*. 'Waggles and the Wrappers'.
- 7 February, *379*, 'Something like a rabbit! *384*, 'Truthful Johnston's story about his prehistoric ancestor.'

Vol. II, 1894: 14 February, *387*. 'How he caught the steamboat'.
- 28 February, *424*. 'Sneezing the Opportunity'.
- 21 March, *470*, 'A Water Chute in the South'. *480*, 'The Padded Buffer'.
- 28 March, *488*. 'The Pneumatic Knight'.
- 11 April, *520*. 'They made him springy'.
- 18 April, *536*. 'The Man with the Agravating Snore'.
- 6 June, *654*. 'Taken in tow'.
- 13 June, *672*. 'For dry weather'.
- 20 June, *694*. 'Tossing the Caber'.
- 11 July, *736*. Cartoon.
Vol. III, 1894: 29 August, *10*, 'Snuff's as Good as a Feast'. *16*, 'Treasure trove'.
- 5 September, *30*. 'Yachting on the Amazon.'
- 12 September, *48*. 'After the Coach'.
- 26 September, *72*. ' "Old Bristles" and the Zulu.'
- 31 October, *150*, 'They got mixed'. *160*, 'An unexpected rise in the world'.
- 7 November, *171*. 'And then – Castigation'.
- 12 December, *251*. 'And He Did'.
- 26 December, *275*. 'And the Goat wept'.
- 1895: 2 January, *291*. 'Pleasures of a Stage Manager'.
- 16 January, *331*. 'Equipped for the coming flay'.
- 6 February, *382*. 'Moral: Don't Tease'.
- 13 February, *392*. 'Then He went on sliding'.
- 3 April, *504*. 'Solving a Difficulty'.
- 5 June, *646*. 'Jack Ashore in China'.
- 19 June, *686–7*. 'Quite a Performance'.
- 26 June, *703*. 'Their feelings got too strong'.
- 21 August, *824*. 'Brought her a fortune.'
Vol. IV, 1895: 4 September, *30*. 'Won – and lost'.
- 25 September, *72*. 'That did it'.
- 13 November, *192*. 'He took life pleasantly'.
- 27 November, *211*. 'A Gratituitous Testimonial'.
- 1896: 8 January, *312*. 'He'd be Revenged'.
- 15 January, *335*. 'A Tableau at our School'.
- 19 February, *405*. 'A Whackswork Show'.
- 1 April, *512*. 'We'll all go a-hunting to-day'.
- 22 April, *555*. 'Gave him a Shock'.
- 29 April, *575*. 'What a Sell!'
- 24 June, *696*. 'For Sale – a Patent Burglar-Rattle'.
- 12 August, *803*. 'Cavalier *versus* Roundhead.'

Vol. IV, 1895: 19 August, *827*. 'Rather Different'.
Vol. V, 1896: 23 September, *72*. 'That mighty pike'.
– 30 September, *88*. 'Flying from Danger Up-to-Date'.
– 28 October, *158–9*. 'Fun from the Camera'.
– 18 November, *200*. 'Nicely "Sold" '.
– 1897: 6 January, *306–7*. 'They managed to get rid of it'.
– 24 March, *488*. 'Waiting to be Patented'.
– 21 July, *763*. 'With disadvantages'.

Cassell's Saturday Journal

Vol. XII, 1894: 14 February, *431*. 'Hanging an acrobat in the Wild West'.
– 28 February, *471*. 'Great Snakes!'

The Sketch

Vol. V, 1894: 11 April. 'In the New Cut'.

Sporting Sketches

Vol. I, 1894: 7 May, *7*. At an Irish local race meeting.
– 13 August, *6*. An Irish regatta.
– 3 September, *6*. A Tale of two Turfites.
– 29 October, *6*. Our local races.
– 19 November, *7*. A Jibber from the West.
– 17 December, *7*. Our Christmas steeplechase.
Vol. II, 1895: 14 January, *7*. Our local football match.
– 28 January, *5*. Hunting cartoon.
– 4 February, *5*. Hunting cartoon.
– 11 February, *5*. Racing cartoon.
– 18 February, *6*. The story of a stumer.
– 11 March, *8*. Cartoon.
– 25 March, *8*. Cartoon.

Lika Joko

1894: 20 October. Illustration to 'The Ballyhooly Cup'.
– 27 October. 'Submarine Society' by Davy Jones – 1. 'The Finish for the
 Sandbank Memorial Mermaiden Plate'.
– 3 November. 'Submarine Society' – 2. Seaweed Stragglers v. Coral-Reef
 Crustaceans.
– 10 November. 'Submarine Society' – 3. Milk and Water.

– 8 December. 'Submarine Society' – 4. The Crystal Palace is a Popular Resort with mermen and mermaidens.'

– 15 December. 'Submarine Society' – 5. The Annual Cattle Show.

– 22 December. 'An A-Moose-ing Incident of Winter Sport'.

1895: 5 January. 'Submarine Society' – 6. Competition for the Golf Medal presented by Davy Bogey Jones, Esq.

– 2 February. 'Submarine Society – 7. Hunting the Red Herring. Dog-Fish drawing Covert at Tanglewood Bottom.'

– 2 March. 'Squire Brummles' Experiences. 1. He buys the tumbledown mansion.'

– 9 March. 'Squire Brummles' Experiences. 2. Football match of country bumpkins.'

– 16 March. 'Squire Brummles' Experiences. 3. Squire Brummles, after a round or two with Pierce Egan (in the library), organises an Exhibition of the Noble Art of Self-Defence at Coverley Court . . .'

1895: 30 March. 'Squire Brummles' Experiences. 4. Squire Brummles by mistake caught up with actual competition in Grand National.'

1895: 6 April. 'Squire Brummles' Experiences. 5. Squire Brummles at the Hunt.'

New Budget

1895, No. 8: 23 May, *23*. Folly as it flies: tragedy at trotting race.

– No. 14, 4 July, *27*, Submarine Society: All the fun of the fair. *44*, The Horn of Plenty: Spring. The Horn of Plenty: Autumn.

Punch

Vol. CX, 1896: 9 May. New Regulation for the safety of bicyclists.
 (Contributed regularly from 1910–41 under the pseudonym W. Bird.)

Gael

1903: December, *424*. 'In the West of Ireland – the town shop at Christmas time.'

Greensheaf

1904, no. 10: 2. Wren Boys.

Boston Evening Transcript

1924: 15 March. 'Primed for the play'. ([Back view of] George Moore, sketched by Jack Yeats at the Abbey Theatre.)

Select Additional Bibliography

Books written and illustrated by Jack B. Yeats
La La Noo. Reprint. Dublin, Irish University Press, 1971
Collected plays, edited by R. Skelton. London, Secker & Warburg, 1971.
A Little Book of Drawings. Dublin, Cuala Press, 1971.
Broadside Characters. Dublin, Cuala Press, 1971.
Ah Well republished with *And To You Also* in paperback, London, Routledge & Kegan Paul, 1974.
A Little Book of Bookplates. Dalkey, Cuala Press, 1979.

Selected Criticism

Connelly, J.F., 'Jack B. Yeats: ringmaster'. *Eire-Ireland*, Winter 1975.

McHugh, R., ed., *Jack B. Yeats: A Centenary Gathering* (Tower series of Anglo-Irish studies III). Dublin, Dolmen, 1971.

Mays, J. 'Jack B. Yeats: some comments on his books'. *Irish University Review*, Spring 1972.

Pilling, J., 'The living ginger: Jack B. Yeats's "The Charmed Life" '. *Journal of Beckett Studies*, 1979.

Pyle, H., 'About to write a letter'. *Irish Arts Review*, Spring 1985.

Pyle, H., ' "Many ferries" – J. M. Synge and realism'. *Eire-Ireland*, Summer 1983.

Pyle, H. ' "Men of destiny" – Jack B. Yeats and W. B. Yeats: the background and the symbols'. *Studies*, Summer/Autumn, 1977.

Pyle, H., ' "There is no night" '. *Irish Arts Review*, Summer 1986.

Pyle, H. *Jack B. Yeats in the National Gallery of Ireland*, Dublin, 1986.

Pyle, H., *Yeats at the Hugh Lane Municipal Gallery of Modern Art, Dublin*. Dublin, 1988.

Rose, M. G., 'Solitary companions in Beckett and Jack B. Yeats'. *Eire-Ireland*, Summer 1969.

Rose, M.G., *Jack B. Yeats: painter and poet* (European University Papers series XVIII, vol. 3) Berne, 1972

Skelton, R., ' "Unarrangeable reality" ' in *The World of W. B. Yeats*. Dublin, Dolmen, 1965.

White, J. and Pyle, H., *Jack B. Yeats; Drawings and Paintings*, National Gallery of Ireland, 1971.

Exhibitions of the work of Jack B. Yeats

1897	November	London	Clifford Gallery, *Watercolour sketches.*
1899	February	London	Walker Art Gallery, *Sketches of Life in the West of Ireland.*
	May	Dublin	Leinster Hall, *Sketches of Life in the West of Ireland*
1900	March	Dublin	Leinster Hall, *Sketches of Life in the West of Ireland and elsewhere*
	24–29 October	Oxford	Clarendon Hotel, *Sketches of Life in the West of Ireland*
1901		London	Walker Art Gallery, *Sketches of Life in the West of Ireland and elsewhere*
	23 October–2 November	Dublin	9 Merrion Row, *Sketches of Life in the West of Ireland*
1902	18–30 August	Dublin	Wells Central Hall, *Sketches of Life in the West of Ireland*
1903	4 February–4 March	London	Walker Art Gallery, *Sketches of Life in the West of Ireland*
	24 August–5 September	Dublin	Central Hall, *Sketches of Life in the West of Ireland*
1904	31 March–16th April	New York	Clausen Galleries, *Recent watercolours*

1905	October	Dublin	Leinster Hall, *Pictures of Life in the West of Ireland*
1906	1–20 October	Dublin	Leinster Hall, *Sketches of Life in the West of Ireland*
1908	3–29 February	London	Walker Art Gallery, *Pictures of Life in the West of Ireland*
1909	10–29 May	Dublin	Leinster Hall, *Pictures of Life in the West of Ireland*
1910	8–21 December	Dublin	Leinster Hall, *Pictures of Life in the West of Ireland*
1912	1–13 July	London	Walker Art Gallery, *Pictures of Life in the West of Ireland*
1914	23 February–7 March	Dublin	Mills Hall, *Pictures of Life in the West of Ireland*
	29 June–18 July	London	Walker Art Gallery, *Pictures of Life in the West of Ireland*
1918	23 March–6 April	Dublin	Mills Hall, *Drawings and Pictures of Life in the West of Ireland*
1919	26 April–10 May	Dublin	Mills Hall, *Drawings and Pictures of Life in the West of Ireland*
	31 May–21 June	London	Little Art Rooms, *Drawings and Pictures of Life in the West of Ireland*
1920	8–22 April	Dublin	Mills Hall, *Drawings and Pictures of Life in the West of Ireland*
1921	19 February–4 March	Dublin	Stephen's Green Gallery, *Drawings and Paintings of Life in the West of Ireland*
1922	24 April–8 May	Dublin	Stephen's Green Gallery, *Drawings and Pictures of Life in the West of Ireland*
1923	25 April–9 May	Dublin	Stephen's Green Gallery, *Drawings and Pictures of Life in the West of Ireland*
1924	7–18 January	London	Gieves Art Gallery, *Paintings of Irish Life*

1924	27 March– 8 April	Dublin	Engineers' Hall, *Pictures of Life in the West of Ireland*
1925	12 March– 4 April	London	Tooth, *Pictures of Irish Life*
	13–31 October	Dublin	Engineers' Hall, *Paintings*
1926	7–24 April	London	Tooth, *Paintings of Irish Life*
1927	25 February– 5 March	Dublin	Engineers' Hall, *Paintings*
	23 May– 4 June	Birmingham	Ruskin Galleries, *Paintings of Ireland*
1928	14 March– 5 April	London	Tooth, *Paintings*
1929	6–23 February	London	Alpine Club Gallery, *Paintings*
	1–14 October	Dublin	Engineers' Hall, *Paintings*
1930	24 June– 7 July	London	Alpine Club Gallery, *Paintings*
1931	21 April– 5 May	Dublin	Engineers' Hall, *Paintings*
1932	March	New York	Ferragail Galleries, *Exhibition of Paintings*
	June	New York	Barbizon Museum of Irish Art, *Exhibition of Paintings*
	5–25 October	London	Leger, *Ireland and Irish Life in Paintings*
1936	19 March– 15 April	London	Dunthorne, *Recent Paintings*
1939	November	Dublin	5 South Leinster Street, *Exhibition of 11 paintings*
1940	28 October– 12 November	Dublin	Contemporary Picture Galleries, *Paintings*
1941	27 October– 8 November	Dublin	Contemporary Picture Galleries, *Later Work*

1942	January	London	National Gallery, *Nicholson & Yeats*
1943	6–13 November	Dublin	Victor Waddington Galleries, *Later Painting*
1945	2–14 March	Dublin	Victor Waddington Galleries, *Paintings*
	June–July	Dublin	National College of Art, *National Loan Exhibition*
	21–29 September	Limerick	Goodwin Galleries, *Paintings*
1946	13 February–9 March	London	Wildenstein, *Oil paintings*
1946	30 October–8 November	Dublin	Victor Waddington Galleries, *Oil paintings*
1947	3–16 October	Dublin	Victor Waddington Galleries, *Paintings*
1948	20 June–4 August	Leeds	Temple Newsam House, *Loan exhibition*
	14 August–15 September	London	Tate Gallery, *Loan exhibition* (presented by the Arts Council of Great Britain, and travelled to Aberdeen Art Gallery and Edinburgh Royal Scottish Academy)
1949	October	Dublin	Victor Waddington Galleries, *Oil paintings*
1951	March	Boston	Institute of Contemporary Art, *A first retrospective American exhibition* (travelled 1951 and 1952 to Washington, Phillips Gallery; San Francisco, De Young Memorial Museum; Colorado Springs Fine Arts Center; Toronto, Art Gallery; Detroit Institute of Arts; New York National Academy)
1953	19 January–1 March	New York	Saidenberg Gallery, *Paintings*

1953	4–28 March	London	Wildenstein, *Recent paintings*
	October	Dublin	Victor Waddington Galleries, *Oil paintings*
1954		Paris	Galerie Beaux-Arts, *Peintures*
1955	February	Dublin	Victor Waddington Galleries, *Oil paintings*
1956	February–March	Belfast	Museum and Art Gallery, *Paintings* (presented by the Council for Encouragement of Music and the Arts)
1957		Edinburgh	Mound Galleries, *Loan Collection* (compiled by the Society of Scottish Artists)
1958	6 March–3 April	London	Waddington Galleries, *Later Works*
1960		York	City Art Gallery, *Paintings* (presented for the York Festival)
	August–September	Sligo	County Library and Museum, *Selection of paintings*
1961	–22 April	Dublin	Dawson Gallery, *Watercolours and pen and ink drawings*
	6–29 April	London	Waddington Galleries, *Early Watercolours*
	14–27 August	Sligo	Town Hall, *Loan Collection* (presented by Sligo Art Society)
	24 October–11 November	London	Waddington Galleries, *Paintings*
	24 October–11 November	Montreal	Waddington Galleries, *Paintings*
1962	6–31 March	New York	Willard Gallery, *Oil Paintings*
	23 April–12 May	Los Angeles	Felix Landau Gallery, *Paintings*

1962	July–October	Venice	Irish section of the XXXI Esposizione Biennale Internazionale d'Arte, *Paintings*
	19 November–16 December	Dublin	Municipal Gallery of Modern Art, *Paintings from the Biennale Exhibition* presented by An Cómhar Cultúra Eireann
	November–12 December	Dublin	Dawson Gallery, *Watercolours and pen and ink drawings*
1963	28 March–27 April	London	Waddington Galleries, *Paintings*
	2–20 August	Sligo	County Library, *Joint exhibition of paintings from the collections of the late Ernie O'Malley and the Yeats Museum, Sligo*
1964	April	Derry	Arts Council of Northern Ireland, *North West Arts Festival*
	May	Belfast	Arts Council of Northern Ireland, *May Festival*
1965	11 January–17 February	Massachussetts	Institute of Technology, Hayden Gallery, *Loan Exhibition*
	11 February–13 March	London	Waddington Galleries, *Paintings*
	14–26 June	Belfast	New Gallery, *Loan Exhibition*
	26 June–10 July	Waterford	Municipal Gallery, *Loan Exhibition*
1966	7 June–7 July	Dublin	Dawson Gallery, *Oil paintings*
1967	28 September–21 October	London	Victor Waddington, *Oil Paintings*
	26 October–18 November	London	Victor Waddington, *Early drawings and watercolours*
1967–8	December–June	Dublin	Trinity College, *Paintings by Jack B. Yeats from the Collection of Howard Robinson*

Group exhibitions to which Jack B. Yeats contributed

1895		Dublin	Royal Hibernian Academy *66th Annual Exhibition* (continued to contribute until 1900, after which he did not contribute until 1911)
1902		Cork	*International Exhibition*
1903		Dublin	Irish Literary Society, *Exhibition*
	April	London	Whitechapel Art Galley, *Shipping Exhibition*
1904	April	St. Louis	*Exposition*
	31 May–23 July	London	Guildhall, *Loan collection of Irish artists* (arranged by the Corporation of London)
		Dublin	Royal Hibernian Academy, *Exhibition of pictures presented to the City of Dublin to form the nucleus of a gallery of modern art*
1905	–28 February	London	Baillie's Gallery, *Exhibition of paintings, drawings and sketches by J. H. Donaldson, Jack B. Yeats, Elinor Monsell and Mrs. Norman*
		Dublin	Rotunda Rooms, *Gaelic League Exhibition*
1906		Limerick	*Industrial Exhibition*
		Dublin	An t-Oireachtas, *Teaspántas Ealadhain*
	December	London	*Exhibition* (arranged by Lady Dudley)
1909		Dublin	Aonach, *Exhibition of paintings*
		London	Albert Hall, *Allied Artists*
	October	Belfast	Art Society, *28th Annual Exhibition*
1910	12 October–20 November	London	Whitechapel Art Gallery, *Shakespearean Memorial Theatrical Exhibition*

1910		New York	Macbeth Gallery, *Group exhibition*
		London	*Allied Artists*
1911		Belfast	Industrial Association, *Exhibition*
		London	*Allied Artists*
		Dublin	Royal Hibernian Academy, *82nd Annual Exhibition* (continued to contribute regularly from now on)
	July	Dublin	Rotunda Rink *Teaspántas Ealadhan an Oireachtais*
		Dublin	Aonach
1912		Paris	*Salon des Independents*
		London	Art Companions, *Second exhibition*
1913	February	New York	Armory, *International Exhibition of Modern Art*
	21 May–29 June	London	Whitechapel Art Gallery, *Summer Exhibition : Irish Art*
	October	Dublin	Black & White Artists' Society of Ireland, *Exhibition*
	December	Dublin	Rotunda Gardens, *Aonach na Nodlag*
1914	December	Dublin	Black & White Artists' Society of Ireland, *Second Exhibition*
1915		Dublin	Royal Hibernian Academy, *Exhibition for Belgian Relief Fund*
		Dublin	Arts Club
		Dublin	Stephen's Green Gallery, *Five Provinces Exhibition*
		Dublin	An t-Oireachtas, *Taispeantas Ealadhan*
1916	March	London	Grafton Galleries, *Allied Artists' Association 8th Salon*
	April	Dublin	Black & White Artists' Society of Ireland, *Third Exhibition*
		Dublin	Arts Club

1917	January–March	London	Royal Academy of Arts, *Winter Exhibition of Graphic Arts in aid of the Red Cross and St. John's Ambulance Society*
	20–21 April	Dublin	Mansion House, *Gift Sale in aid of Irish National Aid and Volunteer Dependents' Fund Exhibition*
		Dublin	Aonach
		Dublin	Arts and Crafts Society
		Birmingham	*Theatre Exhibition*
1918		London	Grafton Galleries, *Allied Artists' Association 10th Salon*
1919	July	London	Grafton Galleries, *Allied Artists' Association 11th Salon*
1920		London	Grafton Galleries, *Allied Artists' Association 12th Salon*
	August	Dublin	Society of Dublin Painters, *First Exhibition*
	August	Dublin	An t-Oireachtas. *An Chead Taispéantas Ealadhan*
1921	January	Glasgow	Society of Painters & Sculptors
	February	New York	Society of Independent Artists', *Annual Exhibition*
	April	Dublin	Society of Dublin Painters, *Second Exhibition*
		London	Heal's Gallery, *Allied Artists' Association 14th Salon*
	September	Liverpool	Walker Art Gallery, *Autumn Exhibition*
	November	Dublin	Society of Dublin Painters, *Third Exhibition*
1922	28 January–25 February	Paris	Galerie Barbazanges, *Exposition d'art Irlandais*

1922	March	New York	Society of Independent Artists, *Annual Exhibition*
1923	June	London	Grosvenor Gallery, *Summer Exhibition of paintings by contemporary British artists*
	September	New York	Society of Independent Artists, *Annual Exhibition*
1924	January	Rome	*International Exhibition of Fine Arts*
	7–30 March	New York	Society of Independent Artists' *8th Annual Exhibition*
	June	Paris	Olympic Games, *Exposition*
1925		New York	Society of Independent Artists, *9th Annual Exhibition*
		Pittsburgh	Carnegie Institute, *International Art Exhibition*
		London	Goupil Gallery Salon
1926		New York	Society of Independent Artists *10th Annual Exhibition* (This was the last year Jack Yeats contributed to the New York Independents)
	March	London	Goupil Gallery, *Spring Exhibition*
	May	London	Radical Club, *Exhibition*
	Autumn	Liverpool	Walker Art Gallery, *Autumn Exhibition*
1927	January–February	London	New Chenil Galleries, *The Society of Present-day Artists 2nd Annual Exhibition*
		London	Princes' Gallery, *Royal Institute of Oil Painters*
		Liverpool	Walker Art Gallery, *Autumn Exhibition*
1928		London	*Royal Institute of Oil Painters*

1928		London	Goupil Gallery, *Autumn Salon*
		Liverpool	Walker Art Gallery, *Autumn Exhibition*
1930	February	Belfast	Museum and Art Gallery, Contemporary Art Society, *Exhibition*
	March	New York	Helen Hackett Galleries, *2nd Irish Exhibition*
	October	Toronto	Art Gallery, *Paintings by Homer Watson and a collection of paintings by Contemporary Irish Artists*
1931	October	Pittsburgh	Carnegie Institute, *International Art Exhibition* (Jack Yeats represents R.H.A.)
	December	New York	Barbizon Museum of Irish Art, *Opening Exhibition*
1932	18 June–10 July	Dublin	Metropolitan School of Art, *Exhibition of Irish art* (Aonach Tailteann)
	December/ January	New York	Barbizon Museum of Irish Art, *Exhibition of Irish Artists*
1933		Chicago	World Fair
	May	New York	Barbizon Museum of Irish Art, *Exhibition of Irish Painting*
1934		Pittsburgh	Carnegie Institute, *International Art Exhibition*
	October	New York	Ritz Tower Museum of Irish Art, *Exhibition of Irish paintings*
	November	Cork	Munster Fine Art Club, *14th Annual Exhibition*
1935		Pittsburgh	Carnegie Institute, *International Art Exhibition*
	August	London	Leger Galleries
	November	Cork	Munster Fine Art Club, *15th Annual Exhibition*

1936	Summer	London	Leger Galleries, *Summer Exhibition*
	15 October–6 December	Pittsburgh	Carnegie Institute, *International Exhibition of Paintings* (with others representing Great Britain)
	November	Cork	Munster Fine Art Club, *16th Annual Exhibition*
	8 December–16 January	London	Leger Galleries, *The Circus*
1937	May	New York	Galleries of Mrs. Cornelius J. Sullivan, *Three Irish Artists*
	Summer	London	Leger Galleries, *Summer Exhibition*
	July	Birmingham	Art Gallery, *Exhibition of paintings*
	14 October–5 December	Pittsburgh	Carnegie Institute, *International Exhibition*
1938	January–February	London	Royal Institute Galleries, *National Society of Painters, Sculptors, Engravers and Potters 9th Annual Exhibition*
	March	Waterford	Art Gallery, *3rd Annual Art Exhibition*
	c. March	New York	Galleries of Mrs. Cornelius J. Sullivan, *Exhibition of watercolours by Irish artists*
	June	London	Contemporary Art Society, *Exhibition*
	13 October–4 December	Pittsburgh	Carnegie Institute, *International Exhibition*
1939	February	London	Royal Institute Galleries, *National Society of Painters etc. 10th Annual Exhibition*
	May	Southport	Atkinson Art Gallery, *Exhibition*
	7–31 October	Dublin	5 South Leinster Street, *Loan and cross-section exhibition of contemporary paintings*

1939	October	Cork	University College, *Art Exhibition*
	19 October–10 December	Pittsburgh	Carnegie Institute, *International Art Exhibition*
		San Francisco	World Fair International Business Machine Corporation, *Contemporary Art of 79 Countries: collection of paintings* (Jack Yeats represented Ireland)
	December	London	Leger Galleries, *British and French Art*
1940	January–March	London	Royal Academy, *United Artists' Exhibition* (24 independent art societies, including the Allied Artists, of which Yeats was a member, were invited, 12 other Irish artists represented)
	February	London	Royal Institute Galleries, *National Society of Painters, 11th Annual Exhibition*
	15–23 February	Waterford	Newtown School, *4th Annual Exhibition of Modern Irish Art*
	April	London	National Gallery, *British Painting since Whistler*
	April	Waterford	Stella Restaurant, *Exhibition of Paintings by Irish artists* (organized by Victor Waddington Galleries, the exhibition subsequently shown in Cork in the Central Hall)
1941	May		Royal Dublin Society Spring Show, *Paintings and Sculpture by Irish Artists* (arranged by Victor Waddington Galleries)
	May	Limerick	*6th Annual Art Exhibition*
1942	January	London	Allied Artists, *Exhibition*
	March	Waterford	Newtown School, *6th Annual Exhibition of Modern Irish Art*

1942	9 April–5 May	London	Leger Galleries, *Some English Paintings of the 18th and 19th Centuries and contemporary Art*
	1 July–4 August	London	Wallace Collection, *Artists Aid Russia Exhibition*
		London	British Institute of Adult Education, for C.E.M.A., *Forty Painters*
		N. Ireland	Queen's University Joint Committee for Adult Education in collaboration with County Regional Education Committee, *A loan exhibition of modern paintings*
	October	London	Leger Galleries, *London Group 4th War-Time Exhibition*
	October	Nottingham	National Council of Y.M.C.A., *Allied Nations' Art Exhibition for the Forces*
	November	Cork	Munster Fine Art Club, *20th Annual Exhibition*
	26 November–23 December	Dublin	Contemporary Picture Galleries, *In Theatre Street*
1943	January		Royal Academy, *United Artists' Exhibition*
	August	Bristol, etc.	Contemporary Art Society, *Exhibition of contemporary paintings* (circulated by C.E.M.A.)
	16 September–9 October	Dublin	National College of Art, *Irish Exhibition of Living Art*
		London	C.E.M.A., *A second exhibition of contemporary paintings*
	November	London	Burlington House, *5th Wartime Exhibition of the London Group*
1944	January	London	Royal Watercolour Society Galleries, *National Society of Painters 12th Annual Exhibition*

1944	March	Limerick	Goodwin Galleries, *Limerick City First Annual Exhibition of Fine Art*
	May	London	Leger Galleries, *Modern Paintings*
	Summer	Belfast	Museum and Art Gallery, *Exhibition of paintings from the collection of Mr. Zoltan Frankl* (organized by C.E.M.A.)
		Dublin	National College of Art, *Irish Exhibition of Living Art*
	October	London	Burlington House, *London Group*
	November	Dublin	An t-Oireachtas, *Taispeántas Ealadhan*
1945		Dublin	National College of Art, *Irish Exhibition of Living Art*
	November	Dublin	An 'Oige, *Exhibition of work of An 'Oige and the Youth Hostel Association of Northern Ireland*
1946	Spring	Southport	Atkinson Art Gallery, *55th Spring Exhibition of Modern Art*
		Edinburgh	Royal Scottish Academy Galleries, *Society of Scottish Artists 52nd Exhibition*
	August	Dublin	National College of Art, *Thomas Davis and the Young Ireland Movement Centenary Exhibition of Pictures of Irish historical interest*
		London	Leger Galleries, *Winter Exhibition*
1948	February	London	R.B.A. Galleries, *National Society of Painters, 15th Annual Exhibition*
	28–31 March	Tuam	St. Jarlath's College, *Tuam Art Club 6th Annual Exhibition*
	Spring	Southport	Atkinson Art Gallery, *57th Spring Exhibition of Modern Art*

1948	May	London	Academy Hall, *London Group Exhibition*
	May	Dublin	7 St. Stephen's Green, *Exhibition of Broadsheets by the Cuala Press*
		Dublin	National College of Art, *Irish Exhibition of Living Art*
	16 September–13 November	Drogheda	Art Gallery, *Loan Exhibition of works by Irish artists*
	October	Limerick	Public Library, Art Gallery and Musem, *Loan of paintings from the collection of Ernie O'Malley*
1949		London	National Society of Painters, etc., *16th Annual Exhibition*
	16 August–17 September	Dublin	National College of Art, *Irish Exhibition of Living Art*
1951	18 August–9 September	Edinburgh	Scottish National Council of U.N. Association, *United Nations International Art Exhibition*
1953	April–July	Dublin	Municipal Gallery, *An Tóstal: Irish Painting 1903–1953*
	July–August	Dublin	Victor Waddington Galleries, *Summer Exhibition: Contemporary Irish painting and sculpture*
1954		Dublin	An t-Oireachtas, *Taispeántas Ealadhan*
1955	18 August–16 September	Dublin	National College of Art, *Irish Exhibition of Living Art*
1956		Dublin	Victor Waddington Galleries, *Thirty Years*
		Cork	Munster Fine Art Society, *Annual Exhibition*
1957		Dublin	National College of Art, *Irish Exhibition of Living Art*

1958	March	Belfast	Museum and Art Gallery, *Zoltan Lewinter-Frankl Collection*
	March	London	Ben Uri Art Gallery, *Friends of the Art Museum of Israel 6th Exhibition*
	April	London	Waddington Galleries, *Group Exhibition*
	July	London	Waddington Galleries, *Three Painters*
1960		London	Tate Gallery, *Contemporary Art Society 50th Anniversary Exhibition*
1961	10 May–15 July	Belfast	Museum and Art Gallery, *Pictures from Ulster Houses*
	2–27 November	Greenwich (Conn.)	Friends of the Greenwich Library, *The Arts of Ireland*
1962	18 June–15 July	Dublin	Municipal Gallery, *Bodkin Irish Collection*
		London	Waddington Galleries, *Watercolours: Yeats; Hayden; Feininger*
	Winter	London	Royal Academy, *Primitives to Picasso*
1964	March	New York	World Fair, *Irish Pavilion*
	July–August	London	Tate Gallery, *50 Years of British Art*
1965		Brighton	Art Gallery, *Wilfred Evill Collection*
		Greater Victoria (B.C.)	University of Victoria, *W. B. Yeats Centenary Festival*
1966	April	Dublin	National Gallery of Ireland, *Cuimhneacháin 1916*
1967	16 January–19 February	Washington	State Capitol Museum, *Norman W. Davis Collection*
	July	Dublin	Peacock Theatre, *Stage Design at the Abbey Theatre*
1968	8 May–15 September	Strasbourg	L'Ancienne Douane, *Europe 1918*

Index

Select List of Additional One-Man Exhibitions

1969	12 Mar–5 April	Montreal	Waddington Fine Arts *Paintings*
	10–19 April	London	Victor Waddington *Small drawings* (followed by exhibitions of *Paintings* in 1971, 1973, 1975)
1971	11–27 February	Toronto	Hart House Gallery *Paintings*
	September – December	Dublin	National Gallery of Ireland *Jack B. Yeats: a centenary exhibition* (afterwards Belfast, Ulster Museum (in part); New York Cultural Center April-June 1972)
	October – December	Sligo	County Library and Museum *Jack B. Yeats and his family* (in Dublin Municipal Gallery April-May 1972)
1978	25 October– 25 November	London	Theo Waddington *Oil paintings* (*Drawings* 1980, *Selection* 1981)
1980	15 March– 30 April	Birmingham	Alabama Museum of Art *Jack Yeats: Irish expressionist*
1983	30 March– 23 April	London	Waddington Galleries *Paintings* (*Paintings* 1987 May-June)
1986	26 March– 20 April	Dublin	National Gallery of Ireland *Jack B. Yeats in the National Gallery*
1988	26 June– 15 October	Dublin	Hugh Lane Municipal Gallery *Yeats at the Municipal Gallery*